GLOBALIZING CONTEMPORARY ART

The art world's new internationalism

GLOBALIZING CONTEMPORARY ART

The art world's new internationalism

Aarhus University Press

Globalizing Contemporary Art
© Lotte Philipsen and Aarhus University Press 2010
Cover: Kitte Fennestad
Typesetting: Narayana Press
Type: Garamond
Paper: Munken Polar
Printed by Narayana Press, Denmark
Printed in Denmark 2010
ISBN 978 87 7934 607 9

Aarhus University Press

Aarhus
Langelandsgade 177
DK – 8200 Aarhus N

Copenhagen
Tuborgvej 164
DK – 2400 Copenhagen NV

www.unipress.dk

Published with the financial support of
The Aarhus University Research Foundation
The Novo Nordisk Foundation
Krista & Viggo Petersens Fond

CONTENTS

New Internationalism

Kassel, Germany, 2007: 1,001 Chinese men and women visited the *Documenta 12* art exhibition as a part of the work *Fairytale* by the artist Ai Weiwei. Apart from the many Chinese visitors, the work consisted of 1,001 restored wooden chairs from the Qing dynasty, which were placed around the exhibition venues for visitors to use. According to the catalogue, the work and its title paid homage to 'the Brothers Grimm who wrote the majority of their fairytale collection in Kassel between 1812 and 1815.'[1] In a fairytale, anything can happen. Magically, people and creatures may transform and move, unrestricted by the laws of physics and logic, and in this respect the art world today resembles a fairytale when compared to the situation a few decades ago.

For instance, it is obvious to consider Ai Weiwei's work as a commentary on the work *7,000 Oak Trees* by Joseph Beuys, which was initiated at *Documenta 7* in 1982 and completed by the opening of *Documenta 8* in 1987. By then 7,000 oak trees had been planted in Kassel.[2] Though the strategies of the two works resemble each other, as both have elements of happenings that leave physical evidence, the difference between planting trees and flying in Chinese people and chairs mirrors to some extent the difference between the art world in 1982 and in 2007. The solid grounding of trees that are meant to grow for centuries and permanently be part of Kassel has now been replaced by a brief visit by people. Whereas Beuys was himself German, and thus 'at home' in Kassel, Ai Weiwei was born, lives and works in Beijing; but since the institutional apparatus of contemporary art has undergone a profound globalization during the past couple of decades – for instance Ai Weiwei lived in New York 1981-1993 – it seems rather natural, today, to invite Ai Weiwei to participate in *Documenta*.

The globalization of the world of contemporary art is the theme of this book, and the issue is unfolded by pursuing the fundamental question: *How*

has New Internationalism in the visual arts challenged the traditional Eurocentric paradigm of the art world? This overarching question guides the research and analysis, and I hope that the reader will find it satisfactorily answered after reading the book. But before even starting to deal with this question, some fundamental premises need to be established.

The central object of investigation is what is known in the field of contemporary art as 'New Internationalism', so I shall begin by briefly accounting for the meaning of this term, which officially stems from the establishment of The Institute of New International Visual Arts (INIVA) in London in 1991. The preparatory work for the institute was concluded by a *Final Report: The Institute of New International Visual Arts*, which, among other things, described 'New Internationalism: An Emerging Concept', listed as nine paragraphs. Since this list from 1991 represents the only official attempt ever made to actually define the concept of New Internationalism positively, we may think of it as a pseudo-manifest:

> In the mainstream of the visual arts 'International' has become a term synonymous only with Western Europe and the USA. This limiting Western / Eurocentric definition has meant that in practice *the vast majority of the world's cultures (including minority cultures with western states)* [*sic*] *have been excluded from exhibitions and from the history of art.*

> 'New internationalism' addresses this discrepancy by placing the achievements of the majority cultures *of the world* into the discourses, the exhibitions and the history of *contemporary visual arts.*

> More importantly it offers the visual perceptions, the philosophies and the histories of non-European and majority cultures as *new and challenging contributions of the mainstream of the visual arts.*

> Essentially it *reflects a changing moment in art history,* resulting from post-war migration and the shifting of cultural and ideological boundaries. It is subject to evolutionary change and therefore cannot be narrowly defined or fixed, principally because it reflects this transitional moment in history.

> It has emerged as a concept which *poses questions to the world of art* and its audience about the nature, their perception and interpretation of contemporary art practice.

It aims to bring the issues of cultural difference and cultural hybridity into the dominant discourse as a vital contribution to the development of visual art in the twenty first century.

'New Internationalism' is *not exclusive*. It will not disregard the achievements of Western Europe and the USA. Neither does it seek a negative confrontation with Western Eurocentric art history. It desires instead to broaden our understanding of the history of art beyond the narrow confines of the past.

'New Internationalism' embraces the concept of 'Black Art' because it hinges upon a cross-fertilisation of views in the contemporary visual arts. However it allows artists a choice, a subjective decision-making process based on personal experience which takes it *beyond the definitions of 'Black Art'.*

'New Internationalism' introduces new ways of addressing production, exhibition presentation and interpretation and will *generate critical debate* within the mainstream institutions with which *a healthy dialogue is envisaged*.[3]

The above nine-point list describes New Internationalism as an attitude that aims at institutional inclusion of non-Western visual art, and hence as an attitude that breaks with a hitherto prevailing Eurocentric notion of 'internationalism' in the visual arts, which was confined to Western art. Thus, the aim of New Internationalism is to replace the 'old' internationalism of the art world, which was practically confined to the West and which has tended to make use of a double-standard system, where non-Western art is judged differently than Western art. The fact that the art world (=the Western art institutional apparatus) has been ignorant of the world-wide scope of contemporary art is what New Internationalism challenges. Following gradually from the success of this challenge, the notion of 'New Internationalism' is today often simply replaced by the notion of 'global'. Likewise, the plain notion of 'international art' has been resurrected, but now in its new, global conception in which interaction or exchange between confined nations have been replaced by a much wider art institutional field in which the concept of the nation-state does not necessarily play a significant role.

The term 'New Internationalism' is used in several other fields, for instance political science and economics, with different meanings than that intended here. In this book 'New Internationalism' will refer strictly to the meaning

described within the field of contemporary visual art, and the focus on the visual arts means that investigations of institutional globalization mechanisms of art forms belonging to other domains – for instance performative arts, music, cinema and literature – lie beyond the scope of this book.

The (un)official status of New Internationalism

The establishment of INIVA in 1991 marked a turning point for New Internationalism, since a call for institutional recognition of globally founded contemporary visual art had now been taken to a level of official receptiveness in Britain, supported financially by the British Arts Council and the London Arts Board. However, the establishment of INIVA simultaneously marks the official founding of the notion of New Internationalism and its dismantling. Curiously, the InIVA website dates the establishment of the institute to 1994 – which was the year the institute moved into its building in Rivington Street, London – and in 2004 InIVA published its own retrospective history in the book *Changing States: A Unique Anthology of Essays and Artworks Celebrating 10 Years of InIVA*. Some time between the founding in 1991 and 1994 the official name of the institute went through a slight alteration, dropping the 'new' part of New Internationalism. As of 1994, the abbreviation INIVA was changed to InIVA – note the shift to a lower-case 'n', which seems to have worked its way into the official logo at some point in the late 90s – which stands for 'Institute of International Visual Arts', and it seems as if the institute officially denies the existence of its childhood years. The alteration from 'new international' to 'international' expresses the difference between New Internationalism on the one hand as an official *concept*, and what on the other may be considered a broader functional *discourse*. From this point on it seemed that using the term 'New Internationalism' as officially as in the title of the institute was too restrictive and obligatory, considering the discourse's heterogeneous agenda.

The turning away from New Internationalism as a strict concept is closely linked to the discursive practice and self-understanding expressed by the people involved with New Internationalism. An important insight into the intentions of New Internationalism is gained from looking into what is now officially considered the first public initiative taken by InIVA, which was the organizing of a symposium entitled *A New Internationalism*, held at the Tate Gallery in London on 27-28 April, 1994.[4] During these two days, a variety of views on New Internationalism were offered by 16 scholars, curators, artists, and re-

searchers, who presented views on the theme from European, North and Latin American, Asian, African, and Australian perspectives.[5] After the symposium, an anthology with the papers presented was published by InIVA, which gives valuable insights into the main issues of concern in 1994, though it is far from providing us with any definition of New Internationalism. In fact, throughout the book, entitled *Global Visions – Towards a New Internationalism in the Visual Arts*, a definition of New Internationalism is obstructed as a number of writers express reservations about the term 'New Internationalism'. They are attentive to the danger of New Internationalism being or becoming just a politically correct buzzword that might be attached to any art institutional praxis, providing it automatically with a label of legitimization, regardless of the actual content of that praxis. In *Global Visions*, artist and critic Rasheed Araeen formulates it like this:

> If 'recoding' only means changing the codes but not transforming the 'object' itself, would it not make nonsense of the whole idea of a *new* internationalism? Would it not imply the construction of a new façade or outer wall, in the manner of postmodern spectacle or decoration? [...] My fear is that this may in fact turn out to be the reality.[6]

And he continues to state that, 'If "new internationalism" means a global projection of the idea of cultural pluralism, or multiculturalism, as it has been formed in the West, then I'm afraid we are on shaky ground.'[7] Likewise, artist and curator Guillermo Santamarina writes that he

> [C]annot stop wondering whether the 'New Internationalism' is nothing more that another variation of a Fashion called World Culture, which, if I am not wrong, arises in Europe with the neo-romanticism of the beginning of the '80s.[8]

And critic and curator Hou Hanru warns that '"New Internationalism" should not become a new "ism" but on the contrary, a process of "de-ismization".'[9] Like Araeen, Hou is highly sceptical about postmodern multiculturalism, since:

> [M]ost of the investigations of 'multiculturalism', the self and the other, and related issues, have unfolded around an axis of a radical change in the relation between the colonial master and slave in the postcolonial period. [...] Our explorations of 'New Internationalism' should therefore not be a simple continuation of the existing

'multicultural' researches but also veritable developments into domains beyond this axis, in order to construct a new situation in which a single cultural order can be multiplied into different, various and rich new orders.[10]

The reservations about the term 'New Internationalism' stem from the wish to articulate new structures and orders so radical that known linguistic forms seem insufficient to describe the agenda.

InIVA is unique insofar as it was established specifically with reference to the notion of New Internationalism, but obviously, a number of other institutional initiatives participated equally in manifesting New Internationalism. For instance, the House of World Cultures was established in Berlin in 1989, and an excerpt from their mission statement reads:

> The House of World Cultures has set itself the task of presenting *non European* cultures through their fine arts, theatre, music, literature, film and the media and engaging them in a public discourse with European cultures.[11]

Whereas the House of World Cultures receives governmental funding, and in this respect resembles InIVA, another initiative called Universes in Universe is strictly private. Universes in Universe is a non-profit website, established in 1997 by artist Pat Binder and art historian Gerhard Haupt, which collects and communicates contemporary art activities in relation to Latin America, Africa and Asia.[12] The website contains information on art institutional structures in these areas, as well as photo documentation from biennials and exhibition projects that take place outside the West or focus on non-Western contemporary art.

Apart from InIVA, these were just two examples out of several institutional initiatives that, taken together, articulate New Internationalism. Describing them all would not contribute qualitatively to the investigation carried out in this book, which, therefore, will focus more specifically on the institutional context that enables us to learn more about the *different* aspects of New Internationalism.

New Internationalism is a phenomenon that is concerned with art's *institutional* mechanisms, rather than with works of art considered in isolation, or as part of broader groupings of styles or themes. Therefore, it does not make sense to speak of 'new internationalists' as members of a specific society, as writers of a manifesto, or as a certain group of people. Instead, at different times, differ-

ent people (artists, critics, curators, museum directors, academics etc.) express opinions or perform actions that are in accordance with a new international logic, and it is the heterogeneous body of such different utterances and actions that constitutes New Internationalism.

Since this book attempts to investigate New Internationalism as a discourse in the field of contemporary art, the specific objects of analysis are neither works of art nor artists, but exhibitions, catalogues, and academic writings on contemporary art, since they constitute the *institutional* field of contemporary art, where New Internationalism unfolds. For instance, a number of concrete phenomena related to the *Documenta* exhibitions will be analysed – such as the curatorial concept and its realization, the layout of the catalogue, where the participating artists were born, reviews by art critics, etc. – but none of the specific art works will be addressed in their own right. The means and mechanisms of *representation* of non-Western art, and not non-Western art in itself, is the focus of this book.

Obviously, works of art constitute the discourses and theories of art, and the works are the very foundation of the disciplines of art history and art sociology; but to a very large extent the works' visibility *as art* depends on their presence in the art institutional apparatus, and it is the mechanisms of inclusion/exclusion of that apparatus which are of relevance here. Accordingly, the specific works of art that do appear in the book will not function as objects of analysis in themselves, and the book certainly does not claim to do them justice in their own right. Instead, they function as examples, arguments, or sub-parts of analysis of institutional discursive practices.

The discourse of New Internationalism

Since the book sets out to analyse the art institutions' most dominant ways of representing non-Western art, the overall methodological approach will be one of discourse analysis, and my discourse theoretical approach will lean on the work of professors of political theory Ernesto Laclau and Chantal Mouffe, which in turn builds on and develops from the ideas of both Michel Foucault and Antonio Gramsci.[13] The overall aim for Laclau and Mouffe is to challenge the neo-liberal political Right and the dominance of market forces, and their means are the promotion of a radical, plural democracy that, above all, has room for differences and conflicts, and hence builds on political liberty. But in order to actively work for a radical, plural democracy, it is necessary to understand

how the forces of power and signification in the social and political field work, and this is where discourse theory enters the picture. We need, therefore, to distinguish between the specific, politically Left-wing project that motivates Laclau and Mouffe, and discourse theory as an analytical method that is in itself politically neutral.

It is important for me to state that when I make use of discourse theory as a method of analysis in this book, I do so in a way that is completely detached from its specific political origin. Whereas Laclau and Mouffe use discourse theory to analyse the possibilities of radical democracy, I use it exclusively to analyse the articulation of New Internationalism. The fact that New Internationalism is in itself often informed by the political Left and – as demonstrated later in this book – aspires to radical democracy only adds to the book's need to separate the methodological approach from specific political preferences. When investigating how and on what premises the interests of New Internationalism have affected the art world, a discourse theoretical approach is beneficial for two reasons:

First of all, New Internationalism itself is not a well-defined phenomenon, but is in reality a dynamic field in constant movement related to its ideological and institutional battles against the traditions it seeks to challenge. Therefore, when the book makes use of the term 'New Internationalism' it is in the sense of 'the discourse of New Internationalism'. Like any other discourse, New Internationalism results from the articulation of unfixed elements into partially fixed moments. This process of articulation 'brings us from the indeterminate level of openness to a decidable level of discourse.'[14] Hence, it is a question not only of analysing a discourse and its context, but of analysing the active *articulation* of a discourse. Since discourse theory believes that a discourse can never be fully fixed, and since this book asks not *what* New Internationalism is, but *how* its interests were and are articulated, *how* it seeks to challenge the traditional internationalism of the art world, and *how*, *to what extent* and *on what premises* this discursive formation has succeeded in realizing these intentions, I find this theoretical approach to be a particularly relevant method for pursuing these questions.

Second, a fundamental, constructive openness – characterized by complex antagonisms that constantly change and are fundamentally unfixable – is argued by Laclau and Mouffe to be at the very core of radical democracy and of discourse theory. This belief, too, plays an important role in the new international attempt to dismantle the ideological structures of the traditional art

institutional apparatus. The argument that the 'truths' of traditional art institutions are merely attempts to fix elements in hegemonic (Western) structures, and that, therefore, elements and moments can be fixed according to different chains of equivalence, is an important deconstructive step in the new international challenge. It would be wrong to suggest that New Internationalism picks up discourse theory and uses it for its own institutional struggle. Generally, New Internationalism does not make any direct references to discourse theory, and the two develop in different environments (political philosophy and visual arts) and are temporally parallel, so it is not possible to state that discourse theory existed prior to New Internationalism. However, it is clearly possible to describe and analyse what New Internationalism does along discourse theoretical principles, and the two share a common background in the work of Michel Foucault, who has been a major inspiration not only to discourse theory, but also to postcolonial theory, especially that of Edward Said. In addition, as we shall see, postcolonialism and New Internationalism share some interests – though they differ profoundly on significant issues.[15] Likewise, the work of postcolonial theorist Homi K. Bhabha builds on the ideas of Jacques Lacan, which are significant to discourse theory, too.

Thus, by analyzing the discourse of New Internationalism by means of discourse theory, the book to some extent puts the discourse to its own test. What New Internationalism does to traditional art institutional practice, this book does to New Internationalism itself, in order to get to the pivotal articulations of the discourse.

'Western', 'non-Western', 'global', and 'globalization'

Numerous theories of cultural globalization have emerged in the past couple of decades – primarily from the field of sociology.[16] In order to briefly clarify how the notions of 'global' and 'globalization' are used in this book, I find it useful to refer to Roland Robertson's distinctions between globalization and globality. Robertson argues that 'globalization' is mainly applied to the description of *historical processes* of dispersing the idea of (Western) modernity worldwide. On the other hand, 'the issue of space is more specifically and independently raised via the concept of globality.'[17] In this repect, it is the notion of globality that applies to the way that this book considers 'the global' as a concrete spatial, geographical, globe-wide territory that is not confined to specific ideologies or industrial/economic stages. The reason for considering 'the global' like this

is that – as we shall see – Western ideology and the Western conception of modernity are to a very large extent what New Internationalism antagonizes, and, in Robertson's words,

> Emphasis on globality enables us to avoid the weaknesses of the proposition that globalization is simply a consequence of modernity. Specifically, globality is the general condition which has *facilitated* the diffusion of 'general modernity', globality at this point being viewed in terms of the interpenetration of geographically distinct 'civilizations.'[18]

The title of this book, *Globalizing Contemporary Art*, thus refers to the recent historical process of rendering contemporary art a domain of globality rather than a domain of Western art. This prompts the question of how to define the notions of 'Western' and 'non-Western'. Since these notions are most often used in cultural rather than geographical categories, the definition of a 'non-Western artist' is not as simple as it may seem; for instance, a Polish or a Japanese artist may be considered as either Western or non-Western, depending on the geo-economic or geo-political perspectives applied in different periods of history. Likewise, of the artists with Australian citizenship working in the same period, those with white skin, whose forefathers were European immigrants, are likely to be considered Western, whereas those with aboriginal backgrounds are most likely to be considered non-Western artists.[19] In the above pseudo-manifest of New Internationalism, however, Western culture is defined specifically as that of Western Europe and the USA, and I shall therefore stick to this geographical definition for now, although the issue will be further elaborated in Chapter 2.

Art institutional globalization can be described as the development of what philosopher Noël Carroll calls 'a single, integrated, cosmopolitan institution of art', which is characterized by 'a reliable set of themes and sense-making strategies that can be mobilized in Shanghai, Sydney, Rio or Cape Town.'[20] Whereas formerly it would not have been accurate to speak of *the* art world, since in reality numerous art worlds existed simultaneously and separately – one for African masks and Balinese folk art, another for Jeff Koons and his colleagues, and so on – this new cosmopolitan art world has moved beyond such a division, and today constitutes one entity. This new, integrated art world is nevertheless manifested to the general public in a number of different *ways*, of which I will briefly comment on three.

The global art institution

First of all, the number of *biennials and triennials of contemporary art* is increasing worldwide, as art historian Charlotte Bydler describes in *The Global ArtWorld Inc.*[21] From Havana to Shanghai to Gothenburg, the biennial seems to be the most popular model for exhibiting contemporary art today. The organizing principle for the world's oldest art biennial, the Venice Biennial, founded in 1895, is the exhibition of art according to its national context. Thus, the layout of the Venice Biennial resembles that of a world exhibition, since each nation exhibits its art in separate pavilions. The very idea that the whole world can be exhibited in one place flourished widely in 19th century Europe, and it is possible, for instance, to detect certain similarities between the layout of the Venice Biennial and the layout of the zoological gardens in the big cities, since most zoos are organized according to different parts of the world with sections labelled, for instance, 'Africa', 'Siberia', 'The Rainforest' etc.

This national principle of organization was adopted by some of the biennials that subsequently emerged in the 20th century, but since the 1980s this principle has generally been abandoned in favour of a curating process centrally governed by a curator or a team of curators, appointed directly by the biennials themselves. The Venice Biennial, for example, is still organized according to the national system, but since 1980 it has also included a centrally curated international section (the Arsenale); and the Bienal de São Paulo was established in 1951 using the national principle, but this was abandoned in favour of the international principle in 1981.[22] As a result, the biennial exhibitions are international, insofar as they are generally curated around an overall theme chosen by the curators, and the national origin of the participating artists is therefore not necessarily of specific significance.

The success and growth of the biennial/triennial institutional type is partly due to its financial appeal for national and regional councils: they find the international branding potentials of hosting a biennial carrying the city name attractive, and thus are more willing to sponsor this kind of event than other, more low-profile cultural events. Both Carroll and Bydler compare international biennials to film festivals, and as such they function as '[G]iant film productions ... [that] need to be enough of a politically official event to be awarded a piece of the cultural budget pie.'[23] The 'coolness' factor, which provides biennials with financially attractive branding assets, is largely related to their physical, and not least their mental connection to urbanism, with its

17

associations of up-front, rapid development, young subcultures, and global (rather than national) orientation. Hence, the success of this institutional type rests on the interplay between the city, which provides financial support in return for the fashionable branding it gets from international contemporary art, and the biennial, which feeds on the urban coolness of being related to a now fashionable city.

Due to similar branding mechanisms, *museums of modern and contemporary art* are a second institutional type within the new global art world.[24] These museums are often created as spectacular structural monuments by world-famous architects, and as such are attractions in themselves, regardless of the art they display. Hence, they have the potential to create so-called 'Bilbao effects', where a landmark museum is capable of branding a city and boosting tourism, resulting in significant economic growth.[25] However, since the cost of realizing these grandiose projects is considerable, they emerge in third world countries only in connection with economic growth. More detailed distinctions between 'modern' and 'contemporary' will be discussed in Chapter 6, but taken together the museums of modern/contemporary art can be considered to be global not only due to their geographic diffusion, but also due to the profiles of their collections: Whereas each biennial show is, in principle, curated differently, the museums need to consider their collections from a longer-term perspective, which results in an emphasis on artists who have already achieved undisputed success in the international art world. Financially, the museums cannot afford to take the risk of acquiring works by completely unknown, young artists who might never turn out to be successful in the long run. Consequently, many museums of modern/contemporary art have almost identical collection profiles, which, stated roughly, consist of one piece by James Turell, one by Maurizio Cattelan, one by Pipilotti Rist and so on, all of which are installed in a spectacular piece of architecture.

A third institutional type positioned somewhere between the biennial and the museum of modern/contemporary art is the *touring exhibition*, which is uniquely curated and on view at numerous venues, often museums like those discussed above, and which travels worldwide (sometimes) for a period of years. This type is not limited to contemporary art, but exhibitions of contemporary art are more often shown at several venues, thus prolonging their existence, than exhibitions of older art, since the lending permits and security related to older works of art tend to be more restrictive. As the cost of touring blockbuster exhibitions is high, and as they do not possess any significant regional branding

potential, this institutional type becomes globalized at a slower pace than the museums of modern/contemporary art: Not only do the landmark museums that house the exhibitions need to have been established in advance, but they also need to be financially capable of receiving the blockbusters. Sponsorship from private collectors/dealers, however, often covers substantial costs related to exhibitions that feature works owned by the collector/dealer. Thus, sometimes the borderline between public museum and private gallery or auction preview becomes blurred.

In addition to the spectacular affairs discussed above, the global art world consists of galleries, both commercial and experimental, art fairs, auction houses, private buying and collecting, art schools and academies, art journals etc.[26] Although Carroll believes this art world to be cosmopolitan, to some extent the globalization of the art world originates in a kind of Westernization, according to its critics. For instance, Europeans founded art schools in several African countries during the period of colonization, and the practice of exhibiting and collecting contemporary experimental art in China has developed under heavy influence from the West.[27] In any case, the global art world constitutes a very heterogeneous field, but for now it suffices to distinguish between three different dimensions of this field: the art *institutional* globalization that is roughly described above; the globalization *of* contemporary art, which is a question of the selection and representation of art from diverse parts of the world by globalized institutions; and the curatorial idea of contemporary *global art* in itself. This book will focus mainly on the second dimension and then, subsequently, on the third.

The book comprises seven chapters. Chapter 1 investigates the nature of the hegemony that New Internationalism antagonizes and elaborates on the desired result of New Internationalism. Whereas Chapter 1 is mostly theoretical, Chapter 2 analyzes concrete institutional manifestations of this battle between old and new internationalism. Chapters 3, 4 and 5 investigate the extent to which New Internationalism overlaps with and differs from a number of other discursive articulations at work in contemporary art in the same period – such as postcolonial theory, feminism, visual culture, the notion of aesthetics and new media art. One of the most controversial analyses of the book is the investigation in Chapter 5 of New Internationalism's relation to the global capitalism of the current art market, which paradoxically shows that the art market seems to be a prime mover in realizing the aim of New Internationalism.

The investigations in Chapters 3 to 5 reveal that a number of incommensu-

rable presumptions are at work when the art institutional apparatus considers contemporary art to be 'global'. Therefore, Chapter 6 develops and elaborates on distinctions between different kinds of formally and thematically global art, which qualifies analyses of *how* works of art are global; and these distinctions are demonstrated in a thorough analysis of the institutional framing of the artist Chris Ofili. Finally, Chapter 7 critically investigates the presuppositions behind the seemingly successful manifestations of New Internationalism, for instance *Documenta 11* in 2002, by analyzing the motives and implications behind the recent curatorial tendency to focus on ethical and political issues in exhibitions of contemporary art.

The art of old and new internationalism

Before starting to analyze New Internationalism in itself, we need to understand more precisely what it challenges. Therefore, the first section of this chapter will investigate the problem(s) that New Internationalism has been seeking to solve.

The hegemony of Western art (history)

New Internationalism's critical stance on the Western art institutional system and Western art history aims at an ethnocentricity that has already been described thoroughly. For instance, the problem is lucidly discussed by Robert S. Nelson in his 1997 article 'The Map of Art History', in which art institutional structures like the classical art historical library systems and the survey book are criticized.[28] The fundamental art historical structure described by Nelson is indeed one of the things New Internationalism seeks to challenge: Namely the naturalization of Western *modernity's* superiority as a fact that can be observed objectively in time and space.

The strength of Nelson's article lies in its telling examples, which include the time-scheme from the famous survey of art history, H. W. Janson's *History of Art*. The survey book gives the reader the impression of providing a thorough view of the history of world art – that is, covering the entire time-space schema – while in reality leaving out as much as it includes.

The problem with this time line is that non-Western regions are presented as if artistically they are stuck in the past. Whereas the Western top bar develops an increasing number of nuances as time approaches the present day – it ends in a stylistic myriad of 'De Stijl', 'Abstract Expressionism' and 'Op Art' among others – non-Western areas, such as India, China, and Japan simply

III COMPARATIVE VIEWS OF THE HISTORY OF ART

1000 A.D.–1976 Unit of time: 50 years

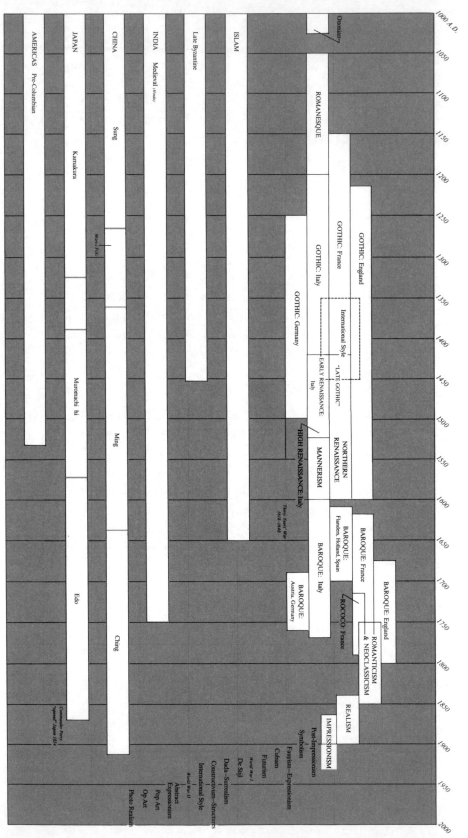

stop at earlier stages. Thus, according to this time line, no art has been created in India since 1750. Nelson quotes Janson's own explanation of the exclusion: 'Three major areas have been omitted – Indian Asia, China and Japan, and pre-Columbian America – because their indigenous artistic traditions are no longer alive today'.[29] In other words: 'They' cannot be modern.

The edition of *The History of Art* to which Nelson refers is from 1977, and obviously at this point there was something wrong with teaching students of art history that the artistic traditions of these regions were no longer alive while, at the same time, the students only needed to visit biennials and exhibitions, or examine art journals, to actually experience contemporary art from these regions for themselves. For instance, the Venice Biennale in 1976 included national pavilions representing Brazil, Colombia, and Venezuela.[30] Another grotesque example from *History of Art* is the peculiar placing of Navaho sand paintings carried out in the 1950s – and even reproduced in the book in photographs showing the artists themselves very much alive next to their works – in the first chapter entitled 'Prehistoric and Ethnographic Art', along with Stonehenge and the cave paintings of Lascaux.[31] Since the Navaho reservation's geographical position is in the USA, it would have been accurate – if time and space were really considered objectively – to place these works in the section of 'Painting since World War II', along with the works by Robert Rauschenberg and Barnett Newman, for instance.

Thus, Nelson's text demonstrates how the so-called "objective" time and space of art history is in reality controlled by the art historian, who, as a subject belonging to one particular culture in one particular moment, is constructing art history to best suit his or her purpose. In the case of Janson's *History of Art*, the purpose is to support embedded national and cultural ideals about the superiority of Western civilization over other cultures. Since this "objective" time-space structure also informs art museum collections and their presentations to the public, and courses in art history departments at universities, it is a very widespread image of power that New Internationalism seeks to challenge.

It is a paradox that the attempted scientific approach to the *world* history of art results in presentations in which *Western* art alone is considered modern, whereas non-Western cultures never really manage to develop fully on a temporal level. Thus, the seemingly scientific separation of time and space in

← H. W. Janson: 'Comparative views of the History of Art' in *History of Art*, 2nd edition, 1977.

traditional art history is not really carried through, but becomes blurred, un-even, and from a new international perspective discriminative, when it comes to the notion of modernity in art. Therefore, the deconstruction of this 'mo-dernity = West' trope is of great importance to New Internationalism, in order for it to place 'the achievements of the majority cultures *of the world* into the discourses, the exhibitions and the history of contemporary visual arts', as it reads in the second paragraph of the *Final Report* leading to the establishment of InIVA. This deconstruction is undertaken through investigations carried out by certain fields of history and sociology that have played significant roles in the articulation of New Internationalism, though the fields of history and sociology themselves have not considered visual arts in particular. For New Internationalism, the achievements of this deconstruction lie in the ability to historicize the creation of the 'modernity = West' trope, and thus reveal its constructed character.

Philosopher Enrique Dussel's distinction between the *Eurocentric* and the *planetary* paradigms of modernity is of significance here.[32] According to the logic of the Eurocentric paradigm, which resembles Hegelian thinking, 'Europe had exceptional internal characteristics that allowed it to supersede, through its rationality, all other cultures', and this rationality made the spirit of modernity spread spatially 'from Italy in the Renaissance to the Germany of the Refor-mation and the Enlightenment, to the France of the French Revolution' and eventually further throughout the world.[33] In the planetary paradigm, on the other hand, Europe is positioned in the centre of the *world-system* and only through comparison with the peripheries of this system is the modernity of this centre position granted.

The positioning of Europe at the centre (of the planetary paradigm) is not a cultural given, but was initiated by the world system, which originated in 1492 when, for the first time, the accumulation of a centre took place on a *world scale*, with Europe (Spain, and later Holland and England) being positioned at this centre. Until Columbus' accidental discovery of America, India was the centre of the inter-regional system, and Europe was at the periphery – what Columbus set out to discover was merely a different route to the well-established centre of trade of the time. In this conception of modernity, as related to radically new experience *as such*, Europe is thus not by definition the place of modernity. If, for instance, China had been interested in exploring unknown parts of the world, had discovered the American continent and had wanted to make trade routes between Europe and America via China, with China accumulating the

profits from this trade, then China would have been the centre of a world system, and hence the place of modernity.[34]

In order to hold the position of the centre, there must be a periphery, and the centre position thus requires, as Cultural Studies professor Stuart Hall formulates it, 'that all societies could be ranked or placed, early or late, lower or higher, on the same scale.'[35] This gradual incorporation of space and time, subsumed under the idea of modernity as the centre of the world system, led to what Hall names the discourse of 'The West and the Rest', which builds on a strongly hierarchical structure, as opposed to a co-ordinated structure, and thus, in theory it does not really matter who plays the role of the periphery, as long as someone plays it, since it is necessary as 'scientific' evidence to 'prove' the West to be superior to the 'Rest', by comparison.

The notion of 'the West' thus undergoes a transformation, from being considered as a *geographical* notion, a place – first as the Western periphery of India, later as the centre of the world system – to the West, considered as a certain *type of society*, a space that Stuart Hall describes as 'developed, industrialized, urbanized, capitalist, secular and modern.'[36] The two concepts of 'The West' and 'modernity' simply merged to a point where they were understood as more or less synonymous. This is why Japan is today broadly recognized as a Western society.[37]

Western art history

Nelson is one of several scholars who carried out critical investigations of the discipline of art history in the mid-nineties. For example, James Elkins, Donald Preziosi, Keith Moxey, and Griselda Pollock all wrote about the founding constructions and inclusion/exclusion mechanisms of space and time in art history – bringing to light the discursive formations of art history.[38] Hence, the primary object of investigation for these art historians is not works of art, but art history itself, and as researchers they had to (at least try to) separate themselves from their own discipline in order to study it critically.

Opposing the view that there exists one, 'true', history of art, Elkins' books entitled *Stories of Art* and *Is Art History Global?* discusses Western and non-Western academic writings on art. Elkins finds that even when Western art history does consider non-Western art it does so by applying a Western frame of reference to the works. However, it does not work the other way around – as he states:

> The [Western] literature on non-Western art is rife with veiled and passing refer-
> ences to 'Classical', 'Baroque', 'Neoclassical', 'Rococo', 'Modern', and 'Postmodern'.
> Notice that art historians don't casually apply non-Western periods to Western art:
> it would not occur to me to try to shed light on a Baroque sculpture by Bernini
> by calling it 'Han-like' or try to elucidate Brunelleschi's architecture by calling the
> earlier work 'Maurya' or 'Andhra' and the later 'Kushen' or 'Gupta'.[39]

In Elkins' opinion, the reason for this asymmetry is that art history is a specific
Western discipline insofar as it aims at writing *history* of art whereas non-
Western text aims at writing about *art*.[40] Therefore Elkins refers to Western
art historical surveys, like that of Janson, as *standard* art history. Academic
tendencies to challenge standard art history have been labelled 'new art history'
or 'critical art history'.[41]

The anthropologist Shelly Errington, too, has studied the discipline of art
history with an anthropological gaze "from the outside", so to speak, and some
of her first impressions of standard art history were that

> [T]he most striking feature is the essentialist linear unfolding of the story through
> a homogeneous medium of time: these texts are never, to my recollection, about
> cross-influences, mutual constructions, the inventions or emergence of categories
> of art or craft or their statuses [...] no 'ways of seeing' or 'period eye' interrupt the
> forward march through time [...] Another point hard to miss by one who reads
> even superficially in art history is that the center and the weight of the discipline's
> attention is the Greeks and the Renaissance, and that the great achievement of the
> West is the transition to virtual space, to optical illusionism.[42]

When New Internationalism seeks to challenge standard Western art history,
it is specifically its naturalization of Western cultural superiority that is the
target.

Whereas Robert Nelson's critical analysis is carried out in a strictly academic
manner, the critique presented in InIVA's *Global Visions* is articulated more
directly, placing 'the Western fuss about a universal time axis' under heavy
siege.[43] The reason for this sharp critique is partly that it is put forward by
people deeply involved in the actual institutional practices through their own
work as artists/curators/critics, and who, therefore, struggle directly with the
consequences of the above structure on a daily basis; and partly that the InIVA
context is different from an academic context, since it is an institution with a

clear mission to '*generate critical debate* within the mainstream institutions', as stated in the last paragraph of the nine-point list.[44]

Viewed from the perspective of New Internationalism, the struggle over how to understand time is closely related to the understanding of space and modernity, too. Therefore, new art history is an ally to New Internationalism insofar as new art history reveals the naturalization within standard art history (of time and space as neutral and objective means of measurement that position events chronologically and geographically) as an ideologically-charged construction.

Conclusively, the critical stance on the standard Western art institutional apparatus plays a very important part in the new international agenda, since this apparatus tends to confuse different taxonomies (artistic, geographical, cultural, questions of modernity) with one another, and function in a naturalizing manner, in order to consistently support the superiority of modern Western culture, regardless of the actual phenomena considered. The discipline of standard Western art history seems opaque and filled with obscure mechanisms of cultural exclusion, and thus forms a body of obstacles in relation to non-Western art. The new international antagonists aim at recognizing artistic modernity wherever and in whatever form it may come about, and thus time and space are subsumed by the idea of *artistic* modernity – not Western modernity.

One of the characteristics of Western modernity is the segregation of knowledge into separate systems. At a general level, that which constituted an integrated system prior to the European Enlightenment has been separated into a secular/bourgeois sphere and a religious/sacred sphere; and more specifically, the former is divided into a number of subsystems, such as economy, religion, fine arts, politics, science and so on.[45] And as we shall see in the following, art is the main issue of New Internationalism.

Art

As mentioned in the introduction, InIVA's anthology *Global Visions – Towards a New Internationalism in the Visual Arts* from 1994 provides a qualified selection of new international thoughts and ideas at the time. Though many different issues are touched upon by the 16 texts – covering, for instance, curatorial strategies in Japan; Mexican notions of a national art; African struggles to have this continent's particular modern art recognized; questions of institutional inclusion and exclusion mechanisms in official US art and cultural history; and

the complexities of cultural un-translatability – it is possible to detect that the main issue of concern, cutting across the formal organization of the anthology, is a call for greater focus on *artistic* practice and theory as significant in themselves, considered separately from anthropological and cultural concerns.[46]

To New Internationalism the key problem is the institutional tendency to mix the analysis of artistic practice with prejudiced assumptions about the artists' cultural background. The danger of this anthropological approach to art is that 'The main interest of anthropology is to pin down cultural differences for dissection, the opposite of [...] the aim of art', as Everlyn Nicodemus puts it.[47] The actual discrimination takes at least three different forms:

First of all, mainstream institutions demonstrate strong reservations with regard to recognizing contemporary works of art as contemporary, simply because the producing artist originates from a non-Western part of the world, which is automatically considered incapable of being modern – let alone contemporary. This situation is described by Olu Oguibe with regard to African artists who

> [H]ave been given entry to the most prestigious spaces in the West on the condition that they are naive, untrained, often unskilled in the manipulation of the specific materials which they are encouraged to employ, and inarticulate.[48]

A similar situation is reported by Hou Hanru in the case of Chinese artists whose work is 'concerned with the urgent problems of international life', and yet criticized in Western reviews for imitating Western art.[49]

Second, the expectation that works by non-Western artists should have a certain regional or "primitive" touch to them, might be supported by non-Western critics, too. In the case of the artist Gabriel Orozco, Guillermo Santamarina writes that many Mexican critics

> [D]ismiss his work for various reasons [...] because it is said that his images are too international; that they are evasive of our own socio-cultural discourse and, instead, very connected to the most fashionable styles of the moment. 'Gabriel is not a real Mexican artist', point out his detractors.[50]

And finally, the concept of modernity in art is in itself understood as synonymous with Western modernity in art, which results in a situation where the prevailing art institutions are unable to recognize modernity with a different

face. The need to separate considerations regarding art from anthropological concerns, in order to actually focus on *artistic* practice and theory, is described like this by *Global Visions* editor and art critic Jean Fisher, in her 'Editor's Note':

> The strategies of anthropology, sociology and so forth nevertheless fail to account for the particularity of critical aesthetic practice, the complex role of historiography in the evaluation of art, the relations between art and its audience, and the nature of the art 'object' as a material expression of both an individual vision and a collective experience that exceeds its status as a cultural sign.[51]

The fact that art in itself is highly significant is also stressed by artist and writer Rasheed Araeen, in his text for *Global Vision*, where he calls for

> [A]n international paradigm in which what takes precedence is art work [sic], with its own set of rules for production and legitimation [sic] in terms of aesthetics, historical formation, location and significance, rules not necessarily derived from any one or originary [sic] culture.[52]

Both this quote and that above, by Fisher, mirror the ambivalent status of art and aesthetics within the New Internationalism on the one hand as phenomena possessing essential qualities – hence, to be considered according to the work's '*own* set of rules', 'the *particularity* of critical aesthetic practice', and 'the *nature* of the "art" object' – and on the other hand as contextually created – hence, constructing the work's significations 'on the terms of *historical formation*, *location* and significance', according to 'the complex role of *historiography*' and 'the *relations* between art and its audience'.

Obviously, the contributors to *Global Visions* argue that works of art must be considered in their specific context, but *what* this context is, and *who* determines this are crucial. For instance, African, Chinese or Mexican works *should not*, on the one hand, be considered in the light of primitivist European prejudgements of "African-ness", "Chinese-ness" or "Mexican-ness"; but on the other hand, the works' specific historical and cultural contexts *should* be considered, in order to recognize their relevant modern, contemporary or political aspects. Who, then, decides which cultural contexts are the right ones, and which are wrong, when focusing on artistic practice? In order to overcome the dichotomy between 'curating cultures and curated cultures', Gerardo Mosquera suggests that trans-cultural projects should include 'participation of

specialists from the curated cultures right from the moment of conception.'[53] However, if one recollects Guillermo Santamarina's description of the specific national expectations put forward by Mexican critics regarding the work of Gabriel Orozco, there is no guarantee that this solution would actually solve the problem.

Since the new international call for a focus on artistic practices simultaneously involves art and aesthetics *as such*, and specific aesthetic *contexts*, the parameters evoked are to some extent incomparable. When arguing that art should be considered as separate from ("wrong") cultural contexts, in order to focus on the nature of art, the argument implicitly refers to an established concept of art as an autonomous domain. But when arguing for art to be considered as integrated with different ("true") cultural contexts, for instance, the notion of autonomous art is dismissed. When advocating for aboriginal aesthetics, the popular culture of Havana etc., the specific cultural contexts are considered crucial to the art concept. As art historian and former director of InIVA, Gilane Tawadros, formulates it:

> We are all acutely aware that these artistic practices and critical debates can only take place within the parameters of mainstream western cultural politics but, to the same extent, we are aware that they cannot be delimited or prescribed by established aesthetic practices or hegemonic discourses.[54]

In order to be operational, New Internationalism needs the notion of 'art' as a common concept, and that necessarily includes its Western provenance, as we shall see later.

Complexity

In addition to the main interest of art and artistic practice, an insistence on complexity, un-translatability, and the impossibility of seamless suture runs throughout *Global Visions*.[55] Art historian and critic Geeta Kapur and art historian Sarat Maharaj in particular elaborate on how complexity plays a fundamental part in cross-cultural and trans-national art.

The irrational leftovers from the knowledge production created when one engages in visual arts from different cultures are considered valuable, precisely because of their incomprehensibility. The otherness evoked in this case is not a cultural or anthropological otherness, but an otherness in terms of the dis-

courses of knowledge within art and aesthetics, such as sensuous, conceptual or semiotic modes of otherness – which are of course very difficult to describe or qualify, due to their un-translatability, into rational academic writing. According to Maharaj, the point is to 'highlight the dimension of what gets lost in translation, what happens to be left over.'[56] His intention is not to praise everything as 'hybridity', which would be the same as rendering every complex difference the same under one equalizing label; but to recognize complexity in itself as the foundation of signification. Kapur, too, speaks against seamless transference of meaning, by pointing to the unfortunate curatorial tendency to regard cultural phenomena within synchronous models that disregard the untranslatable difference between the works.[57] Exhibiting art of different cultures together necessarily considers the works synchronically, which somehow evokes a certain comparability or compatibility at the cost of un-translatability. Put roughly, there is a risk that the works will be rendered more or less identical. In her call for complexity, Kapur states that 'A new internationalism is [...] not a matter of consensus; the very term asks for immediate dismantling.'[58]

The insistence on disjunction, un-translatability, and non-synchronicity can be detected perpetually throughout the discussions undertaken in *Global Visions*. Though not directly presented in the book, the (Western) voices of Michel Foucault and, especially, Jacques Derrida are thus present resonators in New Internationalism.

As opposed to Kapur and Maharaj, art critic Nikos Papastergiadis is less enthusiastic regarding the complexity of New Internationalism. In 1993 Papastergiadis criticized the diffuseness of the concept, and stated that it 'needs to be defined in terms of what are its points of departure, the horizons that it seeks and the associations it encourages.'[59] According to Papastergiadis, New Internationalism 'needs to suggest a method which others can either adopt or reject', and he suggested that we should 'turn back towards the architects of "New Internationalism" and ask for further elaborations of this concept.'[60]

Papastergiadis identified New Internationalism's lack of transparent method at two different levels. Firstly, in the curating process of art works for exhibitions, where the criteria become blurred, without 'the pre-existence of a negative space' that formerly functioned as the point of departure for linking up 'the visual work with the politics of marginalisation'.[61] And second, Papastergiadis finds the relation between cultural *policy* and cultural *practice* confusing, because InIVA incorporates both: On the one hand, it is an officially supported institution and therefore it plays a role in the overall political objective of the

Arts Council of Great Britain in improving conditions for artists with non-Western backgrounds. But on the other hand, 'when it comes to defining the basis, the criteria and the boundaries of "New Internationalism" the main initiatives and responsibility are shifted back to the cultural producers' – that is, to the artists themselves.[62]

According to Papastergiadis, the methodological complexity, or mess, results, for instance, in art exhibitions and catalogues that do not take the artistic and aesthetic practice seriously enough, but in contrast, seem involved in and across a number of other disciplines, such as anthropology, sociology, etc.[63] As described above, this is exactly what New Internationalism wanted to diminish, in favour of a greater focus on the artistic practice in the individual work of art. In other words: New Internationalism, as administered within the frame of InIVA, makes it difficult to distinguish between the institutional method or framework, and the object of this institutional framing. The reason for this may be found in InIVA's particular institutional construction. Curator and writer Richard Hylton describes how the Arts Council's support in the establishment of InIVA represents a break

> [W]ith previous strategies of support for Black visual arts activity. Where organisations such as Third Text, the African and Asian Visual Artists' Archive and Autograph were created by individuals and supported by the Arts Council, INIVA (...) was arguably much more a product of the Arts Council itself.[64]

Thus, Papastergiadis seems in agreement with Sarat Maharaj on the point that complexity plays a significant role within New Internationalism, but they judge this situation very differently. The lamentation of Papastergiadis contrasts with Maharaj's warning against transparency and clear translatability between different levels and cultures within the field of contemporary visual arts. To Maharaj, the methodological lack and mess is not radical enough.

Despite their differences and subtle incompatibilities, art and complexity condense the interests of some of the people positioned centrally within New Internationalism in the early 90s. These interests are based on a self-understanding of inhabiting a field of 'true', fundamental complexity, which stands in opposition to a field of 'false', fundamental simplicity – illustrated, for instance, by the time line in *History of Art*.

Since the antagonism evolves, develops and changes over a period of approximately fifteen years, a more precise definition of what is meant when we

refer to 'New Internationalism' or 'new international antagonism' is needed and, as suggested, some characteristics make up this definition: First of all, New Internationalism is focused on visual arts, and not other art forms, in its struggle to shift the field of visual arts in a new direction towards greater global pluralism and openness. Second, it is therefore especially concerned with the articulations of discursive formations, and the institutional mechanisms of the field of visual art, insofar as these frame the *visibility and signification* of the particular work of art, rather than being concerned with giving instructions for the individual artist or individual works of art. Third, New Internationalism is driven by the aim of actually changing the prevailing institutional situation. It is not a purely theoretical or academic matter, but has as its criteria of success equal institutional premises and opportunities for artists, regardless of their cultural origin. The question of who or what belongs to this New Internationalism, and not just to the broader poststructuralist, postcolonial, or cultural studies field, which – as we shall see – are sometimes in agreement with New Internationalism, is thus determined by the degree of involvement in the specific setting of *visual arts*.

Exhibiting artistic modernism and modernity

The self-understanding of New Internationalism rests on the idea of a dual model, consisting of a simplicity paradigm and a complexity paradigm, with New Internationalism itself placed within the framework of the latter, and standard art history, theory and practice set within the framework of the former. Since this worldview is not a given fact, but the result of the intentions and self-understanding of New Internationalism, the following analysis will be carried out from a new international point of view, within the complexity paradigm, and does not aim to represent an objective overview.

Since the contours of the new international antagonism emerge most clearly in the discussions and negotiations of the controversial concepts of 'time, space, and modernity', 'difference', and 'art and aesthetics', articulations of these concepts will guide the analysis as anchoring points in this chapter and the next.

A main reason for New Internationalism to oppose standard art history is the tendency of the latter to 'cover up' a practice of discriminating ideology by 'scientific' simplification of time, space, and modernity into fixed and, significantly, separate entities into which people, objects, and phenomena can be plotted according to their proper 'objective' position. Janson's *History of Art* is an example of how this practice was carried out in academia, but it is a tricky one to alter with a view to meeting the demands of New Internationalism, since it is not just a question of adding omitted bits and pieces to the existing history of art, but, according to the voices raised in *Global Visions*, of making fundamental changes to a deeply problematic, prevalent academic practice with regard to art history. As sociologist Anthony Giddens has discussed, the very separation and objectification – or as he terms it, the 'emptying' – of time and space, is itself a characteristic feature of Western modernity.[65] Hence,

when standard art history uses this 'objective' time-space schema to legitimize the idea that modernity is exclusively Western, the tautological nature of the gesture reveals it as pure ideology.

The space-time-modernity problem, however, does not stop at the exit doors of the university or the journals of academia. Museums with a much broader public appeal and with more general educational obligations have been, and still are, embedded in the structure of the locked time-space relationship, with non-Western art banished to the past, and Western art as the triumph of modernity. The seemingly scientific conception can be detected in the ordering of a majority of national art institutions throughout Europe and USA. Two examples will suffice: The impressive collections at the Metropolitan Museum of Art in New York include, among others, departments of 'Modern Art' and of 'Asian Art'. Paradoxically, these concepts seem incommensurable, unless one considers 'modern' and 'Asian' to be exclusive categories that can never overlap. In fact on the museum's webpage the most recent, highlighted piece in the Asian Art department is a print by Katsushika Hokusai (*The Great Wave at Kanagawa*, ca. 1830-32), while no works by Asian artists are among the more than 90 highlights on the webpage for the Modern Art collection.[66] Likewise, the new British Library at St. Pancras in London, which opened to the public in 1998, consists of the following departments: 'Humanities', 'Rare Books & Music', 'Business & IP Centre', 'Social Sciences', 'Manuscripts', 'Science', 'Maps', and 'Asian & African Studies' – as if Music, Business, Science, and even Humanities are fundamentally different from anything Asian and African, which, conversely, have everything in common.

Documenta and New Internationalism

The different *Documenta* exhibitions reflect the shifting tendencies and preferences of the art world during the last five decades, and hence it is possible to detect, through *Documenta*, when and how non-Western contemporary art was gradually accepted by the mainstream art institutional apparatus. The *Documenta* exhibition takes place every five years in Kassel, Germany, and is considered 'the most important international art event', which 'surpasses all others in ambition, financing, and planning'[67]. It all started in 1955, when artist and academy professor Arnold Bode and art historian Werner Haftmann organized the first *Documenta*, which represented a profound variety of pre-war modernist art – thus it 'did not exhibit contemporary production

as it does today but was conceived as a retrospective of modern art as it had survived the period of persecution and destruction [by the Nazi party]'.[68] The 1955 show was a vast success, and since then, *Documenta* has been repeated in Kassel every four or five years with different curatorial concepts and works, but always with an overall aim of presenting the best and most relevant aspects of contemporary art.[69]

A significant feature in relation to the first *Documenta*, however, was that the catalogue included a list of 'Participating Countries', revealing that the artists all came from Germany, France, Italy, Holland, Switzerland, England or USA.[70] The texts in the catalogue do not offer any explanation of the list's presence, but it was probably inspired by the organization and the catalogues of the biennials in Venice and São Paulo (est. 1895 and 1951 respectively), where it makes perfect sense to include a list of participating countries, since the concepts of these biennials are 'art world exhibitions' with each country selecting and representing its finest art. With *Documenta*, however, the curators were centrally based in Kassel, and the idea was not to present art from different countries but modern art from before World War II. Thus, the list seems peculiar, but is of interest since it provides evidence of the fact that the national background of artists and works was deeply naturalized as a significant aspect of the art.

Since 1955 the share of non-Western artists represented at *Documenta* has increased from none at the first *Documenta,* to 3 % at the second, 22 % at *Documenta 11* and 46 % at *Documenta 12* in 2007.[71] The reasons for comparing these four exhibitions, and not others, or all *Documenta* exhibitions, are, first, that generally – though not steadily – the percentage of non-Western artists has increased over the years; and secondly that the above figures provide a clear, overall picture of the difference between the first and the latest *Documenta*. However, since the concept of *Documenta* in 1955 was to stage a single exhibition of pre-war European art, it was not until *Documenta* 2 that *Documenta* as a series of exhibitions on contemporary art was initiated – hence the second *Documenta* is important in this respect. As we shall see later, *Documenta 11* plays a particular role when it comes to the global aspect of contemporary art, and it is therefore necessary to include it in the statistics.

Considered quantitatively, the conclusion to be drawn from the above figures is clear: During the last five decades, the number of non-Western artists in a Western mainstream art institution like *Documenta* has grown dramatically, to a point where equality is a fact, since approximately half of the artists today

are non-Western. Qualitatively, however, the case is more complicated. Taking a closer look at the artists in the four different *Documentas* mentioned above reveals the necessity of expanding the comparison beyond the simple bi-polar 'Western' or 'non-Western' artists dichotomy. If the artists' place of birth, rather than their place of work, determines whether he/she is considered Western or non-Western the ratio changes – now the share of non-Western artists at the *Documentas* rises to: 5 % at the first, 14 % at the second, 48 % in *Documenta 11* and 56 % in *Documenta 12*.

Hence, instead of two (Western and non-Western) there are three categories at work, since we can subdivide the category of Western artists, who work in Berlin or New York, for instance, into two different groups: artists born in the West, and artists born outside the West who have migrated to the artistic centres. But this fact is not evident in the list of participating countries in the catalogue for the first *Documenta*, where only seven countries are listed, though the artists were born in 15 different countries. For instance, Wassily Kandinsky (born in Russia) and Ernesto de Fiori (born in Italy) were listed under 'Germany', Marc Chagall (born in Russia) and Richard Mortensen (born in Denmark) were listed under 'France', etc. The catalogue offers a general explanation for this ordering by stating that,

> Due to the political emigration from Russia and Germany the national affiliation of a number of artists has become undeterminable; they have been attributed to either their primary or secondary home countries to the extent of their artistic impact.[72]

Though the curatorial concept behind the first *Documenta* show intended it to be 'a broad, if initial attempt, to regain international contacts across the board and thus at home [in Germany] reengage in a conversation that has been interrupted for so long', the curators' conception of internationality is primarily limited to the West.[73] Given the specific need of the German art world to establish contact with *any* foreign artistic environment whatsoever at that time, the Western comprehension of 'international contacts' is understandable, and bearing in mind that the conceptual focus of the first *Documenta* was on early 20th century modernism, it is of no surprise that seven of the eight non-Western born artists are from Russia and Hungary – a fact that reflects accurately the situation on the European art scene in the first three decades of the century, when Russian and Eastern European artists played an active and constitutive role in the artistic environments in Berlin and Paris. Thus, prior to the Nazi

regime's persecution of so-called 'Degenerate Art', there was a much broader and Eastern orientated sort of 'European internationalism', which naturally included artists from countries that were regarded as foreign to Western Europe after the establishment of the iron curtain.

The fact that the countries listed as participating in the first *Documenta* are all Western, though not all the artists were Western, suggests that it was very difficult for the art institutional apparatus in 1955 to imagine anything non-Western as belonging to the discursive formation of modern art. The situation can be illustrated by paraphrasing Michel Foucault's 'The Order of Discourse', in which he distinguishes between the difference, within scientific disciplines, of being 'true', and being 'in the true'. For something to be 'in the true' it must be articulated in accordance with the existing, commonly accepted ground rules of the discipline, and only then can it be judged as true or false within the disciplinary framework. Foucault himself offered an example from the field of biology, and refers to Gregor Mendel, the founding father of genetics. Scientists of the nineteenth century could not see that Mendel was right – that his theories were 'true' – 'because Mendel was speaking of objects, applying methods, and placing himself on a theoretical horizon which were alien to the biology of his time'.[74] Hence, he was not positioned 'in the true'. Foucault refers to Mendel as a

[T]rue monster, which meant that science could not speak of him; whereas about thirty years earlier [...] Scheiden, for example, who denied plant sexuality, but in accordance with the rules of biological discourse, was merely formulating a disciplined error.[75]

Whereas Mendel was in fact right but not 'in the true', Scheiden was 'in the true' but wrong. The absence of the USSR, for instance, on the list of participating countries, despite the many Soviet artists in the first *Documenta*, suggests that in 1955 the notion of 'new', 'modern' or 'contemporary' Soviet art, however true it was, was not discursively 'in the true'. Being 'true monsters', the works of Soviet artists could only fit into the reach of comprehension of the first *Documenta* if the artists' artistic identities were converted to Western European ones.

In order to be able to picture the development throughout the history of *Documenta*, however, all the above statistics are based on the same, narrow definition of the West, which excludes Africa, Latin-America, Asia, and the European countries formerly part of the USSR. Though this small amateur survey

does not cover all the *Documenta* exhibitions through the years, the tendency shows clearly: More and more of the represented artists are born outside what is traditionally understood as the West, and – perhaps more interesting – an increasing number of artists work in non-Western parts of the world, meaning that the institutional foundations of their artistic practice (academies and art schools, exhibition galleries, biennials, museums, dealers, buyers, collectors, etc.) have spread globally.

Becoming 'Western'

Already by *Documenta 2*, in 1959, the participating artists originated from 26 different countries, and since the concept of the exhibition, 'Art after 1945', focused on new art 'in itself' and presumably did not anchor it in specific Western ideologies or Western political contexts, one might conclude that the Western art institutional apparatus was, in fact, rather globally inclusive as early as the late 50s.[76] The fact that artists from Argentina, Tunisia, Japan, and Brazil, just to mention a few, were exhibited in *Documenta 2*, suggests that including artists from different parts of the world came naturally to a show of contemporary art, so that apparently, the new international demands were already fulfilled before they were officially formulated.

Why, then, did the new international antagonists in the early 90s claim that the art institutional apparatus was permeated by discriminations against non-Western artists? As described, discriminations – resulting from the Western ideological origin of the art institution – *were* felt by non-Western artists to cause great obstacles, and the non-Western artists represented at *Documenta 2* had two characteristics: First, they clearly comprised a minority of the *Documenta 2* artists in total (14 % were not born in the West), and second – and most importantly – most of the non-Western artists lived and worked in the West, most often in Paris or New York. Only 3 % of the *Documenta 2* artists were born *and* worked outside the West. The fact that only very few of the artists born non-Western continued to work outside the West can be interpreted in two ways, within the logical framework of New Internationalism: On the one hand, it is a positive thing, since it opposes the ethnographic stereotypes that dictate that art made by non-Western artists automatically does, or ought to, reflect specific ethnographic themes or expressions (carved masks for African artists, brush calligraphy for Chinese artists, etc.). Hence, it is not considered a problem that artists with non-Western backgrounds engage in abstract painting

with oil on canvas as their medium. On the other hand, the idea that all artists must subsume their preferences to those of the Western art world in order to gain recognition is viewed negatively.

The case can be further elaborated by comparing the *Documenta 2* to the 1984 MoMA show, *'Primitivism' in 20th Century Art*, so a brief digression is needed at this point.

'Primitivism' in 20th Century Art

'Primitivism' in 20th Century Art – Affinity of the Tribal and the Modern was curated and hosted by the Museum of Modern Art (MoMA) in New York in 1984, and juxtaposed modern art from the museum's own collection with African masks and Polynesian wooden sculptures, to show how these 'primitive' works had influenced modern Western art. For instance, Pablo Picasso's *Les Demoiselles d'Avignon* from 1907 was shown with objects labelled, for instance, *Mask. Susu. Guinea* or *Mask. Etoumbi region. People's Republic of the Congo*, to highlight how Picasso's groundbreaking new conception of the structuring of the picture plane of the former was inspired by these objects.[77] Accompanied by a comprehensive two-volume catalogue with reproductions of the all the works exhibited, tribal and modern, plus additional works illustrating the 19 basic research articles, this thorough demonstration of the non-Western inspirations behind some of the most celebrated modern artists seemed to pay tribute to the qualities of non-Western art by revealing its important contribution to the historical avant-gardes of Europe. In the 83-page, richly illustrated 'Introduction' in the catalogue, the director of the exhibition, William Rubin, stated that: 'I want to understand the Primitive sculptures in terms of the Western context in which modern artists "discovered" them.'[78] This involved research into tracing which modern artists had the specific visual knowledge and preference of which primitive sculptures at specific periods of their artistic work, in order to come up with broader conclusions, for instance:

> In their collecting, the Cubist artists showed a marked preference for the art of Africa over that of Oceanic objects. The Surrealists, for their part, were more enthusiastic about Oceanic objects (and those of the American Indians, Northwest Coast peoples, and Eskimos).[79]

Most reviews of '*Primitivism' in 20th Century Art*, however, were far from agreeing that the exhibition demonstrated a fair picture of non-Western art. As the quote above demonstrates, the problem was that what professor of literature Peter Hulme refers to as 'stereotypical dualism' was at work in the exhibition.[80] This means that the splitting of a stereotype, here, the primitive-ness of non-Western art, into opposite elements – mostly 'good' and 'bad', but here the neutral entities of 'African' and 'Oceanic' objects – implies that the analysis has already moved beyond, and left behind a fundamental question such as: On what grounds are non-Western cultures deemed primitive? Like-wise, Western art in this case was divided into 'the Cubist' and 'the Surrealist', but the *superiority* of Western modern art was still unquestioned, and there were never any doubts as to who were 'modern' and who were 'tribal' – it was a given. As anthropologist James Clifford characterized the exhibition in his review, 'Modernism is thus presented as a search for "informing principles" that transcend culture, politics, and history.'[81]

The flood of critical comments that hit William Rubin and his team indi-cated various problems. Professor of art history Thomas McEvilley accused the exhibition of showing interest in only primitivism (Western interpretations of the 'primitive') and not 'the primitive' in itself, which meant that it missed out on the 'real rawness' of the objects, as these 'isolated from one another in the vitrines and under the great lights, seem tame and harmless' since 'the blood is wiped off them'.[82] Additionally, McEvilley regretted the omission of anthropological information as well as dates of works, to accompany the tribal art; and, as a consequence of these omissions, of attributing the aes-thetic function of the modern works to the tribal works. Conversely, James Clifford called for the inclusion of more impure objects constructed from colonial culture contact; he criticized the exclusion of Third World modern-ism, called for critical discussion, rather than celebration of the taxonomic shift caused by the fact that non-Western artefacts were redefined as art, and argued that the catalogue only demonstrated 'the restless desire and power of the modern West to collect the world.'[83] In conclusion, Clifford asked for exhibitions that question the boundaries of the art world. The art historians Yves-Alain Bois and Hal Foster also criticized the exhibition's reductive ap-proach, demonstrated by the fact that the affinity is only shown at a formal expressive or morphological level – as deformation of the human body – and not on structural, semiological, conceptual or ritual levels.[84] The result was that the tribal objects were modernized in an interpretation that controls the

other, and renders the other harmless to Western understandings of art and modernity.

Now, all the above critiques of MoMA's exhibition somehow broadly articulate New Internationalism, as they call for a dismantling of the West's unquestionable monopoly of modernity, and the alleged superiority of Western modern art. However, on a more nuanced level, New Internationalism is clearly more informed by the views of Clifford, Bois, and Foster, than by McEvilley's views. The call for a revelation of the 'true' tribal context in its 'real rawness' and without 'the blood wiped off' has an essentialist character, which does not go along with the voices raised in *Global Visions*. Thus, artist and writer Everlyn Nicodemus suggested that McEvilley 'himself had one foot in the latest phase of the western [sic] primitivism that he attacked' when he brought 'the anthropological argument into the field of artistic discourse'[85], and Geeta Kapur expressed concerns – with reference to McEvilley – 'that variations of primitivism may be the definitional core of a new internationalism'[86], when she warned against the fact that primitivist exhibitions constitute the core of New Internationalism.

When William Rubin, in the *Primitivism* catalogue, described how few of the modern artists knew anything about the cultural contexts of the primitive artefacts from which they took inspiration, he concluded that,

> This ethnocentrism is a function nevertheless of one of modernism's greatest virtues: its unique approbation of the arts of other cultures. Ours is the *only* society that has prized a whole spectrum of arts of distant and alien cultures.[87]

Undoubtedly, he meant the modern artists' approbation of 'primitive' art, but the statement may just as well refer to the *internal* approbation within modern art itself. For instance, the artists Constantin Brancusi (born in Romania), Roberto Matta (born in Chile) and Wifredo Lam (born in Cuba) were represented in the *Primitivism* exhibition as naturally belonging to the field of Western modernism, since they all worked primarily in Paris, in abstract and surrealist circles, respectively. Furthermore, all three were represented at *Documenta 2*, and hence recognized as playing important roles in 'Art after 1945'.

So why were they accepted as modernist artists on equal terms with their European colleagues, and not singled out as strangers or primitives? Perhaps they were regarded as Western artists because their work fitted in with the mainstream avant-garde at the time, in relation to themes and expressions,

fragmentary character of our approach—whose primary purpose is the further illumination of modern art—it may nevertheless shed some new light even on the Primitive objects.

Discourse on our subject has suffered from some confusion as to the definition of primitivism. The word was first used in France in the nineteenth century, and formally entered French as a strictly art-historical term in the seven-volume *Nouveau Larousse illustré* published between 1897 and 1904: *"n.m. B.-arts. Imitation des primitifs."*[7] Though the Larousse reference to "imitation" was both too extreme and too narrow, the sense of this definition as describing painting and sculpture influenced by earlier artists called "primitives" has since been accepted by art history; only the identity of the "primitives" has changed. The Larousse definition reflected a mid-nineteenth-century use of the term insofar as the "primitives" in question were primarily fourteenth- and fifteenth-century Italians and Flemings. But even before the appearance of the *Nouveau Larousse illustré*, artists had expanded the connotations of "primitive" to include not only the Romanesque and Byzantine, but a host of non-Western arts ranging from the Peruvian to the Javanese—with the sense of "primitivism" altering accordingly. Neither word, however, as yet evoked the tribal arts of Africa or Oceania. They would enter the definitions in question only in the twentieth century.

While primitivism began its life as a specifically art-historical term, some American dictionaries subsequently broadened its definition. It appears for the first time in Webster in 1934 as a "belief in the superiority of primitive life," which implies a "return to nature." Within this expanded framework, Webster's art-related definition is simply "the adherence to or reaction to that which is primitive."[8] This sense of the word was evidently firmly entrenched by 1938 when Goldwater used it in the title of *Primitivism in Modern Painting.* The general consistency of all these definitions of primitivism has not, however, prevented certain writers from confusing primitivism (a Western phenomenon) with the arts of Primitive peoples.[9] In view of this, we have drawn attention to the former's very particular art-historical meaning by enclosing it within quotation marks in the title of our book.

Nineteenth-century primitivist painters had appreciated pre-Renaissance Western styles for their "simplicity" and "sincerity"—which they saw in the absence of complex devices of illusionist lighting and perspective—and for their vigor and expressive power, qualities these artists missed in the official art of their own day, which was based on Classical and academic models. The more that bourgeois society prized the virtuosity and finesse of the salon styles, the more certain painters began to value the simple and naive, and even the rude and the raw—to the point that by the end of the nineteenth century, some primitivist artists had come to vaunt those non-Western arts they called "savage." Using this word admiringly, they employed it to describe virtually any art alien to the Greco-Roman line of Western realism that had been reaffirmed and systematized in the Renaissance. Given the present-day connotations of "primitive" and "savage," we may be surprised to discover what art these adjectives identified for late nineteenth-century artists. Van Gogh, for example, referred to the high court and theocratic styles of the ancient Egyptians and the Aztecs of Mexico as "primitive," and charac-

2 RUBIN

Malanggan figure. New Ireland. Painted wood, 52⅜" (133 cm) high. Collection SERGE BRIGNONI, Bern

terized even the Japanese masters he revered as "savage" artists. Gauguin used the words "primitive" and "savage" for styles as different as those of Persia, Egypt, India, Java, Cambodia, and Peru. A self-proclaimed "savage" himself, Gauguin later annexed the Polynesians to his already long list of "primitives," but he was less drawn to their art than to their religion and what remained of their life-style. Decades before African or Oceanic sculpture would become an issue for artists, the exotic arts defined as "primitive" by Gauguin's generation were being admired for many qualities that twentieth-century artists would prize in tribal art—above all, an expressive force deemed missing from the final phases of Western realism, which late nineteenth-century vanguard artists considered overattenuated and bloodless. With the exception of Gauguin's interest in Marquesan and Easter Island sculpture, however, no nineteenth-century artist demonstrated any serious artistic interest in tribal art, either Oceanic or African.[10] Our contemporary sense of Primitive art, largely synonymous with tribal objects, is a strictly twentieth-century definition.

The first decades of the twentieth century saw both a change in meaning and a shrinkage in the scope of what was considered Primitive art. With the "discovery" of African and Oceanic masks and figure sculptures by Matisse, Derain, Vlaminck, and Picasso in the years 1906–07, a strictly modernist interpretation of the term began. As the fulcrum of

2. Detail of spread from the catalogue for *'Primitivism' in 20th Century Art.* "Malanggan figure" to the left and "A Grave Situation" (1964) by Roberto Matta to the right. →

Matta. *A Grave Situation.* 1946. Oil on canvas, 55 x 77" (139.7 x 195.6 cm). Promised gift to the Museum of Contemporary Art, Chicago, from the Mary and Earle Ludgin Collection

meaning shifted toward tribal art, the older usages did not fall away immediately. "Primitive art" simply became increasingly identified, during the following quarter-century, with tribal objects. As far as vanguard artists of the beginning of the century were concerned, this meant largely African and Oceanic art, with a smattering (in Germany) of that of American Indians and Eskimos (which would become better known among Paris artists only in the twenties and thirties).

In Paris, the term "art nègre" (Negro art)[11] began to be used interchangeably with "primitive art." This seemingly narrowed the scope of meaning to something like tribal art.[12] But as a term that should have been reserved for African art alone, it was in fact so loosely employed that it universally identified Oceanic art as well. It was not until the 1920s that Japanese, Egyptian, Persian, Cambodian, and most other non-Western court styles ceased to be called Primitive, and the word came to be applied primarily to tribal art, for which it became the standard generic term.[13] In Goldwater's book, written the following decade, the "primitive" is synonymous with African and Oceanic art. To be sure, pre-Columbian court styles such as the Aztec, Olmec, and Incan continued to be called Primitive (and artists did not always distinguish between them and tribal art). But this was an inconsistency, and should now be recognized as such. In their style, character, and implications, the pre-Columbian court and theocratic arts of Mesoamerica and South America should be grouped with the Egyptian,

Javanese, Persian, and other styles that together with them had consituted the definition of the Primitive during the later nineteenth century.[14] The progressive change in the meaning of the word after 1906 was a function of a change in taste. Consistent with it, pre-Columbian court art enjoyed—except for Moore, the Mexican muralists, and, to a lesser extent, Giacometti—a relatively limited interest among early twentieth-century vanguard artists. Picasso was not unique in finding it too monumental, hieratic, and seemingly repetitious. The perceived inventiveness and variety of tribal art was much more in the spirit of the modernists' enterprise[15]

The inventiveness just mentioned, which led in some African and Oceanic societies to an often astonishing artistic multiformity, constitutes one of the most important common denominators of tribal and modern art. Few remaining sculptures of the Dan people, to take perhaps the most startling example, are much more than a century old; yet the range of invention found in their work (pp. 4, 5) far outdistances that of court arts produced over much longer periods—even millennia of Ancient Egypt after the Old Kingdom.[16] And unlike Egyptian society, which placed a positive value upon the static as regards its imagery, the Dan not only explicitly appreciated diversity but recognized the value of a certain originality. As the fascinating study by the ethnologist P. J. L. Vandenhoute showed, the Dan were even willing "to recognize a superior social efficacity in [such originality]."[17] Although tribal sculp-

and the avant-garde simply could not be anything but Western. What stands out is the institutional staging of Western modernism as one firm unity, which is able to actively recognize, or approve, passive and objectified non-Western cultures. There was simply no room for non-Western modern artists within this structure – it would not have been 'in the true'. The mechanism can be demonstrated by reference to the *Primitivism* catalogue, in which Roberto Matta's 'A Grave Situation' (1946) is reproduced on page 3.

The painting depicts an abstract figure in a disturbed and indeterminate space. This image is meant to correspond to the photograph of an anonymous 'Malanggan figure' from New Ireland on page 2, suggesting that Matta has directly appropriated the 'primitive' figure, or one similar, into his painting in a straightforward manner, where 'primitive' expressions are mimetically imported into the motifs of Western works of art. The list of participating countries in the first *Documenta* catalogue contributes, as does the juxtaposition in the *Primitivism* catalogue almost 30 years later, to the sustaining of a tenacious myth of modern art as solely Western.

Socio-global *Documentas*

If the percentage of non-Western artists was not particularly high at *Documenta* exhibitions until 2002, 'the non-Western' as an issue was present in a different way. In particular, *Documenta 5*, in 1972, and *Documenta 10*, in 1997, had curatorial concepts that focused on social realities and political issues – among them globalization and post-colonialism – and this might be a more promising curatorial approach when it comes to new international inclusion. Hence, a brief look at *Documenta 5* and *10* is of relevance here:

The theme for *Documenta 5* was 'Questioning Reality – Image Worlds Today', and the exhibition sought to structurally transgress the 'art' part of 'Western art', as it included what chief curator Harald Szeeman called 'artistic and non-artistic pictures', in order to mark 'hopefully the beginning of a post-art-market period'.[88] Concretely, the non-artistic pictures consisted, for instance, of a number of political posters in the section 'Utopia in the picture – the picture as utopia'. The initiative illustrated how the structural transgression of the exhibition was concerned with challenging two traditional boundaries: one between art and non-art as such, and another between art and political realities. The first may be inscribed into the broader discourse of visual culture, and the second will be further elaborated in the final chapter of this book, but

what is of interest now is that even though Szeemann suggested that the works of art ought to be understood as 'alternates for every/all pictures in the world', structurally this world was confined to the Western world, as only 6 % of the participating artists were born outside the West, and none of them worked outside the West.[89] Even the first and second *Documentas* presented higher percentages of artists born outside the West. In other words: the ideal of 'Image Worlds Today' was carried out in a way that structurally did not include more than one world – the Western.

Likewise, the catalogue for *Documenta 5* demonstrated an ambivalence: In accordance with the general visual culture of the 70s, it was designed as an orange loose-leaf binder – designed by Ed Ruscha – with tabs covering a number of different themes such as 'Trivial realism & Trivial emblematic', 'Political propaganda', 'Film', etc.[90] One tab contained the 'List of exhibited works', and was designed as a guidebook which could be removed from the binder and easily be carried through the exhibition.[91] This guide reveals a different kind of art-reality transgression than the one aimed at in the texts and themes of the catalogue, since more than half of the book consists of commercial advertisements. Undoubtedly, the sale of advertising space was necessary to provide the needed financial foundations that rendered the printing of the catalogue possible, but it hardly sets a very good example for a 'beginning of a post-art-market period'.[92]

Like number 5, *Documenta 10*, curated in 1997 by Catherine David, consciously made a special effort to articulate not just contemporary art, but contemporary reality under the title 'POe/liTICS'. The catalogue included a number of different themes, but what is of particular interest here is the fact that among these themes are sections on 'Globalization', the '(Post) Colonial', 'A Borderless World?', 'World-economy', 'Global Cities and Global Value Chains', and 'Globalization/Civilization'.[93] The recognition of and focus on a global world of reality, rather than reality naturalized as Western, clearly indicates how the perspective of the art world broadened during the 25 years that separated *Documenta 5* and *10*. The increased thematic focus on globalization was reflected to a certain degree formally in the curating, as almost 20 % of the artists were born outside the West.[94]

We may conclude that since *Documenta* was born big – rather than evolving from an underground environment – and from the outset played a profound role in anchoring and sustaining contemporary art tendencies in the accepted mainstream of the art institution, the above historical account of *Documenta*'s

new international aspects indicates when and to what degree non-Western art was accepted in Western mainstream art institutions. Though the situation in 1997, with *Documenta 10*, was much more inclusive than in 1955, when even the conception of non-Western art seemed impossible, the fundamental structure still remains intact: The Western art institution is the active, curating part that collects the passive artists and works from the curated non-Western parts of the globe. As an exhibition, a concept, or even a brand, *Documenta* is itself a Western art institution, due to its placement in Kassel, its initiation as a response to a specific need in the German art institution to rehabilitate artistic relations destroyed by the Nazi regime, and its directors and curators, who are well established in the Western, 'old-international', art institutional apparatus. We shall return to the most recent *Documentas*, 11 and 12 in chapter 7 to see how this changes, but for now let us turn to the first attempt to exhibit contemporary art in a globally inclusive manner, *Magiciens de la terre* (1989). The critique of the asymmetry between the representations of modern and tribal art, in the *'Primitivism' in 20th Century Art* exhibition of 1984, attracted so much attention in the art world that *Magiciens de la terre* tried to learn from it. Despite the harsh critique that met these two exhibitions, they have come to stand as inevitable points of departure for any historical account of New Internationalism, and as such, they have become part of the discourse itself.[95]

Magiciens de la terre

With the critique of MoMA's exhibition fresh in their minds, the chief curator of *Magiciens de la terre* at the Centre Pompidou and La Grande Halle in Paris in 1989, Jean-Hubert Martin, was very eager to present Western and non-Western works on equal terms.[96] Accordingly, *Magiciens de la terre* is widely viewed as the first attempt to present contemporary visual art from a truly global perspective. The concept of the exhibition was to present works by 100 living artists, and the selection of 50 Western artists and 50 non-Western artists was designed to secure equal representation.[97] The concept resulted in a very broad variety of genres, as shown by the fact that Sunday Jack Akpan, Daniel Buren, Huang Yong Ping, Felipe Linares, Jeff Wall, and a group of six artists from the Yuendemi society all participated, just to mention a few. *Magiciens de la terre* indeed reflected a global aspect, by adopting as its fundamental premise the display of works of art from a world-wide range of geographical areas.

Following on the heels of the notorious MoMA show, the organizers of

Magiciens de la terre were well aware of the curatorial minefield they were entering by including Western and non-Western works in one exhibition, and they therefore considered it of utmost importance to present all the works in the exhibition on an equal footing, regardless of their country of origin. As a strategy of equality, each work had just a small label with the name of the artist, his/her nationality and date of birth, and the work's title, date, dimensions, and medium; in a deliberate attempt to avoid limiting the works through certain prejudiced interpretations, no explanatory or informative text was provided for any of the works. For instance, Ghanaian Samuel Kane Kwei was represented by the work *Mercedes* (1988), which consists of a funeral coffin shaped in the form of a car, and originally intended to be used as a coffin – not a work of art for exhibition – in accordance with funeral traditions in Ghana. At *Magiciens de la terre*, however, this information was not available to the audience. The vigorously magical art was to present itself in this demonstration of global, artistic synchronicity.

The question naturally arises as to how to select and curate art works, when in principle all works by every living artist, worldwide, are available. In an interview with professor of modern art Benjamin Buchloh, Martin explained that he judged and selected works in accordance with his own artistic intuition: 'I want to play the role of someone who selects these objects from various cultures by artistic intuition alone ... according to my own history and my own sensibility.'[98] Thus, Martin seemed highly conscious of the impossibility of casting a universal and objective gaze on art, and he was aware that his own cultural and social background played a decisive role in his selection of works. The inherent problem within standard art history, of tending to displace the time-frame of non-Western art to the past, and of not acknowledging the modernity of the works, seemed therefore to have been overcome with *Magiciens de la terre*. Another decisive curatorial premise mentioned by Martin was that the works had to be suitable for exhibition. He formulated it in this way:

> I have to think of this project as an 'exhibition'. That is, if an ethnographer suggests a particular example of a cult, let us say in a society of the Pacific, but the objects of this culture would not communicate sufficiently with a Western spectator in a visual-sensuous manner, I would refrain from exhibiting them.[99]

As the quote explains, a premise of selection was the fact that the exhibition was held for a Western audience, and, therefore, Western aesthetic judgements –

and specifically 'visual-sensuous' qualities – played a determining role in the ultimate selection. Naturally, this meant that the periphery was read through the optics of the centre, which in this case was the Western aesthetic tradition. There is nothing odd about this. Had the exhibition been curated elsewhere in the world, and aimed at a different audience, different culturally determined premises would obviously have governed the selection.

So instead of addressing the specific times and places of the works' creation, the exhibition considered them all within the same mental space, in which they were presented as transcendental and 'magical' objects that provided the spectators with an artistic and aesthetic experience without the addition of any supplementary information. Jean-Hubert Martin intended to present the spectators with the magicians of the Earth. However, this method was criticized for its reference to 'magic' as a common artistic feature worldwide. As the critic James Hall put it: '[T]he notion of magic seems to be an easy excuse for not even beginning to explain or mediate [...] you can always see a heart of darkness if you make no attempt to turn the lights on.'[100]

In spite of the attempt to show contemporary art on a global level on *equal* premises, this exhibition, too, was met with harsh criticism. For instance, *Third Text* no. 6 (spring 1989) devoted the entire issue to articles on the concept and problems of *Magiciens de la terre*, and several writers in *Global Vision* referred directly to the show as problematic (Araeen, Kapur, Kurodijj, and Nicodemus). The criticism, however, has helped to add a new dimension to New Internationalism. As critic and curator Nicolas Bourriaud stated in a review:

> One can criticize the selection, the method of presentation, the confused documentation, but this is to forget that, for the first time in a long while a curator has forced us to rethink art in time and space, reexamine our values and our understanding of the word 'art' and reflect on the mechanism of the market.[101]

By now it should be clear that the art institutional structure that New Internationalism challenged in the 1980s was caused by the fact that modernity was considered by the art institutional apparatus to be an exclusively Western feature.

In the field of visual arts, then, the dichotomy of 'the West' and 'the rest' meant that artists from non-Western cultures could approach the dominant centre only by submitting to stereotypical Western expectations of the peripheral cultures. The articles in *Global Visions* thus describe examples of how

artists from Mexico, China, and Nigeria must all fulfil these more or less exotic expectations, in order to enter the Western scene of international, contemporary art at the beginning of the 1990s.[102]

The problem of postmodern multiculturalism

The criticism of the Eurocentric centre-periphery *model* is not to be confused with a criticism of the *positions* within the model. The new international aim is not just to move art from non-Western cultures to the centre from the periphery, but to replace this biased model altogether with a much more complex understanding of spatial and temporal *differentiation*.

In this regard, it is important to distinguish between two different main types of differentiation, namely differentiation *of* something or somebody in relation to something or somebody else, and plain differentiation as an act or a process in itself, which is what the authors in *Global Vision* call for. The first transitive differentiation *of* something in relation to something else is found in the hailing of a wide variety of cultures existing side by side, in acceptance of each other. The postmodern concept of 'multiculturalism', for instance, is an example of the differentiation of several particular cultures – mostly immigrant cultures – existing simultaneously in Western metropolises. Each culture has its own traditions and habits that it practises in its own neighbourhood, and the city thus resembles a lively cultural patchwork. Therefore, the concept of multiculturalism is considered by many of the critics in *Global Vision* to be a sustaining part of the prevailing problematic structure.

The reason that postmodernism, and especially its concept of 'multiculturalism' constitute a problem, is that multiculturalism in itself is viewed by many new international antagonists as a discriminatory tool by which Western cultural institutions can handle the 'others', as someone or something that is so different that it needs to be named differently. As Rasheed Araeen puts it:

> There is nothing wrong with multiculturalism *per se*, so long as the concept applies to all. But in the West, it has been used as a cultural tool to ethnicise its non-white population in order to administer and control its aspirations for equality.[103]

And he proceeds with 'The multiculturalism of the visual arts is also rationalized by postmodernism's "anything goes", often in complicity with what is called "postcolonial discourse".'[104]

Another new international attack on postmodernism is put forward by the writer on French thought Denis Ekpo, when he blames the West for having first imposed its modern ideals of Christian humanity and morals on Africa through colonization, and then, when Africans speak about these same issues today, suddenly abandoning its former ideals in favour of an endless relativism, in the name of postmodernism:

> [O]nly from the perspective of legitimation by master-narrative [sic] could Europe's actions – colonialism, capitalist explanation, and so on – be seen to be wrong, unjust or evil. But if, [...] legitimation by grand narratives had lost its force, or had simply disappeared, the critique of colonialism in the past or neo-colonialism in the present carried out in the perspective of grand narratives (truth, wrong and right) not only ceases to be pertinent but misses its mark. This much, Lyotard's postmodern de-legitimations seem to have made abundantly clear.[105]

Thus, 'postmodernism' and 'multiculturalism' are in themselves seen as problems that need to be deconstructed and replaced by other ways of thinking about plurality and difference.

The philosopher Slavoj Žižek has also elaborated on the problem with multiculturalism by identifying a parallel between multiculturalism and capitalist neo-colonization, since today the latter is not bound to the nation-state. Instead, it performs an 'auto-colonization' when 'a global company as it were cuts its umbilical cord with its mother-nation and treats its country of origin as simply another territory to be colonized.'[106] Likewise, multiculturalism is a colonizing practice that does not grant monopoly to the nation-state, and as such, it works like

> A 'racism with a distance' – it 'respects' the Other's identity, conceiving the Other as a self-enclosed 'authentic' community towards which he, the multiculturalist, maintains a distance rendered possible by his privileged universal position. Multiculturalism is a racism which empties its own position of all positive content (the multiculturalist is not a direct racist, he doesn't oppose to the Other the *particular* values of his own culture), but nonetheless retains this position as the privileged *empty point of universality* from which one is able to appreciate (and depreciate) properly other particular cultures – the multiculturalist respect for the Other's specificity is the very form of asserting one's own superiority.[107]

This kind of differentiation of other cultures is perhaps most clearly detected in exhibitions and institutions of knowledge, such as national museums or galleries and national libraries, where it is regarded as important to represent minority cultures that were earlier neglected. At first sight, this institutional representing of other cultures, or spaces other than the Western, seems to be in sympathy with the cultures exhibited; but viewed from a new international perspective, it is problematic for two main reasons: First of all, these cultures are still only represented in the passive form *by* someone else, namely the Western institution, and are not actively representing themselves. Thus, cultures that are geographically and/or ideologically considered absent from the West can only be represented – even if they are actually physically present, as is the case with, for instance, Africans and Asians in New York, Berlin or London.

In a very honest analysis of her own curating practice, Elisabeth Sussman describes the way she used to deal with art from other nations in the late 1980s:

> I assumed that the nation I was presenting was monolithic and stable, restricted within boundaries; that the audience, usually a small art world audience, presented with that nation's art, was similarly monolithic or one-dimensional in its reception and response.[108]

As this quotation exemplifies, Western curating practices may suffer from an essentialist assumption about other cultures, which are therefore represented as simplistic stereotypes. It does not really help much that art museums or university departments of art history include sections or courses labelled 'Chinese', 'Mexican' or 'Nigerian' art, or initiate projects of so-called 'world culture', if the curating practices resemble that which Sussman describes above.

The new international antagonism

How, then, does New Internationalism articulate itself against the exhibition practices and the multiculturalism stemming from the 'West = modernity' trope? Before pursuing this question in detail, it is necessary to distinguish between broader societal modernity, which I shall here term *cultural* modernity, on the one hand, and *artistic* modernity on the other. The former describes general dynamics of modernity in terms of what Giddens identifies as its three main sources, which he sums up accordingly:

The separation of time and space. This is the condition of time-space distantiation of indefinite scope; it provides means of precise temporal and spatial zoning.

The development of disembedding mechanisms. These 'lift out' social activity from localised contexts, reorganising social relations across large time-space distances.

The reflexive appropriation of knowledge. The production of systematic knowledge about social life becomes integral to system reproduction, rolling social life away from the fixities of tradition.[109]

As demonstrated in the previous chapter, such aspects of cultural modernity have informed the emergence of the 'West = modernity' trope, which for its part has informed the discriminative mechanisms of the art institution apparatus. However, the primary concern of New Internationalism is the institutional recognition not of non-Western cultural modernities, but of non-Western *artistic* modernities. This distinction is important, because, recollecting the nine-point pseudo-manifest, we identified one of the main interests of New Internationalism as 'a call for greater focus on *artistic* practice and theory as significant in themselves, considered separately from anthropological and cultural concerns'.

Accordingly, New Internationalism's response to the 'West = modernity' trope is the acknowledgement of artistic modernities, when and wherever they may evolve – hence the plural tense. In a new international perspective, the notion of artistic modernity is thus globally applicable, which of course is not the same as saying it is automatically found everywhere. This means that artistic modernity shows its face in a much more heterogeneous manner than is seen in standard art history, and that it may pop up in one period at one place, and in another period at another place, etc. in a mode that is not controlled by one common centre or one common narrative.

One suggestion as to how we should understand the idea of artistic rather than cultural modernity is given by Everlyn Nicodemus, who argues that modernity in art happens when we witness an artistic revolution. As an example, Nicodemus describes the well-known revolution of cubism at the beginning of the 20th century, as demonstrated by the exhibition *'Primitivism' in 20th Century Art*, in which Picasso and his colleagues took great inspiration from African and Polynesian masks and figurines for their new artistic forms, and where the appropriation of foreign expressions resulted in art that is widely considered not just modern, but downright avant-garde, according to standard art history.

What is not mentioned in these books is that a similar artistic revolution took place at the same time in Nigeria, where the artist Aina Onabolu appropriated the Western academic tradition of easel painting in a naturalistic style. By funding a number of art schools in Nigeria, Onabolu spread this style to a broader circle of artists, thus initiating a completely new way of painting in the region. Hence, artists in Lagos abandoned the language of traditional African art, and appropriated from Europe easel painting, thus 'making a clean break from their past by taking up a Western "traditionalism" left behind by modernists, the realm of the art academy', as Nicodemus puts it.[110] However, this avant-garde revolution in Nigerian art has not been considered worth mentioning in the survey books that so highly value the cubist appropriation of traditional African styles, simply because only one kind of modernity exists in the eyes of the Western culture: namely, its own kind. According to Nicodemus 'Revolts and revolutions are indispensable to art's dialectical relation to modern time [...] the magnificent superiority complex of the West makes it unable to recognize any other revolution in art than its own.'[111]

While Nicodemus's account of Onabolu's work is an example of how New Internationalism aims at re-reading the histories of modernity neglected by traditional Western art history, contemporary artistic activities around the world are what really constitute the discourse. Covering all artistic activity worldwide is neither the aim nor within the scope of this book, but two different examples, two cases, are illustrative in order to draw a picture of what activities are positively parts of the chain of equivalence that makes up New Internationalism.

Tropicália

At the Museum of Modern Art in Rio de Janeiro, the artist Hélio Oiticica, in 1967, exhibited his work *Tropicália* – an installation with sand on the floor, green palms, colourful parrots, and structures made of straw, coloured fabric suspended on wooden frames built to form small, narrow, maze-like corridors leading to a TV set in the middle, receiving a popular Brazilian TV station. The strategy of incorporating particular tropical features into his work (like palm trees and parrots) was explained by Oiticica like this:

> I wanted to accentuate this new language with Brazilian elements, down to its smallest details, in an extremely ambitious attempt to create a language that would

be ours, characteristic of us, that would stand up to the images of international pop and op, in which a good many of our artists were submerged.[112]

The new artistic language referred to above was the idea of 'Tropicália'. The idea was not to aim for a Brazilian culture sealed off from international tendencies, but rather to take in international inspirations and digest them so they would merge with Brazilian culture and result in entirely new and unique expressions. The process of digesting was thus considered an important and necessary part of the concept of Tropicália, and it took its direct inspiration from the Brazilian surrealist Oswald de Andrade's fabulous 'Manifesto antropófago'. This anthropophagous manifesto – written in 1928, according to Western time chronology, but in the 'Year 374 of the Deglution of bishop Sardinha' according to Andrade himself[113] – made use of the metaphor of cannibalism as a way of handling cultural and religious encounters, and in a mode of neo-avant-gardist *Nachträglichheit*, Oiticica attempted to fulfil the concept of anthropophagi by launching his own notion of Tropicália:

> In reality, with Tropicália I wanted to create the 'myth' of miscegenation – we are all Blacks, Indians, Whites, everything at the same time – our culture has nothing to do with the European, despite being to this day, subjugated to it: only the Black and the Indian did not capitulate to it. Whoever is not aware of this is out. For the creation of a true Brazilian culture, distinctive and strong, expressive at least, this accursed European and American influence will have to be absorbed anthropophagically, by the Black and Indian of our land, who are, in reality, the only significant ones, since most products of Brazilian art are hybrids, intellectualized to the extreme, empty of any meaning of their own.[114]

Oiticica's work and ideas kick-started a whole movement of Tropicalism in Brazil, as it quickly spread into broader, popular culture, especially music, which was criticized by Oiticica for turning Tropicália into a style of superficial consumption, a

> 'Tropicalism' [...] Those who made "stars and stripes" are now making their parrots and banana trees, etc., or are interested in slums, samba schools, outlaw anti-heroes (...) Very well, but do not forget that there are elements here that this bourgeois voracity will never be able to consume: the direct life-experience (*vivência*) element, which goes beyond the question of the image.[115]

Tropicália and anthropophagi have been important concrete phenomena for the reflection on artistic modernity on specifically Brazilian terms, and thus did not aspire to be a universal cultural strategy. They did not depend on Western approval, but evolved in a Brazilian context with its own specific international links, and thus illustrate a disobedience to or independence from a universal Western scale of artistic development.

The concept of anthropophagi was taken up by the São Paulo Biennial in 1998 and made a leading motif, a 'Historical Nucleus' for the biennial that year.[116] The cover text of the catalogue states that,

> In art history, the concept is deeply non-Eurocentric [...] *Antropofagia* [...] has multiple, different, fluid, and dense significations which have been explored both critically and poetically in various levels during the selection and articulation of the artworks and the texts of the Bienal.[117]

The curators' interpretation of the concept of anthropophagi led to the inclusion of not only the works by surrealists and, of course, Hélio Oiticica, but also what we might term 'Western' artists like Vincent van Gogh, due to his inspiration from, or 'digestion' of, Japanese woodcuts, and Gerhard Richter, who was seen as pillaging the self.[118]

China Avant-garde

A second example of artistic constitution of modernity and avant-garde working independently of a Western gaze is the exhibition *China Avant-garde*, in February 1989, at the National Gallery in Beijing, which was the first official exhibition of the new post-Cultural Revolution avant-garde art in China. The exhibition plays a paramount role in the history of contemporary Chinese Art for several reasons: It provided a comprehensive survey of the experimental artistic practices in China in the 80s; it was the first officially sanctioned exhibition of the new experimental art in China, and it was even allowed to use the National Gallery for the show, which had significant symbolic value; there was already a scandal at the opening, when artists Xiao Lu and Tang Song, as part of their work, fired a gun at their own installation piece, called 'Dialogue', causing the police to immediately close the exhibition (it was later reopened); and it was denounced five months later by the Chinese government, which blamed the avant-garde art for partly having inspired the students' protest at

Tiananmen Square, which resulted in the notorious military crack-down on the demonstrations, in June 1989.[119]

To a Western spectator in 1989, many of the works in this exhibition would not seem very avant-garde, but within the Chinese artistic context, it was groundbreaking in its departure from the cultural revolutionist propaganda art of ideological Mao-praising and blessings of the communist regime. The simple fact that the works did not seem to unquestioningly subscribe to the artistic dogma of the People's Republic, as formulated by Mao in his Yan'an talks on literature and art in 1942, was enough to render it avant-garde.[120] Thus, although China's experimental art scene in the 80s took inspiration from the developments of Western art in the 20th century, the *China Avant-garde* exhibition expressed a moment of profound artistic modernity *in China*.

Both *Tropicália* and *China Avant-garde* are connected to a Western, international art world. The former, through the heritage of the surrealist movement and its Parisian headquarters in the 1920s, and by its attempt to find alternatives to the Pop and Op art of Western art; and the latter by the Chinese Avant-garde's inspiration from 20th century Western art, with which the Chinese artists became gradually acquainted after the end of the Cultural Revolution.[121] In neither of these cases, however, was the artistic development controlled by, nor did it aspire to fulfil expectations from the West. Both emerged from specific artistic developments within cultural contexts at specific places and specific historical times, which, taken together, brought about specific and very different kinds of artistic modernities. Thus, these two cases confirm that artistic modernities do actually develop in parallel to, and independent of a universal master scheme.

Cases like these play a very important role in constituting New Internationalism, since they constitute empirical evidence of the fact that, in contrast to the views of standard art history, artistic modernity is in fact not a Western monopoly. In addition to the heterogeneous emergences of artistic modernities at the level of *artistic practice*, which result in concrete works of art that are revolutionary when compared to their specific artistic context and tradition, alternatives emerge at the art *institutional* level. And acknowledgement of alternative art institutional initiatives that counterpose the existing Western institutional apparatus is highly prioritized by New Internationalism. One inevitable institutional initiative that is extensively mentioned within the discourse of New Internationalism is the Havana biennial.

Havana biennial

According to curator and critic Nelson Herrera Ysla, the Havana biennial from the beginning

> [D]ecided to discuss and reflect upon all subjects rejected by the mechanisms of dominant power, all that has been perverted, despised or underrated and that corresponds to the most authentic content of a visual culture that has gained in intensity, vitality and strength during the past decades.[122]

Organized by the Wifredo Lam Centre, newly opened in 1983, the first Havana biennial was held in 1984. As formulated by one of its early organizers, 'The Habana Biennial became a non-discriminatory and a non-hierarchical space, an open space for the encounter of artists and analysts of our art, (whether they lived or not in our regions).'[123] The fact that the biennial includes popular arts in addition to professional arts, and thereby further broadens its perspective and its way of differing from Western aesthetics and art praxis, was clearly demonstrated by the display in the third Havana Biennial of 'calligraphy in contemporary Arab art; Latin American textiles; the Cuban lithographic tradition; Mexican dolls; African wire toys; the Cuban Humour tradition...'[124] The Havana Biennial thus very consciously differs from the Venice Biennial, which is described by curator and critic Guy Brett (in 1992) as representing about 40 different countries:

> But to all intents and purposes Venice is and always has been a European (not to mention a 'First World') exhibition [...] all countries accept the national basis of this attempt at internationalism [...] Because of the reality of power, the two alternatives offered the Third World artist come to mean the same thing: either to be narrowly identified with his or her continent, country or people and therefore reduced as an artist in comparison to First World artists, or to be detached from their base, from the reality of the day-to-day of that country and how it affects the art we see.[125]

What makes the Havana biennial succeed on an overall level is, according to Brett, that

> [O]ne has the impression that the real character of the Bienal de La Habana has come about as the result of an argument/dialogue between the given models,

both political and aesthetic, and the opening, de-solemnizing, and sophisticated questioning represented by the nature of recent Cuban art itself.[126]

The effect of these institutional cases of non-Western artistic modernity (such as *Tropicália*, *China Avant-garde*, and the Havana biennial) on the Western art world can be illustrated by referring to Jacques Lacan's story of the sardine can: Once, when on board a small fishing boat, a man pointed out to the young Lacan a sardine can floating in the sea and said 'You see that can? Do you see it? Well, it doesn't see you!'[127] The incident left Lacan uncomfortable, as he realized that he was 'rather out of place in the picture.'[128] Likewise, the dogma of Western art's monopoly of modernity is 'rather out of place in the picture' in relation to the different non-Western artistic modernities. Artist and writer Olu Oguibe even believes that the public success of different artists of non-Western origin in Britain in the early 90s 'set off a wave of paranoia' leading to the notion of 'ethnic art', as 'a deliberate ploy to reinforce the boundaries which seclude those artists from the arena of Western internationalism.'[129]

Apart from paying attention to different non-Western artistic modernities, one way for New Internationalism to stress the global aspect of contemporary art is to look beyond the nation state as governing artistic understanding. In his book *The Black Atlantic*, from 1993, Paul Gilroy considered the 'Black Atlantic as a Counterculture of Modernity', and the book illustrates two points that are important in order to understand the articulation of New Internationalism.[130]

First, it brings forward the history of a transatlantic black culture that is neither essentially African nor essentially American or Caribbean, but instead has evolved from specific historical voyages made by black people back and forth across the Atlantic, which has caused Gilroy to re-evaluate 'Black Power as a hemispheric if not global phenomena.'[131] Hence, it is not a question of, for instance, 'Black America', but of the 'Black Atlantic' as a site of constant transition.

Second, this history of the Black Atlantic culture is based on a denunciation of traditional cultural studies. Though cultural studies professor Stuart Hall is chair of the board of trustees for InIVA, the discipline of cultural studies does not play a significant part in New Internationalism, apart from when it reveals Western modernity, as such, as a historical construct. According to Gilroy, the problem with cultural studies is that it assumes 'that cultures always flow into patterns congruent with the borders of essentially homogeneous nation states'[132], and that

It is certainly the case that ideas about 'race', ethnicity, and nationality form an important seam of continuity linking English cultural studies with one of its sources of inspiration – the doctrines of modern European aesthetics that are consistently configured by the appeal to national and often racial particularity.[133]

We shall return to these 'doctrines of modern European aesthetics' in the next chapter, but for now it is important to comprehend that what prevents cultural studies as such from playing a significant part in the new international articulation is that whereas cultural studies evolve around the investigation of cultures within specific national or ethnic frameworks, New Internationalism holds art as a nodal point in an antagonism against cultural/national/ethnic filters of reception. For the same reason, the next chapter will start by clarifying New Internationalism's relation to postcolonialism.

Racial, sexual and aesthetic differences in art

Postcolonial theory

When discussing how New Internationalism is articulated through its relation to time, space, and modernity, a lot of the references and arguments are similar to those found in a broader postcolonial field, as we shall see. New Internationalism, however, differs from postcolonialism on significant points.

First, post-colonial theory primarily takes literature as its point of departure. Its founding point in Western academia, Edward Said's book *Orientalism*, from 1978, is concerned with disclosing Western, stereotypical ideas of the Orient and the Orientals as they were presented in literature (novels, declaration documents, speeches, etc.) but not in the visual arts.[134] This leads us to the second point at which postcolonial theory differs from New Internationalism: the former is politically and ethically informed, insofar as its primary antagonism is one of confronting Western colonialism. As one of its most influential characters, postcolonial theorist Homi K. Bhabha states:

> [Postcolonial perspectives] intervene in those ideological discourses of modernity that attempt to give a hegemonic 'normality' to the uneven development and the differential, often disadvantaged, histories of nations, races, communities, peoples.[135]

According to some of its critics, this means that postcolonial theory is governed precisely by a traditional Western developmental scheme. As philosophers Peter Osborne and Stella Sandford put it:

Post-colonial theory, or colonial discourse theory, as it is alternatively known, has generated an immense amount of productive research into specific colonial histories. However, as a unified theoretical model it has inherited (indeed exacerbated) many of the weaknesses of its predecessor, Third-Worldist culturalist nationalism. For it subjects cultural analysis to a typological development schema – pre-colonial/colonial/post-colonial – projected onto a geographical distribution of powers (First World/Third World, or more recently, the 'West'/'the rest') which is largely imaginary, since it abstracts from the contingencies of history (and tends to forget the world-historical impact of the socialist experiment altogether).[136]

However, one of Bhabha's points is to look beyond the dichotomy of the West/the rest, by paying attention to what lies in between, to the notion of hybridity, and the so-called Third Space of enunciation.[137] However, the concept of hybridity is not unconditionally accepted as a moment of the new international process of articulation, since it is sometimes interpreted as just another idea that clusters everything non-Western together under the same name, and, despite their communal untranslatability, considers them to be the same. Sarat Maharaj discussed such problems related to the notion of hybridity in *Global Visions* in 1994, and in the same year the art historian Annie E. Coombes also criticized the use of hybridity in contemporary exhibitions such as *Magiciens de la terre*.[138]

According to Coombes, the notion of hybridity is a strategy that is used to neutralize tensions and conflicting political interests between the West and its former colonies. By displaying the visual evidence of cultural meetings, such meetings are rendered interesting but unproblematic. Coombes argues that 'hybridity' is always considered to be a matter of meetings between Western and non-Western cultures and never applies to the 'other within', the diaspora in Western metropolises. A similar claim is made by Richard Hylton, who, looking back in 2007, states that:

> The consensus among curators in the 1990s seemed to be that the most interesting art by coloured people was that being produced by artists in Africa or South Asia, or China, or the Pacific rim, or Australia, or wherever. Anywhere but here in Britain.[139]

In the light of this situation, Coombes calls for a 'need to recognise the significance of the fact that "hybridity" and "difference" in most of these exhibitions is articulated as a symptom of what is identified as "post-colonial" (...) as op-

posed to "diasporic" formations.'[140] As this quote testifies, Coombes considers the 'post-colonial' to be incapable of accounting for any other experiences than gained in places that were formerly colonized by the West. As an example, she describes the criticism of the so-called 'hybrid' exhibition, *Hidden Peoples of the Amazon*, in 1985, at The Museum of Mankind in London. The criticism from Indian rights organizations did not concern the absence of evidence of cultural contact. This was in fact shown, for instance, by

> [T]wo photographs supposed to demonstrate a flourishing hybrid culture – a ceremonial house made out of recycled cans and a Panare Indian in 'traditional' clothing riding a yellow Yamaha bike on a cleared highway.[141]

Instead, the criticism was aimed at

> [T]he absence of any evidence of the ongoing struggle between the Indians and the Brazilian government [...] the absence of any self-determination by those Indians represented in the exhibition.[142]

Coombes quotes a response to the exhibition by one of the leaders of an Indian rights organization, who criticized the exhibition for displaying a false picture of the Indians' situation: 'It was as though we could have the white's machine without losing our land and our way of life.'[143]

There is no doubt that postcolonial theory and New Internationalism overlap in several areas, as they both oppose Western cultural domination. Specifically, this is illustrated by the fact that postcolonial theorists – especially Bhabha, who is also on InIVA's board of trustees – often contribute to catalogues for exhibitions of contemporary art. As demonstrated above, however, their nodal points differ significantly, insofar as New Internationalism is articulated around art without cultural discrimination, and postcolonial theory is articulated around the disclosure and deconstruction of Western colonialism.

The final chapter will elaborate more critically on the relationship between postcolonial theory and New Internationalism, but for now it suffices to sum up their differences accordingly: New Internationalism works for institutional equality of contemporary visual art, and postcolonial theory works against the discourse of Western colonialism considered within a much broader cultural, political, economic and historical framework. Insofar as these two different primary concerns overlap, or can be of use to each other, they form a united

antagonism, but their ultimate goals differ. Especially Rasheed Araeen has argued against 'The tyranny of postcolonial cultural theory'.[144]

Black Art

The nine paragraphs on the InIVA list that outlines the objectives of New Internationalism includes only one reference to other art movements or tendencies, namely the concept of Black Art:

> 'New Internationalism' embraces the concept of Black Art' because it hinges on a cross-fertilization of views in the contemporary visual arts. However, it allows artists a choice, a subjective decision-making process based on personal experience which takes it beyond the definitions of 'Black Art'.[145]

The Black Arts Movement was born in 1965 in New York, when the recognized poet, playwright and publisher LeRoi Jones (Amiri Baraka) demonstratively moved to Harlem after the assassination of Malcolm X.[146] It is thus associated with the Black Power movement, but the Black Arts movement also has strong relations with the Harlem Renaissance of the 1920s.[147] And the Black Arts Movement in the USA of the 60s would be the natural place to look for some important roots of New Internationalism, because it demonstrates how the initial antagonistic impulses of this discourse emerge, not from outside, but from an environment inside a Western *geography* that did not belong to the *cultural space* of the West. The split between place as rational covering of an area, and space as culturally and mentally constituted becomes obvious when reading about black aesthetics that, in the words of Brother Knight from the Black Arts Movement:

> Unless the Black artist establishes a 'Black aesthetic' he will have no future at all. To accept the white aesthetic is to accept and validate a society that will not allow him to live [...] And the Black artist, in creating his own aesthetic, must be accountable for it only to the Black people. Further, he must hasten his own dissolution as an individual (in the Western sense) – painful though the process may be, having been breast-fed the poison of 'individual experience'.[148]

From this quote, it is clear that the difference between spatial centre and periphery was not felt to be a question of physical distance, and that Western

modernity with its 'individual experience' had been proven wrong, and needed to be replaced by a 'black' alternative. As the quote demonstrates, the individual experience is even considered a "poison" that the sinister white society, with its "white aesthetic" has "breast-fed" to the Black artist, who therefore needs to undergo a detoxifying process in order to reach his own full identity (in the writings of the Black Arts Movement, the artist is never referred to as 'she').

When New Internationalism's definition list in 1991 refers congenially to Black Art, it is because it is in agreement with the Black Arts Movement's refusal of a Western monolithic understanding of space and modernity. What separates the two, on the other hand, is the question of art's political role, which is considered to be fundamental by The Black Arts Movement. Accordingly, 'The Black Arts Movement believes that your ethics and your aesthetics are one' – art and aesthetics are thus subsumed under the political aim of a broader antagonism and – 'Black Art is the aesthetic and spiritual sister of the Black Power concept'[149]. Unlike the main interest of New Internationalism, artistic visibility and acceptance is not the aim of the Black Arts Movement – in fact, it seeks actively to withdraw Black Art from the 'white' cultural circuits, which only 'alienates him [the Black artist] from his community' – instead Black Art should speak 'directly to the needs and aspirations of Black America.'[150] This may give the black artist new opportunities within 'black culture', but at the same time it fixes him as essentially Black, and deprives him of a free choice regarding the kind of art he creates.

The strategy of the Black Arts Movement is to act in just as discriminatory a fashion as the white culture, which is seen as the cultural oppressor – only now there is a reversal of signs, but the Black artist is still doomed to be exactly that, and cannot escape his racial or cultural background and become 'just' an artist in his own right. This is what takes the new international antagonism 'beyond the definitions of Black Art'. While, according to theatre scholar Larry Neal, 'the Black Arts Movement is an ethical movement', New Internationalism is concerned with the system of artistic and aesthetic representation, and thus with changing this system in order to secure equal opportunities, *regardless* of the artists' cultural background. Cultural difference is hence understood much more essentially within the concept of Black Art than within New Internationalism. The strong ethical impulse in Black Art implies that art and aesthetics converge as utilitarian means in the political battle: Black Art must develop a Black aesthetic as a transparent shape or form that is well suited for evoking the Black spirit, without drawing attention away from the political message.

Therefore: 'Poetry is a concrete function, an action. No more abstraction', as Neal puts it.[151] Also, as this quote indicates, literature, poetry, and theatre were the preferred media of Black Art, whereas New Internationalism is concerned with the visual arts.

The anger and the antagonistic drive of the Black Arts Movement, however, have influenced New Internationalism, and taken it beyond purely theoretical or academic puzzlement. In Britain, the development from Black Art to New Internationalism has been carried through to a great extent by Rasheed Araeen, whose own career and writings during the past three decades are very illustrative of this development. Born in Pakistan, Araeen came to London as a young artist in 1964, fascinated and inspired by the minimalist movement, but soon discovered that the modern British art world was not at all open to artists of colour.[152] These circumstances forced him into more theoretical considerations regarding the politics of the Western art institutions, and he began to strongly advocate for Black Art in Britain. In 1978, he started the journal *Black Phoenix*, which rather directly opposed the exclusively Western conception of 'internationalism' in the art world. Though the notion of New Internationalism was not used until around 1990, Araeen seemed to have it right at the tip of his tongue in 1978, when he published the text 'Preliminary Notes for a BLACK MANIFESTO' in *Black Phoenix*. Generally, the text's 10 tightly written pages offer a thorough analysis of the fundamental problems of artistic discrimination as seen from the perspective of New Internationalism. The problem can be summed up by Araeen's statement that

> WESTERN ART IS NOT INTERNATIONAL; IT IS MERELY TRANS-ATLANTIC ART. [...] Therefore, in an international context, it would be more appropriate to call it IMPERIALIST ART.[153]

Even though this is a written text, one can almost hear the anger of Araeen's voice through the capital letters, as he argues that the nature of Western art is imperialist. In general, the many bold paragraphs, statements in italics, and sentences written in capital letters provide the text with the same strong tone of commitment that characterizes the previously mentioned writings of the Black Arts Movement.

It is a curious fact that Rasheed Araeen's text was published in 1978 – the same year as Said's *Orientalism* – which illustrates that generally, the first signs of New Internationalism and of postcolonial theory emerged from one and the

same period, yet they did so *independently* of each other. The journal *Third Text* was launched in 1987 with Araeen as a driving force, and the editorial self-understanding has been one of complexity and integration, rather than the segregation of Western modernity. Excerpts from the very first editorial of *Third Text* illustrate this:

> How do we deal with the affluence of the oil rich countries [...] within the concept of the Third World as an underdeveloped entity? Saudi Arabia and Bangladesh, for instance, represent two opposite extremes, and yet they are related through the shared experience of colonialism and neo-colonial domination. [...] Contrary to the humanist belief, art is not about human self-expression *per se* but requires a market for its assertion as a commodity; [...] Its ideological function is intrinsically bound up with its exchange value. [...] *Third Text* offers a platform, not only for the contestation of the racism and sexism inherent in the dominant discourses on art and culture, but also of those essentialist assumptions which define 'black art' as simply the work of artists who happen to be black analogous to the notion of feminist art as any work produced by a woman artist. [...] Focusing on the visual arts, *Third Text* foregrounds theoretical debates and historical analyses of art practice.[154]

Third Text established a platform for critical and serious (peer-reviewed) engagement with the practice of contemporary art on a global scale – for instance, the first issue contained a presentation of Mona Hatoum's work, a conversation with Sonia Boyce, and a feature on Lygia Clark's work and collaboration with Hélio Oiticica in Brazil. Furthermore, *Third Text* articulated the discrepancy between artistic practices, like the ones just mentioned, on the one hand, and the exclusion practices of the 'international' art institutions on the other hand – in the first issue this was discussed in Rasheed Araeen's 'From Primitivism to Ethnic Arts' and Desa Philippi's 'The Conjuncture of Race and Gender in Anthropology and Art History; a Critical Study of Nancy Spero's Work'.

Araeen himself insists that *Third Text* began as early as 1975, when he started writing critical texts. He considers these early writings, *Black Phoenix* and *Third Text* to be continuous.[155] Put briefly, though Araeen has been critical towards the *notion* of New Internationalism his work belongs to the discourse, and his work over the years illustrates very well the development from Black Art to New Internationalism, and the differences between the two.

Perhaps as a result of Araeen's engagement with the issue of Black Art, the definition of 'black artists' generally changed towards the late 80s, especially in

Britain, from meaning artists of strictly African origin or descent, to a broader definition of all artists of African, Asian, or Middle Eastern origin.[156] However, there were different opinions on the issue. For example, Araeen would refer to Black Art as made by 'AfroAsian' artists.[157] On the other hand, in 1988 Eddie Chambers wrote that:

> I would define Black art as art produced by black people largely and specially for the black audience, and which, in terms of its content addresses black experience. It deals with in [sic] its totality the history of slavery, imperialism and racism, which affects the position of black people here in the West as well as other parts of the world – in the Americas, and in Africa itself.[158]

Thus a 'black experience' refers to 'slavery, imperialism and racism', and, according to Chambers, art can be defined as 'Black art' only when all the following three conditions apply: the artist must be racially black, he/she must be culturally 'black', and the subject matter of the work of art must somehow belong to 'black' culture or history. Consequently, according to Eddie Chambers: 'Not every Black artist produces Black art'.[159] However, as Araeen points out, Chambers' own selection of works for the exhibition *Black Art – Plotting the Course* included works that are not about Western imperialism. When discussing the exhibition's work "The Rotimaker" (a pastel by Shanti Thomas from 1985), which shows an Indian woman making bread, the subject matter is still defended by Chambers as relating to a Black experience, even though the same motif might just as well have been painted by a white artist. In effect, this interpretation of Black experience makes it of little practical use. Araeen, conversely, defines Black Art more narrowly, as art existing within, and dealing with a *political* context of racism and imperialism that is not necessarily of any relevance in a painting of, for instance, an Indian woman making bread.[160]

The following excerpt from Rasheed Araeen and Eddie Chambers' discussion points out the two fundamentally different views on Black Art:

> EC: My position is based on the premise that whatever Black peoples do, wherever they are, is important [...] Let us take the example of the painting The Domino Players by Errol Lloyd. It is about how West Indian men socialise among themselves; how they play dominoes; what domino means to them vis-à-vis the Caribbean experience. And the Caribbean experience is an important part of Black experience.

RA: So, in other words, a painting about white people playing darts in a pub would be an example of white art?

EC: Well, if it's painted by a white artist, I suppose it had to be.

RA: Why couldn't it be painted by a black artist? And if it was painted by a black artist would it become black art?

EC: Well, if it was really painted by a Black artist, I would approach it differently expecting to find things there which would indicate more than just white people playing darts in the pub [...]

RA: I find it very difficult to accept that.[161]

Of the two different interpretations of Black Art illustrated here in 1988, New Internationalism is clearly most in agreement with Araeen, since it sets out to challenge institutional discriminations against artists of colour, based on the belief that there are no essential differences between them and white artists. Only socio-cultural differences should be acknowledged. By now we begin to see how New Internationalism is treading a thin line: Attention must be paid to the particular historical artistic experiences that made and still make room for different kinds of artistic modernities in specific contexts, while, simultaneously, the basic assumption is that there is no difference between Western and non-Western artists – they have merely been treated differently by the Western institutional establishment.

From Black Art to black representation

From the 90s, the focus changed from being an *internal* matter – of different interpretations of what Black Art was or should be and of the lack of institutional representation of Black Art – towards attention to the *external* critical and institutional reception of the work of artists of colour, whether termed Black Art or not, and to *how* the representation was carried out. The shift of Black Art's status from ideology to history, from being a question of ontology to one of representation, mirrors a change in the conception of race. One kind of confrontation with an essentialist understanding of identity in the 90s is the extreme constructivism, presented by philosopher Judith Butler, which tries

to do away with any kind of essential marks of cultural identity by making it a question of performativity and cultural behaviour.[162] This approach can be beneficial on an internal level of Black Art, where it provides a tool for the individual artist with dark skin, as it can help the artist to understand and create him/herself as a dynamic, *individual* artist rather than a person doomed to an identity as strictly a 'Black artist'. The performative constructivism, however, does not solve the external problem of how this artist is read and represented institutionally, where he/she is still most likely to be confined to a 'Black artist' identity.

To respond to this problem, philosopher Linda Martín Alcoff has suggested a different definition of race, in which she attempts to contextualize the ontological status of race according to this logic:

> In claiming that race is an ontological category, I do not mean to say that we should *begin* by treating it as such, but that we must begin acknowledging the fact that race has been 'real' for a long time [...] There is a visual registry operating in social relations that is socially constructed, historically evolving and culturally variegated, but nonetheless powerfully determinant over individual experiences and choices.[163]

This understanding of race expresses very well the approach of New Internationalism to the question of racial difference, since it balances the same thin line between essentialism and constructivism: race is not an essential cultural identity, but it has mistakenly been, and still is, treated as if that is the case, and it is necessary to recognize this mistaken conception in order to be able to respond to it. As Alcoff puts it:

> One thing that this view has in its favour is that it would make sense of the non-reciprocal visibility of dominant and non-dominant racial identities: where the invisibility of whiteness renders it an unassailable form, the visibility of non-whiteness marks it as a target and a denigrated particularity.[164]

Simultaneously with the contextualization of race as ontology, the term 'race' itself has increasingly been replaced by the notion of 'ethnicity', which suggests a fundamental difference between the two terms with 'race' belonging to a biological domain and 'ethnicity' to a social. As expressed by anthropologist Thomas Hylland Eriksen, 'ethnicity is essentially an aspect of a relationship, not a property of a group'.[165]

The turn away from internal definitions of Black Art, towards external questions of reception and representation in the early 90s, is illustrated by the troublesome making of the exhibition *The Theater of Refusal, Black Art and Mainstream Criticism* (University of California, 1993-94).[166] In the catalogue introduction, Catherine Lord describes how the exhibition was first conceived in 1989, at which point it was called *Black Art and Postmodern Aesthetics*. However, as some of the planned gallery venues closed down prior to the show, it was postponed three times, and by the early 90s, the circumstances had moved in a direction where:

> The exhibition now needed to address the enormous amount of (so-called) critical discourse generated by the attention newly paid to ethnic minority artists, by mainstream institutions in the late 1980s and early 1990s. Lack had been replaced by excess, silence by chatter. We therefore decided to retitle the exhibition and to reframe its design so that it would more clearly address issues of artists' careers and the *construction of those careers by the art press, by galleries, and by museums.*[167]

As a consequence, the exhibition displayed the work of each artist alongside excerpts from prior critical reviews of the artist's work, in a way that bound them together as one discursive entity. For instance, Gary Simmons' work *Us / Them*, which consists of two white robes hung next to each other and embroidered respectively with the words 'Us' and 'Them' in big italic golden letters – thus paraphrasing robes for the couple that read 'His' and 'Her' – was supplemented by the following quote from a review of the work, written by Susan Kandel in Arts Magazine, October 1991:

> The trouble with Gary Simmons's mixed media work on racism is that it sees the world in black and white. Metaphorically, that is: look at the Us/Them Robes – plush and white, hanging side by side, compelling the viewer to line up on one or the other side of the divide. But literally too; no colour here, no messiness or fuss, just clean lines and minimal forms. Of course, the problem with Minimalism was that it tidied things up a little too much, eliminating interiority...[168]

The Theater of Refusal pointed at an inevitable intertwinement between the work of art, its critical reception, and the institutional framing of it, which, taken together, are what creates meaning in art. Of course, the *Theater of Refusal* itself thus contributed to the ongoing process of ascribing signification to the

work of art. Apart from the display of former critical responses to the artists in the exhibition, *The Theater of Refusal* framed the participating artists and their works in a specific Black Art discourse. As Gary Simmons comments in a round table discussion related to the exhibition: 'I can't tell you how many calls I get from some curator in Sheboygan who's putting together three blacks, two Hispanics and one lesbian for their Other show.'[169] And, in a way, this was also what *The Theater of Refusal* did. Though it 'revealed' the presumptions of mainstream criticism, it nevertheless kept up the transparency of its own institutional sustainment of Black Art.

Likewise, the exhibition *The Other Story*, arranged by Rasheed Araeen in 1989, which aimed at telling the story of Black Art in Britain that had hitherto been ignored, had to frame Black Art precisely as 'other', compared to main-stream art in Britain, to be able to actually tell this story. This dilemma persists in the fact that one can only recognize the problems of the *black* artists when these artists are seen *as* black.

The role that the Black Arts movement and Black Art as a concept play in the articulation of New Internationalism concerns an institutional level and relates to the reception and representation of artists of colour, whereas Black Art as a certain kind of artistic language or quality is of much less importance. In New Internationalism, the political battle is not fought through specific expressions of concrete, singular works, but in the art institutional field; and when Black Art in the beginning of the 90s shifted its focus to this field, the two started to agree, and to a certain degree merged. The more successful New Internationalism was in its struggle for equal, common, art institutional premises, the more absurd it became to speak of a certain kind of Black Art as something that differed from the common premises.

Feminism

The Theater of Refusal opened just one month after the opening of the noto-rious *Whitney Biennial 1993* in New York. The controversy of the Biennial was caused by the exhibition's focus on works that dealt with racial and sexual minority cultures, and with a strong political content. Nan Golding's photo-graphic works of her transvestite friends in the nightlife of New York, and the Rodney King amateur video, which showed white uniformed officers from the L.A. police department beating up a black man in the street, were para-digmatic examples of the works and visual artefacts on display in the Biennial,

which grouped together different themes of peripheral minority identities and placed them right at the mainstream centre of the contemporary art world, at the Whitney Museum of American Art. The biennial thus addressed racial themes in art as part of a much broader context concerning minority culture and politics in general, which made sense at the time, since different artistic 'minority' groups, to some extent parallel, had pursued similar goals of artistic recognition since the 70s. Of particular relevance to New Internationalism's struggle for racially and ethnically equal premises in the art world is the struggle of the feminist art movement.

In 1971, Linda Nochlin polemically asked 'Why Have There Been No Great Women Artists?' and started the intense debate on art history's neglect of female artists, which led to feminist art theory and practice.[170] To a large extent the discourse of feminist art theory and New Internationalism have run parallel to and independently of each other in the visual arts field since the 70s – one seeking recognition for women artists, and the other for non-Western artists. In spite of their different agendas, however, they both belong to the overall postmodern paradigmatic concern with minority artists groups, and some of their problems, mechanisms, and strategies are strikingly similar. When the critic Craig Owens, in 1983, noted that women's 'exteriority to Western representation exposes its limits' and that 'Here, we arrive at an apparent crossing of feminist critique of patriarchy and the postmodernist critique of representation', he could have claimed the same for New Internationalism's critique of art institutional discrimination and Western representation.[171] The modes of representation within Western culture and their institutional manifestations are the fundamental problems that unite the different minority groups of race, gender, sexuality, disability, religion, and ethnicity. However, Owens acknowledges that a general alignment between gender and ethnicity is problematic:

> Not only does this forced coalition treat feminism itself as monolithic, thereby suppressing its multiple internal differences (essentialist, culturalist, linguistic, Freudian, anti-Freudian...): it also posits a vast, undifferentiated category, 'Difference', to which all marginalized or oppressed groups can be assimilated.[172]

Ten years later, in 1993, art historian Amelia Jones also stressed the need to consider feminism's own political specificity, instead of just submitting feminism as a *pars pro toto* of a general postmodern critique of representation, which she believes is exactly what Craig Owens ends up doing, and therefore she argues

against the tendency to see different minority struggles in the late 20th century art world from only one theoretical angle.[173] What is, however, of interest in this book, is how the antagonistic strategies of the feminist art movement differ from and coincide with the strategies of New Internationalism in relation to the question of difference, so a closer comparative look will be relevant here.

Both oppose the Western art institutional apparatus that deems both women and non-Western artists to be the art world's 'others', and hence excludes them. And, likewise, both experienced internal struggles between a tendency to invoke a specific artistic practice according to an essential 'otherness' – and seeking institutional acceptance for such practices – on the one hand, and on the other hand, a poststructuralist tendency to dismantle essential otherness. Some of the strategies of the Women's Art Movement in the 70s resemble those of the Black Art Movement, in the sense that both can be characterized as protest movements more than art movements. The Californian part of the Women's Art Movement in particular had a strong educational impulse, in terms of enlightening its members, as well as people on the street, whereas the New York faction attacked the well-established art museums more directly through performances and actions.[174] In the Californian tendency, art was thus used more as a means of communication or liberation, or as a tool of protest for women, than as an end in itself. The participants, who understood themselves as activists working artistically (as opposed to artists or critics working as activists, as in New York) shared some resemblance with the Black Art Movement in their ethical – rather than primarily artistic – goals of fundamental changes to society.

Considered together race, gender, and art constitute an interesting case study of the mechanisms of discursive antagonisms and articulations resulting in a number of different discursive chains of equivalence. For instance, the Women's Art Movement's work for gender equality in the art world easily becomes mixed up with internal racism, as when the artist Betye Saar in 1973 curated the exhibition *Black Mirror* around black women artists, and thereby complicated the discursive simplification in the Women's Art Movement by creating a chain of equivalence between a certain race and a specific gender. The audience who attended the exhibition were primarily of colour, and included both women and men, and Saar expressed her disappointment that 'the white women did not support it. I felt the separatism, even within the context of being in Womenspace.'[175] Generally, the impression seems to be that the Women's Art Movement in the 60s and 70s was dominated by Euro-American leadership that

clearly privileged gender over race, so that the movement's promotion of black female artists turned out to be just as under-represented as in the traditional male art world. As the artist Ana Mendieta put it in 1980:

> During the mid to late sixties as women in the United States politicized themselves and came together in the Feminist Movement with the purpose to end the domination and exploitation by the white male culture, they failed to remember us [non-white women]. American Feminism as it stands is basically a white middle class movement.[176]

From the Women's Art Movement's point of view, female artists of colour, on the other hand, were said to be more shaped by ethnicity than gender in their primary identities, and the content of their work.[177] Whether gender or ethnicity was considered more important, it seems that the non-white women's identities as *artists* were doomed to come in only third in this identity struggle.

Thus, the early Women's Art Movement to some extent shared features with the strategies and goals of the Black Arts movement in two ways, which separated them from New Internationalism: Both aimed to eventually effect ethical changes in the modes of representation in society in general, more than 'just' changes in art institutional modes of representation and both relied on essentially biological givens (race and sex) as their platform of resistance, rather than on cultural affiliations (ethnicity and gender).

Traditionally, feminist art theory has divided feminist art practice into two different groups: One, primarily working in the 70s, focused on the female sex as an essential entity on which their works were based, in a celebration and promotion of women as possessing unique qualities, and in this respect it shared characteristics with the Black Arts Movement as described above. Another group, primarily working in the 80s, focused on the deconstruction of traditional modes of representation in which women are depicted as passive objects of the male gaze. Genealogically, the starting point for this second group was film theorist Laura Mulvey's text 'Visual Pleasure and Narrative Cinema' of 1975, and significant artists are, for instance Cindy Sherman, Barbara Kruger, and the early Hannah Wilke, who all work critically against a stereotypical image of women, by displaying, and hence exposing, such stereotyped imagery from (male) mass culture, rather than agitating positively for a different (female) agenda.[178]

Though the very division of a feminist artistic discourse into two such

different groups has been contested, by art historian Helen Molesworth, for instance, it is useful here because it shows that the antagonistic aims of the second 'critique-of-representation' group is where the feminist discourse and New Internationalism are in agreement.[179] Both are deeply concerned about the modes and mechanisms of representation, and as Osborne and Sandford put it:

> In narrating the move away from the concept of 'race' with its emphasis on immediately perceptible differences (such as 'colour'), to the study of ethnicities, it is tempting to suggest that, in the course of the past three decades of race studies, 'ethnicity' has come to stand to 'race' much as 'gender' stands to 'sex' within Anglo-American feminist theory. In both cases, sociology has been the primary disciplinary means for the new developments.[180]

However, this does not mean that feminist and new international critiques of the art institution are the same, when we disregard the fact that their struggles are concerned with different minority groups in relation to the art world. As described above, they may be grouped under the same label of poststructuralist challenges to the male-dominated art world of standard Western art history; but they also differ from each other when it comes to the domains of their representational critique: Whereas the new international critique is levelled strictly at *art* institutional practices of representation, feminist critique is levelled at a broader field of representation, covering not only the representation of women – literally, as well as discursively – within the art world, but also their representation in popular culture and mass media. From Mulvey's 1975 text addressing cinema, to Amelia Jones' detection of a common ground between feminism and visual culture, the feminist art movement and queer studies have not confined themselves to the sphere of the art world, but have remained concerned with representation and meaning construction of subjectivity in a broader cultural field. As Jones puts it, 'Feminism, in most of its forms, proposes or demands a political and/or ethical stance towards cultural experience.'[181] Though representations in the art world are also a concern of feminism, it is not necessarily the primary nodal point, and this may be the crucial difference between the structure of the feminist discourse and that of New Internationalism.

Art and aesthetics

As pointed out above, the discrimination by Western mainstream art institutions, based on race/ethnicity and sex/gender, led to struggles that were significantly similar with respect to equal premises for institutional representation. Thus, the problems faced by the art ignored by the West were of a broader discursive and political character than the obstacles experienced by individual artists who fell victim to the institutional discrimination. By taking the *Whitney Biennial 1993* as an illustrative point of departure, the following will elaborate on how this broader discursive problem is related to the concept of art. Actually, the *Whitney Biennial 1993,* apart from its focus on minority cultures as described above, demonstrated how the notion of art and aesthetics as such played a significant role in relation to New Internationalism.

To a very large extent the biennial was regarded as valuing 'the political' higher than 'the artistic', which caused intense debates on whether or not this was a positive or negative development in contemporary art. On one side, with art historian Rosalind Krauss and philosopher Arthur C. Danto as the protagonists, critics felt that the political content of the works and the show in its entirety were articulated so explicitly and in such simplified fashion that it happened at the expense of artistic and aesthetic qualities.[182] Krauss complained that the young generation of artists in the show did not acknowledge the modernist struggle to free the work of art from its former illustrative task, and that Homi K. Bhabha's text in the catalogue did not address the works visually – as she put it, 'We have this development in which there is an absolute incapacity to attend to the signifier', and she identifies a tendency where 'the work is imitating models of discourse.'[183] Likewise, Danto's review of the show included a harsh critique of the works on display: 'Its messages rarely rise to, let alone above, a level set by the bumper sticker, the T-shirt, the issue button. The average work here is a one-line zinger.'[184]

On the other side, Benjamin Buchloh was more excited about the expressions in the works because they seemed to reach out to new, different groups of the audience by speaking in a more direct artistic language. The complaints from Krauss and Danto that the works' aesthetic quality was poor raised a crucial issue in relation to New Internationalism, which Buchloh formulated like this: 'This presumed capacity to read the aesthetic experience is not at all universal but is highly overdetermined in terms of class, race, and gender'.[185] In the heat of this discussion in New York, Buchloh rather hostilely but precisely

pinpointed the problem of the art institutional apparatus, when he argued that sometimes the institutions will need to be pushed forward with exhibitions like the *Whitney Biennial 1993*, since they do not move on their own: 'Europeans are a very interesting comparison here – with their holy emphasis on pure criteria of aesthetic quality regardless of race, ethnicity, and class.'[186] Obviously, Buchloh is quite sceptical about the Europeans' 'holy emphasis on pure criteria of aesthetic quality', and his claim goes right to the core of art's definition and limits, which – as we shall see – is the nodal point of New Internationalism.

One of the main issues in New Internationalism was identified as a call for greater focus on *art*, as opposed to anthropology, in relation to non-Western artists. Therefore, New Internationalism needs to be on common ground regarding which concept of art it refers to. This poses a delicate problem, since the very notion of art can be considered in itself a sort of Western imperialism. As the artist, art historian and director of the Center for Art and Media in Karlsruhe Peter Weibel puts it:

> The discourse of colonialism has been repeated and reflected by art in various ways. First of all, art as a discourse is structurally built on the dialectics of differentiation – hence, on strategies of marginalisation and demarcation, and therefore it, in itself, reflects the colonial way of thinking. Secondly, in its ideological subject matter, art is the pure expression of Europe's colonial mentality.[187]

So when New Internationalism asks for a greater focus on art, precisely which kind of art concept does it refer to? In order to identify more thoroughly the relationship between New Internationalism's global perspective and the Western origins of the art institutions' art concept, we need to further investigate the latter, and hence it is necessary to look into the genealogy of the modern Western concept of art in the following.

The concept of art

In Western culture, the modern concept of art is generally recognized as originating in 18th century Germany – more precisely, from Immanuel Kant's philosophy – when, during the Enlightenment, art, like a number of other domains, was philosophically and institutionally singled out as an autonomous discourse that was no longer interwoven with sacred or courtly discourses.[188] Whereas practically this process had developed since the renaissance, it was not until the

end of the 18th century that this differentiation was articulated theoretically, and henceforth consciously constituted.

In his *Critique of Judgement* in 1790, Kant made a number of distinctions, two of which are of relevance at this point: First of all, the distinction between natural and artificially made objects, art; and second the distinction between art with a purpose (functionally or representationally) and art without purpose (pure improvisation or decoration).[189] It is this last concept of art without purpose – and hence autonomous – that has been institutionally cemented as the modern Western definition of 'fine art', or commonly just 'art', as opposed to 'applied art', 'design', or 'craft'. This notion of art *as such* also covers art forms other than the visual arts – poetry, theatre, music – but commonly, the word 'art', in addition to meaning fine art as such, is also used synonymously to mean 'visual art'. Thus, visual art (along with, for instance, music) belongs to art. It is important to distinguish between these two different levels, and to acknowledge that the autonomous character of art as such does not imply that the singular work of art cannot engage in political or social realities.

Since Kant primarily considered *nature* to be capable of evoking aesthetic relations, the distinction between art and nature means that art and aesthetics, too, are different concepts. Aesthetic relations may derive from encounters with nature or art, but there is no *guarantee* that works of art will evoke aesthetic relations. The reason for this fundamental incompatibility between the encounter with art and nature is that a *pure* aesthetic judgement can only be passed on objects that possess finality without representation of a specific end – that is nature.

Kant does in fact unite nature and art through his notion of genius. According to Kant, the genius is capable of creating artificial objects that do not possess a specific end – that is art – because the genius has a special connection to nature. Nature speaks through the genius without letting the genius understand the purpose of or any objective rules behind the work of art that the genius itself creates.[190] Hence, the genius is rendered an empty developer of objects that, though made artificially by a human being, belong to nature. As opposed to the genius itself, the works of art created by the genius possess the principles of their own natural beauty, which, therefore, can be receptively *sensed* – not rationally understood – by the receiver or viewer contemplating the works, and thus may inspire other geniuses.

With Kant's introduction of the genius, art is displaced from being human-made, and therefore possessing a purpose with a specific end – that is, an outer,

descriptive definition – to being a question of what inner qualities the work possesses – that is, an inner, normative definition. This tendency to merge a descriptive definition of art and an evaluative aesthetic judgement was further strengthened (with Novalis and Friedrich Schlegel) in what philosopher Jean-Marie Schaeffer calls the 'speculative theory of art', where art is understood as something particularly valuable in itself, and thus gains a very privileged position.[191] What is of relevance here is not how different periods during the 19th and the beginning of the 20th century held different opinions as to *what* true art was, and what qualities it was supposed to possess, but rather *that* art was defined normatively as possessing inner qualities, and that this German romantic understanding of art claimed to be universal.

Professor of aesthetics Morten Kyndrup describes this merging of art and aesthetics as a marriage, which eventually, in the second half of the 20th century came to a divorce.[192] A significant role in this divorce was played by the emerging of institutional art theory, to which Arthur C. Danto made an important contribution during his search for a new theory of art consistent with contemporary works of art. In 1964, Danto came to the conclusion that what defines an object as a work of art is not related to particular properties of the object itself. Instead, he wrote, 'To see something as art requires something the eye cannot decry – an atmosphere of artistic theory, a knowledge of the history of art: an art world.'[193] Accordingly, the art institutional apparatus alone has the power to designate an object status as art, through the use of a defining 'is': *This is art*. The philosopher George Dickie has analysed this aspect of the art world still further, from 1969 onwards, and in his 1984 book, *The Art Circle*, he arrived at the institutional theory of art proper, which is based on a completely value-neutral concept of art.[194] Whereas Danto initiates the institution theory by asking philosophically puzzling questions – like 'How are we to define art, when there is no visual way to distinguish between Andy Warhol's Brillo box, which is recognized as a work of art, and the Brillo box in the supermarket, which is not?' – Dickie thus elaborated on these philosophical questions and turned them into functional theory, where once again *art is separated from aesthetic and evaluative relations*, as originally described by Kant, prior to the notion of the genius.[195]

Fundamentally, the shift from a romantic theory of art to an institutional theory alters the definition of art from being a question of creative *origin* to one of institutional *reception*, and this is what makes institutional art theory relevant to New Internationalism. Institutional art theory supports New Inter-

nationalism's claim that in reality the problem with non-Western art not being fully accepted by Western art institutions is not related to the works of art, but to the institutional apparatus which defines art. As art historian Douglas Crimp has pointed out, with reference to Marcel Broodthaers's artistic strategy, an institutional separation of the studio and the museum developed during the 19th century, and: '[T]he function of the art museum (and of the artist working within its discursive authority) is to declare, in regard to each of the objects housed there, "This is a work of art."'[196]

According to Dickie, the institutional theory of art requires creation and acceptance: that an artist, recognized by the art world as such, creates an object or phenomenon intended as art, and that this object/phenomenon is accepted as art by the art world.[197] In reality, however, reception – the institutional acceptance of a work – has proven to be most important, since art museums may collect and exhibit historical, anonymous objects that may not have been intended as art (recollect the example of a car-shaped funeral coffin from Ghana being presented as a work of art in *Magiciens de la terre*).

To sum up, the institutional theory of art implies that all objects, regardless of their geographical or cultural origin, can, *in principle*, be admitted into the art institution as works of art. Thus, the descriptive character of the institutional theory of art is in accordance with, and highly relevant to New Internationalism's goal that geographical or ethnic discrimination in art institutions should be dismantled.

Habitual institutional management

Obviously, however, institutional art *theory* does not in itself solve the problem in *actuality*. The fact that anything, in principle, can become art does not mean that anything *is* art. The reason that we do not treat the products of people who cultivate art as a hobby within the discursive formation of fine art is that the art value (artistic as well as financial) is ascribed by an institutional habitus, founded on a gradual entrance into the art world. Sociologist Pierre Bourdieu describes the mechanism with reference to a publisher:

> He contributes to 'making' the value of the author he supports by the sole fact of bringing him or her into a known and renowned existence, so that the author is assured of publication [...] By this means, the author is drawn into the cycle of consecration and is introduced into more and more select company and into more

and more rare and exotic places (for example, in the case of a painter, group exhibi-
tions, one-person exhibitions, prestigious collections, museums).[198]

Only if the established and recognized gallery owner or critic accepts an un-
known amateur artist and welcomes him/her into the official institutional
framework does the product of the amateur gain the status of 'work of art' and
start being considered in accordance with the discursive premises of the art
world, where it is legitimate to discuss, for instance, to which artistic traditions
the work relates. Or whether it is likely to fetch a good price in the art market.
Thus, even within the framework of the descriptive, institutional theory of art,
taste and preferences are still *de facto* involved in the art world's actual *manage-
ment* of institutional art theory. Therefore, it is this habitual management and
its inclusion-exclusion mechanisms that New Internationalism antagonizes,
and not institutional art theory as such, which constitutes a supportive ally.

The question for New Internationalism, then, is how can this discrimina-
tive institutional management of a sympathetic art theory be overcome? One
solution would be to ignore the notion of art, and focus instead on a much
broader field of cultural practices and aesthetics, but that is not in the interest
of New Internationalism, for two reasons: First of all, the discourse is defined
as a visual arts discourse – and therefore belongs to the domain of art – due to
the specific circumstances and needs in this field. For instance, already in the
70s, the institutional apparatuses of film and music had international profiles
much broader than the visual arts institutions, and it is therefore important
to New Internationalism to focus *specifically* on the visual arts domain. And
second, the reason it insists on being a discourse of art, rather than spilling into
a broader domain of cultural analysis like cultural or postcolonial studies, is that
it wants to avoid becoming a field of area studies or, even worse, ethnography,
which would tend to stress differences, and hence different evaluative systems,
the double standards that it actually seeks to challenge.

Therefore, New Internationalism fights from within the system, from within
the framework of Western art institutions, where it seeks to put an end to
the remains of the idea of the artist-genius that still haunts exhibitions of
contemporary art. The disagreement between Rosalind Krauss and Benjamin
Buchloh regarding the *Whitney Biennial 1993* has already been mentioned with
reference to Buchloh's critique of the romantic idea of a 'pure' aesthetic and its
European origin. An important point made by Edward Said in *Orientalism* is
that there is no such thing as 'pure' knowledge – all knowledge can somehow

be considered politically motivated.[199] Likewise, and in spite of Kant's notion of 'pure' aesthetic relations, there is also no such thing as 'pure' aesthetics, as Bourdieu has pointed out.[200] Thus, Western research into the aesthetics of non-Western cultures is, like any kind of research, based on political interests. A lucid example is offered by Annie E. Coombes in her analysis of the case of the 'Benin Bronzes' – three hundred cast brass plaques from Benin, put on display by the British Museum in 1897, and admired for their impressively naturalistic detail, carried out with great technical skill. Coombes considers it probable that the recognition, in 1899, by ethnographic curators in the British Museum that the 'Benin bronzes' could in fact be ascribed to a (hitherto unknown) African aesthetic – in spite of the prevalent assumption that African culture was in general deprived and savage – was driven by a wish among the curators to foreground the importance of the discipline of ethnography as such, and attract more funding to the ethnographic department of the British Museum.[201]

New Internationalism is in agreement with Buchloh's position that normative taste within the art institution is contextually constructed. This does not entail, however, that New Internationalism identifies with the *political* character of the *Whitney Biennial 1993*. The institutional interest in minority cultures, for instance at the biennial, marked a tendency to consider the works as direct reflections of the artist's person – to use the words of Donald Preziosi, who has investigated art historical modes of interpreting Vincent Van Gogh, this interest was not just an interest in 'the-man-and-his-work' but an interest in 'the-man-as-his-work'.[202] Professor of German literature Jochen Schulte-Sasse has described this mechanism accordingly:

> The interest in the artist's personality displaces the interest in art to the dimension of interpersonal relations. Since what counts is the desire of the individual to overcome self-alienation (...), a need emerges for an identification of/with a supposedly unscathed, whole, unified, and reconciled personality.[203]

In 1990, the artist Adrian Piper predicted this upcoming focus on minority identities in the art world and – even though (or perhaps because) she is a black woman – she expressed reservations about it:

> Because racism and sexism often go together, amelioration of both together can be achieved by showcasing the work of CWAs [Coloured Women Artists]. I am

encouraged by this recent development, but I am also suspicious of its long-term significance. It coincides too neatly with an interest in difference and otherness in other fields such as comparative literature, history, and anthropology, *in which the main subject of investigation is the person, not the artifact.* [...] And in an area as ill-equipped to investigate social relations as the art world, this means imposing only slightly more sophisticated racial and gender stereotypes rather than looking at art.[204]

The assumption that the artist *personally* is the channel or source of a special Kantian sensibility – be it of beauty or politics – was also touched upon and indirectly discussed by the artist Barbara Kruger, when she participated in *Magiciens de la terre* with a text-work for the exhibition and the catalogue, which asked in big letters: 'Who are the magicians of the earth?'[205] Below, Kruger listed 28 possible answers: 'Doctors? Politicians? Plumbers? Writers? Arms Merchants? Farmers? Movie Stars? Accountants? Artists? Secretaries? Soldiers? Tribal Chieftains? Beauticians? Priests?...' By listing 'artists' among a number of different identity taxonomies (occupational, educational, social, civil etc.), Kruger seemed to question the curatorial assumption of *Magiciens de la terre* that artists on a personal level are geniuses who possess a magical power to create works of sacred character.

Whereas Kruger's work comments artistically on the presence of the romantic genius idea in the institution of contemporary art, Rasheed Araeen has more directly criticized the institutional confusion between art as a professional practice – which, therefore, needs professional institutional management – and the artist-subject who may or may not belong to a minority group. For instance, according to Araeen, it was a common practice of the British Arts Council in the 80s to appoint coloured people to positions in minority art programmes regardless of their formal qualifications:

> Imagine that an oppressed person, who is never involved in art and has no knowledge of art and its history, who cannot even differentiate one picture from another on the basis of their visual qualities let alone their historical formations and significances, is put in charge of the art section of an important institution. [...] This is exactly what happened at the GLC [Greater London Council] ... It did not understand that art was a specific discipline [...] and that you could not treat the work of a committed professional artist in the same way you looked at drawings by children.[206]

As this quote illustrates, the problem is once again that the-man-and-his-work (work here in the sense of job) is mistaken for the-man-as-his-work. Furthermore, the quote demonstrates that the notion of art functions as the very nodal point in the discursive formation of New Internationalism. It is the institutional recognition of non-Western contemporary art *as art*, in accordance with institutional art theory – not as romantic wonders or culture or aesthetics or politics – that constitutes the core of the antagonism.

Thus, it is a fact that New Internationalism is specifically concerned with recognition of contemporary art regardless of the artists' origin – the antagonism is not aimed at recognition of certain *cultures* as interesting or of certain artists as nice *individuals* – and that art and institutional recognition of *artists* and *artistic practices and modernities* are crucial. Simultaneously, however, it is a curious fact that by promoting emphasis on art, artists and artistic practice as the weapon against the 'West = modernity' trope governing art institutional practice, New Internationalism implicitly subscribes to the very system that it aims to dismantle, since those notions praised by New Internationalism stem directly from Western philosophy, as we have seen. Thus, the idea of 'artistic modernities' (in plural) that is promoted by New Internationalism is ambiguous insofar as 'artistic' is comprehended in accordance with Kantian thoughts on man-made sensuous creation, which has governed traditional Western art theory and art history, whereas the insistence on 'modernities' explicitly confronts the 'West = modernity' trope (which arose from a Eurocentric paradigm) in order to depart from that very Western tradition. In this respect New Internationalism seems theoretically speaking to rest on shaky ground.

New international influences

So far we have seen how New Internationalism was articulated from the 70s up until 1994, when it reached a significant institutional manifestation through the establishment of InIVA. The main interest of equal premises in visual *art* has been accounted for, along with its institutional genealogy, and its position compared to related fields such as postcolonial theory, the Black Art Movement and feminist art theory. Since this book sets out to analyse *how, to what extent*, and *on what premises* New Internationalism has succeeded in realizing its own interest, the following chapters will investigate how the discourse has developed since 1994. This chapter will therefore investigate the development of New Internationalism through its manifestations in three different areas: Localism, Visual Culture, and Urbanism.

Localism

In the 90s, the articulation and manifestation of New Internationalism had as their result an increased awareness of the need for the art institutional apparatus in general to respond to the discourse, and a number of the institutions responded to some extent with a sort of localism. Specifically, this meant that initiatives were launched that focused on non-Western contemporary art, but did so by framing the art according to local cultural confines, which meant that a number of art exhibitions included terms like 'African' or 'China' in their titles. For instance, in the 90s the Guggenheim Museum in New York presented *Japanese Art after 1945: Scream against the Sky* (1995), *Africa: The Art of a Continent* (1996), *In/sight: African photographers, 1940 to the present* (1996) and *China: 5000 years* (1998).

New Internationalism has meant that art museums in general feel a pressure and a need to broaden or 'globalize' their perspective. As a specific result,

the Guggenheim Museum announced in January 2006 'the appointment of Alexandra Munroe as the Guggenheim's first Senior Curator of Asian Art.'[207] The purpose of establishing this new position was to

> [A]llow the Guggenheim to expand its holdings in modern and contemporary Asian art [...and...] steer the Guggenheim's Asian art activities [...] Thus, the creation of a new curatorial position devoted to Asian art is a natural next step in the Guggenheim's global art program.[208]

Undoubtedly this was an acknowledgement of contemporary art's broadened geographical scope in general, and a sign of 'America's readiness to recalibrate its cultural compass toward the Pacific' in particular, as Munroe herself stated.[209] Simultaneously, however, the creation of this curatorial position was hardly in accordance with the intentions of New Internationalism, since it suggests that art from Asia differs essentially from contemporary art in general, and therefore should receive special attention, just as the examples from the Metropolitan Museum of Art's and the British Library's split between 'Asia' on the one side and 'Modern', 'Humanities', Science' etc. on the other suggest, as described in chapter 2.

The problem, considered from a new international perspective, is not that the Guggenheim's new curatorial position will lead to a greater focus on Asian art within the Guggenheim, but rather that it frames Asian art in a way that tends to consider the artistic aspect less relevant than the Asian-ness of the works, and hence approaches them as ethnographic objects rather than works of art. As Guggenheim director Lisa Dennison states: 'The point is really the integration of Asian art and *culture* into all of our core activities', and according to Munroe, the reason for the Guggenheim to incorporate the Asian angle in all its activities is 'not an act of political correctness. It's an act of historical correctness' due to the fact that 'there is a great sense that the West has ignored or dismissed their activities [the Asian artists'].'[210] Following a new international logic, however, Asian art, like art from any other part of the globe, should be included on equal terms as the rest of the works in Guggenheim's collection, as an act of what we may call 'artistic' rather than 'historical' correctness.

The Guggenheim did in fact recognize contemporary art from Asia, as art, prior to the establishment of the new curatorial position. Their collection includes works by several major artists from Asia, and ten finalists from Asia have been nominated for the Guggenheim-administered, prestigious *Hugo*

Boss prize, out of the eight times the prize has been awarded so far.[211] Hence, contemporary art from Asia has been given recognition by Guggenheim in the past, but now the museum seems to aim at a broader cultural, or anthropological, framing of contemporary art from this region.

In reality it does make sense to establish a curatorial division with expert knowledge of contemporary art from Asia, just as we would expect an enterprise like the Guggenheim to employ experts on contemporary art from other parts of the world – including Europe and North America. In this respect the initiative is in accordance with the intention of New Internationalism. What is disturbing, however, from a new international point of view, is that contemporary art from Asia seems to be understood as closely linked to Asian *culture*.

Apart from the museums, national arts councils promote contemporary art as illustrative of national or regional qualities. Institutions like the Goethe-Institut, Japan Foundation, British Council etc. have as their primary goal the promotion of national culture; and though these institutes often promote artists that have international art careers in their own right – for instance, Candida Höfer, Ryoji Ikeda, and Tracey Emin – the framing of these artists and their work as 'national culture' seems out of touch with the global reality of contemporary art today.

As professor of comparative literature Jonathan Culler has demonstrated in his analysis of different phenomena, such as 'tourism', 'the legal system', or 'rubbish', framing is crucial – it is contextual framing that ascribes significance to things, and renders a building worthy of preservation or condemns it to demolition, or makes an act legal or illegal.[212] Likewise, the institutional framing of a work of art is essential, as a comparison of two different works from the collection of the Metropolitan Museum of Art may illustrate:

3. Henry Ravell: "A Church Dome a Cuernavaca", Mexico, 1910s, photograph. Metropolitan Museum of Art, Department of "Photography".

4. Sidney Nichols Shurcliff: "Ceremonial house in Kanganaman village, Sepik River, Papua New Guinea, May 15 1929", photograph. Metropolitan Museum of Art, "Arts of Africa, Oceania, and the Americas".

The two pictures share a number of similarities: Both photographers are American, both pictures are from the first half of the 20th century, and even the subjects have something in common (buildings of religious worship in a foreign country). However, they are interpreted dramatically differently, as we find Ravell's picture in the department of 'Photographs' and Shurcliff's in 'Arts of Africa, Oceania, and the Americas'. Exhibited among wooden masks, clay sculptures and golden jewellery, the latter is rendered completely transparent as an image and the attention as well as interest of the audience automatically turn to the specific motif, the house of worship, as a cultural object of ethnography – as evidence of a specific local culture. Thus, by aligning Shurcliff with ethnographic objects, the museum prepares the ground for cultural criteria – in their broadest sense – of judgement and valuation of the object. Conversely, Ravell's picture is aligned with photographs by Alfred Stieglitz, Man Ray, and Cindy Sherman, in the department of 'Photographs', which renders it not only a picture resulting from a specific technique, but also a work of art, and hence attracts a much higher level of formal and poetic attention on the part of the viewers than does Shurcliff's photograph. An even more manifestly anthropological approach to non-Western contemporary art has emerged in ethnographic museums in recent years, which will be investigated in the following section.

Contemporary art in ethnographic museums

During the Enlightenment, the Renaissance collections of valuables – the so-called cabinets of curiosity, or *Wunderkammern* – were divided into different museum types, such as natural science museums, art galleries, and museums of cultural history. According to Tony Bennett, this traditional division between art museums, on the one hand, and museums of cultural history, often called National Museums, on the other, has prompted two different views of museum objects: Whereas the objects in the art museum, like those in the cabinet of curiosity, 'are valued for their uniqueness, and [...] therefore, no object can stand in for another', the condition for science museums and museums of cultural knowledge is, 'that the object displayed is viewed as representative of other objects falling within the same class'.[213] The view on the object in art museums as unique has helped to sustain the idea of art's autonomy, whether this autonomy is believed to be a result of a work's inner, essential truth or a result of institutional designation.[214]

However, Philip Fisher has argued that the pedagogic aspirations of modern art museums mean that to a certain degree the work of art is considered just as illustrative as objects in other kinds of museums, since the works are merely seen as representatives of different schools, styles, and periods.[215] As one stone axe or one bamboo mat may be replaced by others in a display at the museum of cultural history, one impressionist painting or one piece of conceptual art from the late 60s may be replaced by others, in order to represent styles and tendencies, at the art museum, since they are only meant to illustrate what can never in itself be present in the exhibition: the idea of one coherent history of art, which, recollecting Elkins' *Stories of Art*, is a solely Western idea.

Viewed from the perspective of New Internationalism, the institutional consideration of the individual work of art as unique is clearly preferable, since it meets the demand for greater focus on artistic practice, as opposed to the focus on standard art history as such, which was part of the initial discriminative problem. The conception of works of art as illustrative stand-ins for an absent 'history of art' is questionable, since this history of art tends to exclude and/or discriminate against non-Western art. As Peter Weibel has phrased it,

> Therefore, our 'Art Museums' are filled with Western products of art, whereas for the art of other civilizations we have built so-called 'Cultural Centres'. The Eurocentric mechanisms of exclusion are symptomatically expressed in this separation. The separation between 'art museum' and 'ethnographic museum' marks exactly the borderline between inclusion and exclusion.[216]

The recent museological tendency to exhibit non-Western, contemporary art in anthropological museums is, therefore, disturbing, considered from a new international point of view.

The Tropenmuseum in Amsterdam, in its own words, 'one of Europe's leading ethnographic museums', may serve as an example of this tendency.[217] Mirjam Shatanawi, curator at the Tropenmuseum, sees

> [A] larger trend in which art museums are becoming more like ethnographic museums and vice versa [...] The Tropenmuseum now presents artwork [sic] from all times and places and regularly features exhibitions that take a critical stance toward ethnography, colonialism, and the museum's own history.[218]

For instance, among the so-called 'Highlights' from the Tropenmuseum's African department is a piece from 2003, by Conçalo Mabunda, who is a recognized artist from Mozambique; and in 2002, the British Museum acquired Kester Maputo's *Throne of Weapons* (2001).[219]

This new trend of ethnographic museums collecting and exhibiting contemporary art as attestation of certain local cultures is problematic from the perspective of New Internationalism, because it frames the artists and their works as cultural others, rather than recognizing them as artists in their own right, since non-Western contemporary art is exhibited in museums of cultural history to illustrate not art, but 'non-Western-ness' as such. This displacement of the framework of reception from an artistic context to an anthropological one is not to be confused with the tendency within contemporary art itself, as we shall see in the final chapter, to reflect on and become involved with political or social realities in a broader cultural field.

Shatanawi describes how in 2006 she curated a show of works by visual artist Khosrow Hassanzadeh from Iran, which was criticized by the audience for being less informative about Iran, and more visual than expected. As Shantanawi herself reflects on the exhibition: 'its location in an institution with a history of alienation certainly didn't help. It also didn't help that the museum's PR department named the show "Inside Iran".'[220] Whereas, principally, museums of fine art invite their audiences to experiences of aesthetic pleasure, and the anthropological museum invites its audience to learn about cultures, in effect, the actual displays and exhibitions often work as combinations of the two. As has been demonstrated by now, art museums more or less indirectly articulate issues of cultural difference, and as Annie E. Coombes has shown,

> When public ethnographic collections were established [...] their effectivity operated on a number of competing levels [...] promoting the material in the collection simultaneously as fodder for [...] scientific and comparative study of culture [...] but also in their capacity as objects of aesthetic pleasure, exotic delectation, and spectacle.[221]

So New Internationalism's revelation and challenge of the *ideological* cultural agenda of Western art history in the museums would eventually matter little, if the problem remains naturalized in, or even is displaced to, museums of anthropology. This is why, considered from the perspective of New Internationalism,

the recent tendency of anthropological museums to collect and display works of art as contemporary evidence of non-Western cultures poses a problem.

Therefore, the institutional tendency to localism – an emphasis on local origins, regarding contemporary art – only constitutes a part of New Internationalism, insofar as this localism *attempts* to meet the challenges presented by the New International interest. But the institutional responses, such as the ones described above, partly miss the target: They *do* look beyond the confines of Western culture, and they *do* recognize alternative modernities. However, it is not recognition of alternative *artistic* modernities, but of *cultural* modernities, which may then be illustrated by works of art from the regions in question. Consequently, this kind of localism is not in accordance with the discourse's nodal point of art.

Visual culture

The field of visual culture interestingly appears to correspond to the new-international demands from the beginning of the 1990s, in the respect that it, too, represents a challenge to traditional art history. When visual culture emerged as an academic field in the mid-1990s, it formed a very heterogeneous landscape, and researchers are still not in agreement about what the discipline is, or what it should be.[222] However, a very broad formulation of the potentials of visual culture, which might serve to characterize it, is offered by visual culture theorist Nicholas Mirzoeff when he writes, with a reference to Martin Heidegger's notion of a 'world picture', that: 'Visual culture does not depend on pictures but on the modern tendency to picture or visualize existence.'[223]

The borders between text and image, between theory and work of art or any other visual phenomenon, between method and object of analysis, are blurred in the field of visual culture, and, as we have seen, Nikos Papastergiadis described InIVA as an institution that defined its aims in an ambiguous way – simultaneously by its institutional framework *and* by the artistic activities within this framework. Metaphorically speaking, it is, therefore, not always possible to distinguish between figure and ground, and in this respect there are similarities between New Internationalism and visual culture.

The fact that the field of visual culture is not confined to the visual adds to this methodologically complex situation. According to Mirzoeff: 'visualizing does not replace linguistic discourse but makes it more comprehensible, quicker and more effective.'[224] The domain of visual culture is thus much broader than

the term 'visual' suggests, and as professor of cultural studies Ella Shohat and professor of cinema studies Robert Stam state: 'It is not now a question of replacing the blindnesses of the "linguistic turn" with the "new" blindnesses of the "visual turn".'[225] What is instead the point in visual culture is, roughly, the idea that there is no single point and no clear definition of what we could gain from it. The ways and methods in this field seem as many as the questions one can ask regarding meanings in culture.

Apart from the fact that visual culture represents an alternative to traditional art history, and that it is a heterogeneous field with different players pursuing different aims, it is this disciplinary uncertainty and heterogeneity of visual culture that renders it relevant to New Internationalism, insofar as this, too, is methodologically complex. The similarity between the two fields thus fundamentally exists at a methodological level: in the deconstruction of, and turning away from defined scientific methods that distance themselves from the object of study, because these methods tend to present themselves as objectifying tools, whereas they actually emerge from certain cultural and theoretical beliefs. The comparison of a statement by Hou Hanru on New Internationalism with one by professor of visual culture Irit Rogoff on visual culture shows the similarity in approach of these fields. Hou Hanru:

> 'New Internationalism' should not become a new 'ism' but, on the contrary, a process of 'de-ismisation'. It can be compared to the scientific concept of "entropy": when a stable order of matter enters a period of disintegration, towards a total chaos, it reaches the limit of its own development.[226]

And Irit Rogoff about the establishment of the Department of Visual Cultures at Goldsmith's College, London:

> We wanted a praxis that would not define the possible in advance, which all together did not operate within limited definitions. Instead, we wanted to find out what was possible as we advanced. As a result of that we now have a kind of 'unlimited field' instead of a discipline. Instead of discussing whether what we do is 'intra-disciplinary', 'cross-disciplinary', 'inter-disciplinary' or 'trans-disciplinary', then what we do is 'un-disciplinary'.[227]

The dissolving of a clear border between work or object on the one hand, and method or optics on the other, which may be detected in both New Internationalism and visual culture, is what makes these fields relevant to one another.

One example would be Rogoff's book, *Terra Infirma: geography's visual culture*, in which she reverses the traditional optics, and reads the general concepts of 'geography' and 'global space' through visual culture – through art works, advertisements, documentary photographs, objects, and other 'texts'. These texts are partly read as producing time and space as meaningful navigational tools for the viewer, instead of being read through a pre-existing cultural model, such as, for instance, 'modernism' or 'postmodernism'. This approach allows Rogoff to use phenomena in visual culture as her starting point, such as when she investigates the meaning created by the Immigration Museum on Ellis Island in New York. The concrete visual displays of suitcases, and old photographs showing European immigrants from the nineteenth century, in addition to the 'self-museumification' of the preserved ruins of the site, are the very texts that create a certain meaning:

> In part this display of ruined rooms artfully arranged behind large plate-glass sheets makes it very clear that the classic notion of migration within US culture is writ European. Once the United States can no longer provide refuge and improved circumstances to those coming from the 'mother' cultures of Europe, then the entire project shifts – as do the populations of migrants, now arriving primarily from South East and East Asia, from Latin America – from a euphoric narrative of new beginnings to a completely opposite one of misery, cultural incomprehension and extreme foreignness.[228]

Of course the works, artefacts, or texts do not generate a certain meaning just by themselves – in the end, meaning is created in the domain of the viewer, or as Rogoff puts it, in: 'the subjectivities of identification or desire or abjection from which we view and by which we inform what we view.'[229] The question is, to what extent is the viewer willing to make room for the texts to interact with his or her subjectivities?

Added to the sceptical view of methodology, this emphasis on actual engagement with the texts/works, rather than just fitting them into established theories, is a strategy common to both the visual culture studies (as represented by Rogoff) and New Internationalism, with its emphasis on artistic *practice* and theory. Thus, according to Rasheed Araeen, one of the problems in the

1990s was that 'This [obsession with cultural difference] has produced a problem for the critical assessment of works of art'.[230] New Internationalism's urge to look at the works without judging them according to anthropological or sociological presumptions thus seems to uphold a strong connection between New Internationalism and visual culture that also (in most of its formulations) privileges the work/image/text over theory/method.

At this point it may seem as if visual culture and New Internationalism are really two of a kind, and the fields do have essential views in common, but again, as in case of localism, the critical dividing point between New Internationalism and visual culture is the former's insistence on art, insofar as art does not hold any privileged position within visual culture. On the contrary, scholars of visual culture – many of them trained art historians who perhaps grew tired of the sacred aura surrounding art – are eager to investigate visual expressions of popular culture. Professor of literature and art history W.T.J. Mitchell's research on visual presentations of dinosaurs, from science presentations to children's bed linen, is a prime example.[231]

Thus, when works of art are investigated *as* visual culture, they are in principle aligned with anything else that is considered visual culture. Accordingly, the works of art are not viewed as belonging specifically to the overall concept of art, and therefore cannot claim any specific autonomous status. In other words: a 'work of art' is transformed into an 'image' that may generate cultural signification, when it is considered as visual culture. Hence, in spite of their similarities, New Internationalism's insistence on equal inclusion/exclusion criteria for *art* (regardless of its cultural origin) as a nodal point of the discourse is what separates it from visual culture.

Urbanism

The previous two sections have analysed how New Internationalism has partly intertwined with the tendency of localism and the discipline of visual culture, during the 90s and at the beginning of the 21st century. What significantly prevents both of these phenomena from being full-blooded moments in the new international process of articulation is that neither of them commit to the discourse's nodal point of art. Let me anticipate one of the conclusions of the following by disclosing that this is also the case with the tendency of urbanism. However, this tendency meets some of the intentions of New Internationalism in significant ways that are interesting to analyze.

In general, urbanism means the study of cities or a way of living in an urban culture. In the following, however, it is used as a name for the tendency within art institutions to present exhibitions that focus on the heavy development of cities around the globe – a development that professor of sociology Saskia Sassen has termed *The Global City*.[232] Examples of this tendency are the exhibitions *Cities on the Move* (several venues in Europe and Asia 1997-99), *Century City* (Tate Modern in London 2001), and *Global Cities* (Tate Modern, 2007).

Cities on the Move focused on the rapid growth of selected Asian cities, and according to the curators, Hou Hanru and Hans Ulrich Obrist,

> The exhibition endeavours to shed some light on the incredibly dynamic architecture and art scenes of these cities which are mostly unknown in Europe, and will try to introduce to visitors more than a hundred different positions and points of view. Recurrent themes are Density, Growth, Complexity, Connectivity, Speed, Traffic, Dislocation, Migration, Homelessness and Ecology.[233]

As this quote testifies, it was not really a matter of exhibiting particular works of art, but of exhibiting dynamic urbanism as such, which includes art among other phenomena. In order to do so, the exhibition mixed art and visual culture into one huge exhibition-installation that was designed to resemble the cacophonic urban nerve of city life. Works of art, architectural presentations, backdrop artefacts, and posters with background information on the cities were combined in a way that made it difficult to distinguish where one taxonomy ended and another began.

A heterogeneous installation principle also governed *Century City*, at the Tate Modern. In fact, this exhibition comprised nine different sub-exhibitions, each with a different curator, and each covering one city in one period of the 20th century.[234] Interestingly, to a large extent this concept met the quest of New Internationalism in recognizing artistic modernity whenever and, especially, *wherever* it appears, as the separate sub-sections of Century City were: Bombay/Mumbai 1992-2001, Lagos 1955-70, London 1990-2001, Moscow 1916-30, New York 1969-74, Paris 1905-15, Rio de Janeiro 1955-69, Tokyo 1969-73, Vienna 1908-18. As this listing suggests, the overall exhibition was not presented chronologically, nor did it attempt to give one coherent picture of urban modernity. As one of the curators, Iwona Blazwick, stated: 'Seeing that there are many modernisms was part of our project.'[235] By speaking of 'modernisms' and not 'modernities', however, Blazwick seems to make use of

the conceptual framework of standard art history – in which modernism has its specific place in the pre-modern, modern, postmodern narrative – in the curatorial understanding of such different artistic modernities.

Century City played a significant defining role for the Tate Modern, since this was the museum's first major loan exhibition, and therefore pointed the way for the institution's future profile. When asked why the Tate Modern chose to start out with *Century City*, the director at the time, Lars Nittve, gave as one of the reasons that 'it is very important for future programs to indicate that we are not a museum that equates internationalism with the NATO Alliance. We go beyond that.'[236] From this commitment to go beyond traditional Western boundaries – and from the fact that each section was organized by different curators – it followed that the understanding of what was artistically interesting differed from section to section. Whereas some sections focused strictly on the visual art of the city and period, others combined visual art with music, literature, visual culture in general, documentary text, and maps.[237] The sections that were arranged according to this latter principle obviously conveyed a heterogeneous impression to the audience, but the fact that this principle only applied to some of the sections, while others followed the idea of autonomous art in their presentations of the works, rendered the exhibition as a whole heterogeneous. In her review of the exhibition, Eleanor Heartney commented on this, stating that '"Century City" seemed crafted to obliterate the possibility of any canonical structure. Instead, it proposed to open up for discussion a set of new territories, both procedural and substantive.'[238]

Whereas the Tate Modern reviewed some of the dynamic urban centres of the 20th century with *Century City*, the museum presented cities of future significance in the 21st century with the exhibition *Global Cities* in 2007.[239] This time, one curatorial team organized the whole exhibition, which consisted of five main sections: 'Size', 'Speed', 'Form', 'Density', and 'Diversity' plus commissions by six groups of artists/architects who worked on local projects, which were displayed in a different part of the museum. Ten different cities around the globe were explored in the five main themes, but not all ten appeared in every theme.[240] For instance, 'Size' included Tokyo, Mexico City, and São Paulo; while 'Density' included Mexico City, Cairo, London, and Mumbai. Furthermore, the exhibition followed the same heterogeneous curatorial principle as *Cities on the Move*, and accordingly it was difficult to establish one common frame of reference.

A great deal of statistical information added to the heterogeneity of the

show. Symptomatically, the first sentence in the introduction of the exhibition's leaflet (formed as a newspaper) reads 'More than 50 % of us now live in cities and, according to the United Nations, this number is set to rise to 75 % by 2050.'[241] In the exhibition itself, figures and diagrams were also extensively present, but they appeared as fragments of information, and did not constitute a common frame of reference. For instance, in the 'Speed' section, we learn that 60 % of Cairo's residents 'live in unlicensed housing, some up to 14 storeys high', and that in Los Angeles 'Only 10 % of the city is allocated green open spaces'.[242] However, we are informed neither of the percentage of the Los Angeles population living in unlicensed housing – and how tall this housing may be – nor of how much of Cairo is allocated green open spaces.

Figures and diagrams are not commonly on display in art museums, as they mostly belong to the domains of science and economics, where they are associated with the status of hard evidence – at least to an outside party. Hence, their presence in an art gallery is likely to result in a certain level of frustration when they are incomparable. One could almost say that their presence was artistic, insofar as their incommensurability eventually added a certain degree of confusion to the show. Even when the figures for the same reference were mentioned in relation to all cities in one thematic category, it was not always obvious what was to be gained from that piece of information, as this excerpt may illustrate: 'London is the 360th fastest-growing city in the world, adding only 2.3 new residents an hour (less than one-tenth of Shanghai's rate).'[243]

Though the purpose of the inclusion of statistical documentation may not always be obvious, it may work as intended, insofar as it does help to dismantle some of the excluding barriers of the museum walls by referring to global realities of the world. As the examples above demonstrate, the ideal of these exhibitions of urbanism is, seemingly, to distance themselves from the contemplative atmosphere of modern museum galleries, the white cube, and instead offer the audience a sense of urbanism through the *staging* of the artefacts on display, as well as through the artefacts themselves.[244] By doing so, the exhibitions of urbanism embrace the intentions of New Internationalism, with respect to dismantling traditional ethnocentric structures and practices of Western art institutions, and placing the emphasis on difference as fundamentally complex and valuable.

Considered from the perspective of New Internationalism, the urbanism tendency in art institutions has interesting potentials, as it bypasses the influence of national ideology by focusing specifically on the dynamic of the big

cities – a dynamic that, in reality, is always international, as international con-
nections tend to cluster in cities. This allows for the judgement of works by
artists of different origins along one temporary scale: that of a specific city. And
as this one scale is only temporary – no city will remain artistically dynamic
forever – urbanism also supports the idea of different kinds of modernities.
However, the incompatibility between the different taxonomies at work in the
objects/texts on display in these exhibitions represents a more delicate issue.
Refreshing as it may be, it challenges the uniqueness of artistic practice, and
in this respect it is at variance with the nodal point of New Internationalism.

Though none of the tendencies described above – localism, visual culture,
and urbanism – are fully identical with the intentions of New Internationalism,
they all contribute to institutional manifestations of the discourse, by embracing
non-Western contemporary art. Therefore, these tendencies can be considered
diverse subject positions that form part of New Internationalism since 1994,
despite the fact that they all differ from the initial intentions in different ways.
As we shall see later, the tendencies described here were to a large extent united
in the phenomenon of *Documenta 11*.

CHAPTER 5

Global dimensions of contemporary art

Very often, when the issues of contemporary art and globalization are discussed together, the notions of 'new media art' and 'the art market' are brought up as dimensions that play significant roles. Accordingly, this chapter investigates how the interest of New Internationalism is met within these frameworks. Another notion whose new international potentials it seems obvious to investigate is the notion of 'world art', and therefore this chapter will start by looking into this idea.

World art

One term that appears to be highly relevant for the interests of New Internationalism is the notion of 'world art'. Today, however, 'world art' is rarely used in relation to contemporary art, and the reason for this is related to its traditional use, which can be demonstrated by a small survey: A search for 'world art' (= 'verdenskunst') in the database of the Danish State Library prompts a result of about ten books. The two most recent titles are very different from one another, but also rather illustrative of the field, so a brief look is relevant.

The first is called *500 Years of World Art* (*'500 års verdenskunst'*) and contains texts about 38 visual artists, written by various art historians, in 2004.[245] As the title suggests, this book includes art covering a long period, but the world is not, in fact, very well represented. With the exceptions of Kasimir Malewitsch and Cildo Meireles, all the artists in the book are from Europe or the USA. Thus, 'world art' and 'Western art' are generally considered synonymous in some Danish art historical circles, in 2004, and the preface solely refers to the art historical development in the West, though 'Brazilian Cildo Meireles' is

mentioned as 'an example of a parallel as well as independent development in the art of the third world'.[246] *500 Years of World Art* is characteristic of most Danish books on world art, which use the term as a value-laden adjective when describing European works of art that the authors believe to be particularly commendable, whereas any deeper reflections on art from the world, as such, seem conspicuous by their absence.

In contrast, the whole wide world is included in the most recent title in the Danish State Library, Sue Nicholson's *World Art* ('*Lær om verdenskunsten*'). This is a colourful book for non-specialists with heavily illustrated step-by-step guides, inviting the reader – who is supposedly in the age range of 8-12 years old – to create, among others, 'Chinese Calligraphy', 'Arab Tile', and 'Russian Egg'.[247] Even though the abundance of references to glue sticks, glitter, and felt-tip pens clearly suggests that this is a completely different genre that bears no resemblance to fine art, the book in fact includes a much broader geographical perspective of the world than most books on 'world art' aimed at a mature audience.

These two examples accurately demonstrate the problem with the notion of 'world art' and its usage: Either emphasis is placed on 'art', leaving the world behind, because art in this context is naturalized as the Western concept of art, its institutionalization and its historiography; or emphasis is placed on 'world', which means that genres other than that which art historians understand as art inevitably become highly relevant. The result is that the notion of 'world art' is not used very often, and it connotes something quite old fashioned and Western.

Johan Wolfgang Goethe is generally recognized as the founding father of the notion of world art, which was derived from his ideas on 'world literature', put forward in 1827.[248] Initially, Goethe launched the idea of world literature as a reaction to the growing cultural nationalism in Europe – as a space for exchange, inspiration, and the recognition of different national tendencies. As Weibel, who takes inspiration from Goethe, puts it: 'In Goethe's understanding world literature was a hybrid, built on the dialectics between the difference of particularity (nationality) and universality (common ground of mankind).'[249] Soon after 1827, however, the notion of 'world literature' was used in the sense of literary canon, and Weibel pays attention to the fact that the idea of world art grows out of the process of Western cultural canonization. Hence:

'World art' has been defined as 'Western art', and 'Western Art' as 'White art.' The idea of 'World art' is a child of Western civilization, born to serve the ideological purpose of repressing and excluding every artistic expression that does not conform to the Western canon.[250]

It is this historical interpretation of world art as Western art that eventually resulted in survey books like Janson's *History of Art*.

An attempt has been made, however, by sociologist Niklas Luhmann, to consider world art from a different angle, which will briefly be addressed here. In his text "Weltkunst", of 1990, Luhmann considers the world not as a geographical or planetary entity, but as a *mode of being*, which he explains like this:

> World is to be understood like the presupposed whole of all distinctions, like the non-schematic of the schema or like the blind spot of all contemplations – that is, what one cannot see, when one describes, what one contemplates, by use of a certain distinction.[251]

Significantly, Luhmann's term 'world art' pays attention to distinction rather than substance, which is relevant to New Internationalism, since it is concerned with institutional distinctions rather than subject matter or artistic material of specific works of art. In this respect, New Internationalism seems to be in agreement with the way Luhmann defines his distinctions:

> We do not understand 'World art' as an art that represents the world in a superior manner, but instead as an art that observes the world in its state of being observed, and hence pays attention to distinctions that determine what can be seen and what cannot be seen.[252]

The consequence of this quite general definition is, apparently, that all art is world art. According to Luhmann, however, only *modern* art is world art. The reason for this is modern art's close relation to transcendental philosophy, which enables it to reflect this world state of being observed existentially, by acknowledging that it *cannot* observe the *whole* world. In order to describe this specific kind of world observation that rests on the recognition that it is impossible to contemplate the whole world, Luhmann has developed the notions of 'second-order observing' and 'third-order observing'. As opposed to the simple and direct first-order observing of things and phenomena, which

observes the world but does not reflect on its own process of observation, second- and third-order observations consider the world as a constant process of becoming, rather than a state of being. According to Luhmann, the sub-system of art differs from other domains, since art possesses the special quality of being in itself a sort of second-order observation that 'offers a position from which *something else* can be determined *as reality*'.[253]

Luhmann's notions of second- and third-order observation are suitable for institutional analysis, and hence relevant here. We may consider New Internationalism as a second-order observation of the traditional 'old international' art world insofar as it adds further complexity to this art world by critically observing its structures of inclusion/exclusion in order to deconstruct them. Likewise, this book may be considered a third-order observation, since it observes this second-order observation of New Internationalism, and the critical reader of the book may work as a fourth-order observer and so forth. As the above illustrates, Luhmann's system theory may provide us with an understanding of how systems or discourses can be observed 'from the outside', so to speak. However, as pointed out by Erkki Sevänen, in Luhmann's theory it is the work of art – not fine art as such or the art institutional apparatus – which, in a formalistic understanding, communicates that it is art.[254] Clearly, this contradicts institutional art theory.

In contrast to Luhmann's ideas, New Internationalism is not a theory or a system of communication, but a discourse of antagonism that is articulated around the nodal point of art – specifically visual arts. This nodal point constitutes the platform from which the discourse observes and struggles against ethnic or geographic discrimination in the art institutional apparatus, and an antagonism has no interest in second-order observations of itself – that may be the task for theory or for different antagonisms, but not for the specific antagonism itself. In this respect, Luhmann's idea of world art seems too broad and too abstract to be able to realize the interest of New Internationalism. It also poses a problem in that, although modern art in general is world art, according to Luhmann, it is so *due* to its origin in transcendental, *Western* philosophy. And since world art is itself a notion of Western ideology, insofar as it is commonly used as a synonym for extraordinary Western works of art, the concept does not seem attractive when attempting to realize the interests of New Internationalism. All in all, the concept of 'world art' is not really relevant to the current realizations of the interest of New Internationalism.

New media art

The concept of new media art is another, more popular way to consider art as 'global'. The notion of new media art is informed by Marshall McLuhan's media theory, and generally argues that artists' use of new electronic media in their work has rendered contemporary art boundless – hence global.[255] Inspired by professor of literature Fredric Jameson's theory on post-modernity's displacement of meaningful *information* by global *communication* in the late-capitalist age, philosopher Noël Carroll suggests that

> [T]he popularity of photography, film, video, and, increasingly, computer, digital, and Internet art is itself *emblematic* of the emerging cosmopolitan artworld insofar as their media are themselves cosmopolitan.[256]

The view that certain art forms are in themselves cosmopolitan, since the media forms in question function as the primary tools of communication on a global scale, is supplemented by a more epistemological interpretation of new media art promoted by Peter Weibel. Roughly speaking, Weibel traces the history of new media art, following a route from the iconoclasms of the British Enlightenment and French Revolution, through Marx's critique of bourgeois ideology, post-impressionism, Suprematism, and the influence of photography on art, to art's political engagements in the late 60s, and currently, new media art.[257] As this genealogical account suggests, 'new media art' is in itself a rather broad term, but this present discussion in particular concerns so-called 'digital art', which is art that somehow makes use of digital technology.

The *global*, or *cosmopolitan*, as Carroll calls it, characteristic of digital art stems from the fact that the above genealogy eventually constitutes an opposition to the Euro-centrism of modernism. By referring to activist and curator Lucy Lippard's account of art's conceptual and political turn in the late 60s and early 70s, Weibel claims that

> In the 1960s, the first world political opposition against the exploitation of the third world created a context which brought about a radical revision of the conditions and conventions of European society and history and the art of modernity [...] The media-supported second modernity focused on the introduction of real actions and people into art's representational frame.[258]

Accordingly, the 'media-supported second modernity' with its digital art seems to be well-suited as a strategic tool for New Internationalism, which obviously would be interested in supporting any revision – the more radical, the better – of 'European society and history and the art of modernity'.

Weibel argues that electronic art engages with its audience in a participative, interactive, and virtual way, which enables a transition from

> [M]ono-perspective to multiple perspectives, from hegemony to pluralism, from text to context, from locality to non-locality [...] from the dictatorship of subjectivity to the immanent world of the machine.[259]

In other words, it allows us 'to break out of the prison of space and time coordinates described by Descartes', and such a break is in close accordance with the interests of New Internationalism, since these seemingly rational coordinates of space and time govern standard art history.[260] Weibel's immanent world of the machine is not a planetary geography that is culturally divided into different zones, such as Western or non-Western, but instead is interpreted as a web of electronic circuits and impulses that are characterized by dynamic inconsistency. Hence, according to Weibel, by entering this electronic world – for instance through a work of art – we are no longer confined to 'a limited, localized experience, but rather a simultaneous, non-local, universal experience.'[261] This is possible, because 'The digital signal is defined by its original neutrality.'[262] It is this *neutrality* of the digital signal that is considered a pivotal tool against *ideology*, and hence a potential weapon against the ideology of Western art history.

The philosopher Mario Perniola also identifies similarities between art, media, and neutrality in his text "Art as a neutral mutant".[263] Using references to telematics and electronic coding, Perniola states that art is neither ontologically related to its place or culture of origin – an idea which he refers to as ethno-aesthetics – nor is it constantly nomadic, but instead, he argues, it is *simultaneous* and *in transit*: art is interface. Art as simultaneity does not rely on the metaphysics of identity, but 'presumes reassessment of the in-betweens, of *l'entre-deux*, of a *Zwischen*.'[264] Since art is fundamentally understood as an activity of *transit*, it is in itself neutral. By describing the concept of art as neutral, Perniola is in accordance with the institutional theory of art where the work of art – as an object of specific significance as art – comes into existence only when the art world *ascribes* artistic meaning and value to the object. This inscription of meaning is only possible insofar as the object is basically neutral

from the outset, which is what renders it independent of Western ideology, and hence relevant to New Internationalism.

A relationship between New Internationalism and digital art is thus established by the fact that both participate in an antagonism against the ideology of Western modernism. Obviously, this is rather a broad, heterogeneous – and popular – antagonism, which includes a large number of different phenomena that are part of this formation for a number of different reasons. But a closer relationship between New Internationalism and digital art is founded on a linkage between the descriptive, hence neutral and potentially global, nature of institutional art theory and the neutral, hence potentially global, characteristic of digital technology claimed by Weibel and Perniola.

However, whereas Perniola's concern is the current characteristics of *art*, which he is able to explain by making analogies to and using metaphors from the principles of electronics, Weibel combines the two. The analogy between the global potential of art as such, on the one hand, and, on the other, the global potential of electronic digitalization as such, is transformed into a kind of extra-global potential of digital art. Whereas Perniola presents an analogy between the two theories, which he *compares* – one of art and another of electronic media – Weibel himself presents a digitalized theoretical version, which *combines* these theories into one. From Weibel's point of view, art functions like electronics, and hence digital works of art are 'more art', 'better art', and most importantly here, 'more universal art' than works in different media, because they apply to everybody. 'After all isn't electronic art a world of the internal observer par excellence by virtue of its participatory interactive, observer-centred and virtual nature?' Weibel asks.[265] It is by arguing for a formula where $1 + 1 = 3$, that Weibel concludes that since we live in a digital time, digital art enables us to reflect on this time from within, so to speak.

The problem with regarding works as global because of their use of medium is that it naturalizes a specific technology in itself as the parameter by which the work in its entirety is deemed more or less global. This claim can be investigated further, by comparing two different works of art depicting seemingly similar motives – for instance Caravaggio's *The Supper at Emmaus* (1601, oil and egg tempera on canvas, 141 x 196,2 cm. National Gallery, London) and Sam Taylor-Wood's *Atlantic* (1997, three-screen with sound, shot on 16 mm film, dimensions variable), which both depict gesturing people gathered at a dinner table. If Weibel is right, it would be accurate to state that Taylor-Wood's video installation – due to its use of laser disc projection – is *automatically*

more global than Caravaggio's painting of a similar motif. And of course the art world, like any other domain, has been influenced by digital technology. As Teresa Gleadowe, founding director of the MA programme 'Curating Contemporary Art' at the Royal College of Art in London, puts it:

> Electronic communication has increased the speed at which an exhibition or publication can be realized, and international travel has become an essential component of the activity of the artist or curator. Art has become a globalized field, no longer bounded by the physical presence of the work of art.[266]

Likewise, one can argue that, as a *medium*, digital film and video has more global potential than a unique oil painting, since it is much easier to access from across the globe, for instance by downloads. But in the examples of Caravaggio's painting and Taylor-Wood's laser disc installation, others might argue that Caravaggio's biblical subject matter is of relevance to all Christian believers in the world, and hence has broader global potentials than the private drama between a man and a woman in Taylor-Wood's piece. Or what about Alighiero Boetti's works, which consist of embroidered tapestries made of quilted fabrics, but still depict maps that comment on the international political situations of nation states? The crucial question that emerges is: on which discursive levels are the different global dimensions of art to be positioned, in relation to one another? And, since a work's subject matter, artistic material, use of strategy and inter-textuality with other works – not to mention its institutional reception – *all* intertwine in the constitution of the work, it seems suspect that one component, digital technology, should be considered a neutral aspect that *automatically* renders the work global.

Art historian Julian Stallabrass also considers art on the net to be capable of challenging traditional art institutional structures. According to Stallabrass, net art offers a space where: 'democracy is severed from the market, dialogue is rapid, borrowing is frequent, openness is part of the ethos, and there is a blurred line between makers and viewers.'[267] Paradoxically, this claimed innocence of digital technology resembles an ideology in itself. Simon Penny, an artist who himself makes use of digital media in his work, regrets what he calls the 'amnesiac quality' of the discourses on cyberspace and the digital:

> It is forgotten that the primary purpose of digital communication networks are [sic], and always has been, strategic, military and commercial [...] Another infuriat-

ing tendency in cyberdiscourse is to elide (or blithly [sic] ignore) the necessity of a hardware infrastructure for the gloriously virtual cyberculture. It is difficult to understand how a digital utopia of freedom of expression can be proposed, without acknowledging its dependence upon millions of dollars worth of (mostly privately owned) computers, fibre-optics, satellites, and dishes.[268]

As the above quote argues, there is reason to be sceptical about the claimed neutrality of digital technology, and since the chain of equivalence between New Internationalism and digital art rests upon this neutrality and its global nature, the disappearance of the neutrality means that digital art is not automatically more global than non-digital art. Hence, Weibel's idiom seems to reduce art to its use of technology. This is particularly evident when speaks with great expectations about the evolution of art – not digital art, but art in general – in which the next state is art in the network, where: 'There will be sheer immaterial art worlds floating in the Internet.'[269] What sets out to be an advanced and dynamic theory of art thus seems to suffer from a kind of digital fetishism that is in danger of overlooking the fact that a work of art does not necessarily need to be either electronic or digitalized in order to relate to global issues.

The art market

When Noël Carroll and Peter Weibel believe electronic art to be more cosmopolitan or more global than what we may term 'object art' (painting or sculpture, for instance), they disregard one major aspect of the art institutional apparatus: economics. The global circuits of economics, however – which, according to Fredric Jameson exist as a kind of cyber-space – are often referred to as playing a significant role in the global art world, due to their ability to bypass traditional cultural territories.[270] In this respect, capitalism characterizes 'deterritorialization' as the ultimate globalization term, as Fredric Jameson points out with reference to Gilles Deleuze and Felix Guattari. According to Jameson, capitalism implies:

[A] new ontological and free-floating state, one in which the content (...) has definitively been suppressed in favour of the form, in which the inherent nature of the product becomes insignificant [...] it would be a great mistake to imagine something like 'the globe' as yet a new larger space replacing the older national or

imperial ones. Globalization is rather a kind of cyberspace in which money capital has reached its ultimate dematerialization, as messages which pass instantaneously from one nodal point to another across the former globe, the former material world.[271]

Accordingly, the following will investigate how the interests of New Internationalism are realized within the framework of this 'ultimate dematerialization' of capitalism.

On the side of artistic production, considerable costs are connected with creating works of art that consist of professional film recordings, handicrafts demanding extensive manual labour, or expensive materials, for instance. Some national arts councils are able to provide financial support for artistic production, whereas others are not in a financial position to do so, and thus economic inequality between rich and poor countries may in itself create artistic inequality.[272] However, the *big* production expenses are covered by sponsors, by commissions from museums or galleries, or by dealers or private collectors who buy the works in advance. As curator and writer Francesco Bonami puts it: 'They [dealers] are the few who can invest and take risks.'[273] According to Bonami, commercial galleries today lead the economic field to an extent where they almost become more prestigious than national art galleries and public international biennials: 'Before, most of the artists made it to Venice or Documenta after a solid gallery career. Today many artists land in good galleries only *after* a solid career in the biennial system.'[274] The fact that engagement with commercial galleries with good reputations is seemingly positioned at the top of the art institutional hierarchy runs against the traditional conception that art is defined, among other things, by its autonomy from political and economic interests.[275]

However, the financial dimension of art does not seem to pose any problem for New Internationalism. *Third Text*'s first editorial stated that 'Contrary to the humanist belief, art is not about human self-expression *per se* but requires a market for its assertion as a commodity; ... Its ideological function is intrinsically bound up with its exchange value.'[276] The art market is thus referred to as a premise for art, not as a problem, just as the financial circuits related to art were not mentioned in the initial InIVA nine-point list on New Internationalism – neither negatively nor positively. As this *Third Text* editorial points out, it is not the economics involved in the production of works that is of particular importance, but instead the mechanisms of the economic circuits related to

the subsequent level of *distribution* – the buying and selling of works on the international art market – that are of significant relevance.

On the art market, like other markets, value is not essentially linked to the goods, but is ascribed in accordance with the rules of supply and demand, and expectations regarding future ratios of supply and demand. This explains why the economic value of a work of art is determined not by the actual value of materials and working hours put into it, but by what we may call the 'artistic' value of the work.

Within the framework of this capitalist logic, auction houses of fine art function like stock exchanges, and auction results are monitored closely by collectors and investors. In addition to art magazines that concentrate primarily on aesthetic criticism, a different category of art magazines describe and analyse the financial aspects of the art world. One of them is *The Art Newspaper*, whose article "China overtakes France" (Feb. 2008) may serve as a typical example, as it informs the reader about the result of a recent report on the art market:

> China had already taken over from France by the end of 2006 (...). At this point, Dr McAndrew found, China had a 20 % share of total sales, the same as the UK. [...] Auction prices have proved more lucrative in Hong Kong than in China for the past few years. In 2007, Sotheby's and Christie's made around $800m in the region, while their combined Paris salerooms made nearly half that amount at around $440m. The priciest lot to sell at auction in Hong Kong last year was Cai Guo-Qiang's Set of Fourteen Drawings for Asia-Pacific Economic Cooperation [...] It sold at Christie's for HK$74.2m ($9.5m), setting a new record for Chinese contemporary art at auction.[277]

The above excerpts from the article say a lot about how the financial art world functions. Apart from the many figures and the use of terms like 'sales', 'lucrative', and the description of a series of works as 'the priciest lot', it illustrates some of the current art financial motives by mentioning that the seller of Cai Guo-Qiang's drawings was Asia-Pacific Economic Cooperation (APEC), which describes itself as 'the premier forum for facilitating economic growth, cooperation, trade and investment in the Asia-Pacific region.'[278] APEC is neither an artistic nor a cultural enterprise, but a financial one, and Cai's drawings were originally commissioned by APEC *purely* for the purpose of investment. In this respect, it differs from more traditional instances of companies that buy art despite the fact that their core businesses are not related to art in any

way – such as the Rockefeller Foundation's department of support for the arts, the Robert Lehman collection at the Metropolitan Museum in New York, or the New Carlsberg Foundation in Copenhagen, all of which function as art patrons, despite their core businesses in oil, banking, and beer respectively.

Traditionally, either the founder or owner of the company has a personal passion for art, or the owner or the board wishes to act philanthropically and give something back to society by supporting culture, education, research etc. Additionally, a common reason for companies to support art today is that it works as a powerful branding strategy – recollect, for instance, the *Hugo Boss Prize*.[279] But APEC had no other purpose in its commission than financial investment, and apparently the investment paid off. From an artistic or aesthetic point of view, the art investors' influence on the art market causes great lamentation – as artist Andrea Fraser puts it:

> Art works are increasingly reduced to pure instruments of financial investment, as art-focused hedge funds sell shares of single paintings [...] We are living through an historical tragedy: the extinguishing of the field of art as a site of resistance to the logic, values and power of the market.[280]

Whereas this sort of hedge fund art investment seems cynical to critics who focus on art's aesthetic and artistic qualities, it makes perfect sense within the logic of global capitalism. And considered from the art market's point of view, object art clearly outmatches digital art, since it offers a simple, concrete, and above all *unique* object to which economic value can be ascribed. Since the market logic plays a strong role in the level of distribution, it may have an effect at the production level, to the extent where even electronic art is often turned into object art, as art historian Mark Godfrey explains:

> The 'new media' of the 1960s increasingly recall the old media of the past: photography is no longer treated as a quick and useful tool and instead is deployed to make work on the scale of 19th-century history paintings. Videos are editioned as bronze sculptures used to be, and for some artists working with the medium, production costs have soared. No longer bound to their own studios, they operate like Hollywood producers, raising hundreds of thousands of dollars before beginning a shoot.[281]

As long as the work still possesses a unique artistic value the ascribed economic value is linked directly to the particular work in question, and the buyer does not have to fear that digital reproducibility, which – according to Weibel's prediction – may result in 'sheer immaterial art worlds floating in the Internet' will cause the *economic* value of his/her work of art to evaporate into similar sheer immateriality.[282] The more unique the work, the smaller the supply and the higher the value – provided there is a demand. In this respect, art incarnates the principles of capitalism to perfection.

Accordingly, object art is much better suited for the global art market than digital art. All things being equal, drawings, paintings, and unique sculptures are almost always valued higher by the market than prints, photos, and sculptures cast in series; but also when it comes to the more diffuse value of artistic aura, the former are praised for their direct indexical relation to the artist. In this respect, the character of the artist-genius still proves to be of significance, insofar as the indexical relation is considered significant, as though the artist is really capable of transferring artistic value into the work when producing it, which can then be exchanged for economic value once the work is sold. This logic corresponds well with the kind of art historical logic favouring 'the-man-as-his-work'. Therefore, the economic value of the work of art stems not from the value of the work's raw materials and working hours, but from the artistic value, which for its part stems from the artist subject.

As described earlier on, New Internationalism expresses strong reservations about such fetishising of the artist subject, since discrimination against non-Western art by standard art history was based on this preoccupation with the artist's origin or cultural background. However, the initial intentions of New Internationalism demonstrated that the interest of the discourse lies in challenging the discriminations of the Western art institutional apparatus, and in focusing on artistic practice, whereas the art market is not considered a relevant issue – just as it is not considered to be of relevance to the practices of standard art history. But the forces of the free market system of today may unexpectedly prove to be a strong ally to New Internationalism.

New international potentials of capitalism

First of all, the art market system (commercial galleries, dealers, and auction houses) operates globally. Information and communication technology, along with modern transport systems mean that today the potential customers visiting

any High Street gallery, or the potential visitors to any exhibition, are not just the local people, but anyone, anywhere, with Internet access. Hence, virtually all art on the art market is included in this global network. One could argue that this is yet another way of appropriating art of the 'periphery' into a dominant Western centre, and that this kind of inclusion is ideologically discriminatory. However, recollecting Dussel's statement that capitalism has 'transformed into an *independent system* that owing to its own self-referential and autopoietic logic can destroy Europe and its periphery, even the entire planet', we can hardly claim that global capitalism in itself favours the West (the effects of Western government support and custom duties unmentioned).[283] For instance, the recent global recession has disclosed to the general public that China practically owns the USA, though China has not (yet) claimed its debt.

This view on the development of capitalism is shared by political philosophers Michael Hardt and Antonio Negri, who, in their book *Empire*, state that capitalism today has left its original status as an imperial tool by which certain Western nation-states controlled and exploited other nation-states.[284] Instead of a capitalist world system divided into a first, second and third world, capitalism has developed into a state where

> [C]apital separates populations from specifically coded territories and sets them in motion. It clears the Estates and creates a 'free' proletariat. Traditional cultures and social organizations are destroyed in capital's tireless pathways of a single cultural and economic system of production and circulation. [...] capital brings all forms of value together on one common plane and links them all through money, their general equivalent. Capital tends to reduce all previously established forms of status, title, and privilege to the level of the cash nexus, that is to quantitative and commensurable economic terms. [...] even the boundaries of the nation-state tend to fade into the background as capital realizes itself in the world market. Capital tends toward a smooth space defined by uncoded flows, flexibility, continual modulation, and tendential equalization.[285]

Since they are strongly committed to the political Left, it comes as no surprise that Hardt and Negri's view on capitalism is rather hostile, and reflects a fundamental Marxist belief that class and labour exploitation are at the very foundation of a totalizing capitalism. The description, however, demonstrates that capitalism today and New Internationalism have some overall features in common. If capitalism means that 'Traditional cultures and social organiza-

tions are destroyed', that 'all previously established forms of status, title, and privilege' are reduced to one level (the level of money), and that 'the boundaries of the nation-state tend to fade into the background', it seems, paradoxically yet logically, that New Internationalism should praise capitalism as an allied partner that is able to challenge traditional patterns of Eurocentric thinking. Some of the main interests of the discourse in the domain of the visual arts have already been fulfilled in the domain of economics, so a close partnership seems an obvious way to shortcut some of the obstacles in the art institutional apparatus. In accordance with Marx, Hardt and Negri identify the vice of capitalism as a merger between economic and political power into one common worldwide body of dominance, a world market, which they term Empire. What is of interest in relation to New Internationalism is that

> In contrast to imperialism, Empire establishes no territorial center of power and does not rely on fixed boundaries or barriers. It is a *decentered* and *deterritorializing* apparatus of rule that progressively incorporates the entire global realm within its open, expanding frontiers.[286]

Whereas imperialism was an economic strategy of the past, the neo-liberalism of the world market directly annuls imperialism:

> Imperialism was a system designed to serve the needs and further the interests of capital in its phase of global conquest. [...] Imperialism is a machine of global striation, channelling, coding, and territorializing the flows of capital, blocking certain flows and facilitating others. The world market, in contrast, requires a smooth space of uncoded and deterritorialized flows. [...] The full realization of the world market is necessarily the end of imperialism.[287]

Even Marx and Engels noted the global aspects of free trade in 1848, when they wrote that:

> National differences and antagonism between peoples are daily more and more vanishing, owing to the development of the bourgeoisie, to freedom of commerce, to the world market, to uniformity in the mode of production and in the conditions of life corresponding thereto.[288]

What is of significance here, is that Marx and Engels state that the vanishing of national differences results not from uniformity in production, but from uniformity in *the mode* of production. Hence, the communist statement compares to the principles of institutional art theory, where acknowledgement of an object as 'art' is not in itself an actual act of physical production but, precisely, a mode of production. It is on the level of the 'mode' that New Internationalism, too, seeks to overcome national differences in the art institutional apparatus – certainly not on the level of concrete artistic 'production'. The new international idea is not that all works of art should look uniform, should follow some sterile international matrix, or be created on the Internet or on a plane in international airspace, but that the institutional mode of recognition – which is a mode of production insofar as institutional recognition is what renders a work of art *art* – should offer equal terms for artists and their works, regardless of their place of origin. And the art market actually fulfils this expectation, since it follows a strictly capitalist logic, which today is characterized by being autonomous and neutral, 'freed' from its once European identity.

This renders the inequalities in the art market free from ideology and cultural discrimination. When, for instance, the prices for contemporary Indian art rise (as they are doing at present) due to the booming of a wealthy Indian middleclass (in India and abroad), one could argue that this creates inequality compared to contemporary Nepalese art, which is not experiencing a similar increase in value. But this difference in value is founded on the autonomous – we may even term them neutral or systematic – mechanisms of capitalism, and not on culturally normative ideology. Hence, capitalist logic's attitude towards goods resembles the logic of institutional art theory, which in its attitude towards works of art is concerned not with any essential, ideologically informed core value either, but rather with the question of whether this or that object is likely to be valued as art by others. A critic reviewing an object as art and a buyer paying for an object on the market perform similar gestures – both ascribe value and identity: one ascribes artistic value to an object that he/she has identified as art, and another ascribes economic value to an object that is identified as goods – and these gestures both take place at the same level, which is the *mode* level prior to the attribution of any actual, specific value of expensive/cheap or good/bad.

In the art world, however, it is not good form to compare artistic value directly to economic value, which an example may illustrate: In September 2008, Sotheby's auction house held a two-day auction of new works by the

artist Damien Hirst.[289] What made this auction special was that all the works put up for sale came directly from Hirst's own studio. No dealers, galleries or collectors were involved, and this constituted a new alliance between artists and auction houses, which are openly committed to selling to the highest bidder regardless of who the buyer is. To people not professionally familiar with the art world this may not seem controversial at all: business-wise it makes sense to sell at the highest price possible – that is the whole point of being in the market. But so far, works of art have traditionally been sold first through dealers and galleries, who take a large interest in whether the secondary buyers are serious – in the sense that they really appreciate the artist's work and do not use it as a quick investment, and then put it up for sale at auction shortly thereafter. Thus, traditionally, the art world has required that buyers not only have the money needed to buy, but also display artistic respect that makes them 'worthy' of buying works in high demand.

According to this logic, auction houses have been looked upon as insensitive and greedy capitalists, who suck the soul out of art by focusing solely on profit. Thus, even in cases where works are sold for several million Dollars, Euros or Yen, more diffuse issues such as artistic integrity and art appreciation have been significant. It is because of such traditional patterns of art trade that the collaboration between Sotheby's and Hirst was controversial, and gave rise to claims such as 'The final frontier *protecting* contemporary art galleries from the *relentless* encroachment of the auction houses has been emphatically breached' and 'Damien has *demolished the moral barrier* of using auctions for distribution and profit'.[290] One dealer-collector even compared the significance of Hirst's move on the art world with that of Marcel Duchamp's readymade *Fountain*: 'It seems to be a game for Damien. He's seeing if he can get away with murder, just as Duchamp did with his urinal.'[291] If we follow the logic of this quote, then the victim of Hirst's murderous act is the remnant of the romantic ideas of the speculative art theory. Hirst is doing away with the idea that a work of art has a semi-divine value, channelled into the work through the artist-genius, and therefore belongs to a sphere that is morally better than that of other profane values – and in this respect it is a murder to which New Internationalism should happily be an accomplice. According to commentators, the Hirst auction may even be guilty of eventually reducing the economic value of art generally.[292]

In this respect, the development of the art market, exemplified by the arrangement of the Hirst/Sotheby's auction, is in accordance with bourgeois principles, as interpreted by Marx and Engels:

[The bourgeoisie] has put an end to all feudal, patriarchal, idyllic relations. [...] It has resolved personal worth into exchange value, and [...] has set up that single, unconscionable freedom – Free Trade.[293]

According to Julian Stallabrass, free trade and autonomous art are closely inter-twined on the art market. This fact, however, must remain hidden, since 'Art can only meet the instrumental demands of business and state if its function is concealed by the ideal of freedom, and its qualitative separation from free trade is held to faithfully [...] To break with the supplemental autonomy of free art is to remove one of the masks of free trade.'[294] Notwithstanding that Stallabrass judges art's autonomy as well as free trade critically, as he considers both to sustain the permanence of capitalist logic in everyday life, he still views art's autonomy and global capitalism as closely related.[295] Hence it seems, surprisingly, that the art market, governed by the rules of global capitalism, is able to support the nodal point of New Internationalism, and, at the same time, act globally without any ideological preferences for Western culture.

The above discussions of how the interest of New Internationalism is realized within different dimensions of the global art world – exhibitions and museums, the concept of 'world art' and of 'new media art', and the art market respectively – expose some fundamental dissimilarities between these different dimensions. Some take artistic media as their point of departure, others the subject matter of the specific work of art, the economic framework, the artist's place of birth or place of work etc., all of which means that there is a co-existence of different and highly incommensurable dimensions in the field of opportunity of realizing the new international interest. Thus, after analysing different dimensions or different discursive frameworks that regard art globally in different ways, it seems as if they provide suggestions for art's global realization that are incomparable. A work of video art on the Internet may seem highly global according to one logic – because it makes use of digital media – but unattractive, according the logic of another global framework – because the less unique it is, the harder it is to capitalize. Consequently, it is difficult to compare if and how these frameworks fulfil the interest of New Internationalism.

In order to be able to align such different approaches, the following will therefore pursue a more theoretical and philosophical mapping of how the global dimensions of contemporary art unfold. Above all, it may be beneficial to differentiate between two fundamentally different dimensions of contemporary art's 'globality': a thematic dimension and a formal dimension.

CHAPTER 6

Formally and thematically global dimensions

To state that a work is *thematically* global means that the specific work addresses global isssues or globalization through its motif or subject matter. To state, on the other hand, that a work is *formally* global concerns the work's discursive framing: for example, how it is curated and displayed among other works, or the way in which the artist's background or critical receptions of the work are addressed. Whereas I am responsible for applying the terms 'thematically' and 'formally' to these different modes of contemporary art's engagement in the global, this general ambiguity of 'global art' is also presented by art historian Niru Ratham. He describes the contemporary art scene accordingly:

> It had become clear by the end of the twentieth century that increasing num-bers of artists, both from the erstwhile western [sic] centres of art production and from elsewhere in the world, were making work *either* overtly addressed to the phenomenon of globalisation, *or* comprehensible in terms of the debates that were growing around the concept, even if they did not explicitly engage with it. This second type of activity would include the Indigenous Australian art shown at 'Magiciens de la terre', and in many international exhibitions since. Such work engages with the conditions of Indigenous Australian life and traditions, but is drawn into the international artworld through the globalisation of the exhibition and market system.[296]

The first artistic approach to globalization referred to by Ratham above, where the phenomenon of globalization is overtly addressed, is what I refer to as thematically global, whereas I refer to the latter approach – which is not so much an active approach as a discursive institutional framing – as formally

global. Put roughly, the formal level concerns *how* and the thematic concerns *what*, which will be elaborated in the following with regard to contemporary art's global dimensions. To begin with, I shall briefly account for two different sub-dimensions of art's *formal* global character.

A formally global art world

First of all, the art institutional apparatus, in the form of biennials, museums, exhibitions, and galleries, has undergone a process of globalization to an extent that we can speak of a global art world, and it is through its existence and participation in the system of the global art world that art can be considered global in the formal sense. Therefore, the vast majority of contemporary works of art are formally global. For instance, as Ratnam noted: '[T]he Indigenous Australian art shown at "Magiciens de la terre" [...is...] drawn into the international artworld through the globalization of the exhibition and market system.'[297]

Accordingly, institutional globalization means that today, virtually all contemporary art is part of an institutional paradigm, which is global, and this is also the case for a majority of works from earlier periods. The works by Rembrandt or the terracotta soldiers of Xi'an, for instance, are in this sense part of a global paradigm just like indigenous Australian art or installation pieces by Olafur Eliasson, because institutionally they are continually described and exhibited in different areas across the globe. The general global circuits of economy, cultural exchange, and communication in the late 20th and the 21st century naturally influence the art institutional domain as they influence any other domains.

Second, contemporary art may be considered formally global, due to the fact that it is 'contemporary'. Frequently, 'contemporary' is an ambiguous term, because it has two different meanings: on the one hand it signifies the temporal stage of 'the present' or 'now', as opposed to periods in the past or in the future; but on the other hand it signifies the co-existence of different temporal phenomena in the same time, *con-temporary*.[298]

Arthur C. Danto has suggested focusing to a greater extent on the latter definition, indicating co-existence, and he believes that the idea of 'contemporary' art differs significantly from other notions – such as 'modern' art, 'postmodern' art, art of the 'avant-garde' or the 'neo-avant-garde' – because it is 'too pluralistic in intention and realization to allow itself to be captured along a single dimension'.[299] According to Danto, the 'single dimension' along which art

is normally captured is the narrative of modern art, as it was promoted by art critic Clement Greenberg, constituting the final phase in the macro-temporal idea of the 'era of art', which unfolded from A.D. 1400 to the 1980s. This idea of the era of art is presented by Danto and art historian Hans Belting, among others.[300] Hence, this era of art is implicitly understood as the era of Western art. In Belting's opinion it 'makes sense that *contemporary art*, in many cases, is understood as synonymous with *global art*. Globalism, in fact, is almost an antithesis to universalism because it decentralizes a unified and uni-directional world view and allows for "multiple modernities"'.[301]

Danto acknowledges the existence of art after the 'era of art', but he sees this art, contemporary art, as freed from the traditional narrative of modern art. Since contemporary art is regarded as existing outside this narrative direction, Danto also refers to it as 'post-historical' art.[302] In Danto's description, contemporary art is presented in a way that closely resembles descriptions of postmodern art, though Danto distinguishes between the two by suggesting that postmodern art is only a certain sector of contemporary art, consisting of impure and hybrid art like

> [T]he works of Robert Rauschenberg, the paintings of Julian Schnabel and David Salle, and I guess the architecture of Frank Gehry. But much contemporary art would be left out – say the works of Jenny Holzer or the paintings of Robert Mangold.[303]

Indeed, this distinction between contemporary art and postmodern art is open to discussion, as one can argue that the field of postmodern art is more nuanced than suggested here – for instance, Jenny Holzer is described as belonging to the 'Anti-aesthetes' post-modernist artists in Eleanor Heartney's book on postmodernism.[304]

Danto's description of contemporary art is relevant in relation to New Internationalism, because of the global potentials offered by contemporary art's secession from the Western narrative of art. The co-existence within the international art institutional apparatus of the different temporal artistic cultures – from Australian sand paintings and interactive installations, to digital video art and Chinese photography – is what renders this art con-temporary: 'together now'. This understanding implies that the notion of the 'contemporary', like the notion of art, is institutionally determined, and that not all works of the present are contemporary. For instance, works that are not exhibited,

collected or put up for sale along with art of different temporal artistic cultures discursively exist along their own single narrative.

Thus, contemporaneity, within the visual arts, describes an institutional state of simultaneity rather than a temporal state of 'most recent'. According to this logic – and this is a rather tentative suggestion – a clear cut is required between this idea of the contemporary as a state of co-existence and that of the contemporary as the temporal present, the 'now'. By disregarding the 'now' understanding of the contemporary, and emphasizing the idea of co-existence, it is possible to imagine exhibitions of contemporary art that include almost no works of art created in the present.

Consequently, it may not make sense to speak of 'new international' contemporary art, 'international' contemporary art, or 'global' contemporary art, because these adjectives are already embedded in the notion of *contemporary* art itself, as a phenomenon that automatically involves the simultaneity of heterogeneously 'different' works of art. Since such an understanding of contemporary art is not related to the work itself, but relies solely on its institutional context, this is a formal contemporaneity. In conclusion, we may consider contemporary art to be global at the *formal* level due to the globalization of the art institution (the global art world) and due to the global principles of the notion of 'contemporary'. Both aspects are formally global, since they belong to the discursive paradigm of enunciation of contemporary works of art, but do not concern specific artistic utterances. From this it follows that, in reality, contemporary art is automatically formally global. Conversely, it is much more difficult to determine whether a work of art is global on the thematic level, as we shall see.

Thematically global art

In addition to its formally global status, a work of art may or may not address globalization *thematically*, by treating so-called global issues *in* the work.

Alighiero Boetti's tapestries of world maps could serve as an example of art that is global on a formal as well as a thematic level. Not only are these maps included in a global institutional paradigm, they were also woven by craftswomen from Afghanistan, after Boetti's design, though he himself was Italian. What is thematically global about the works, though, is that, according to the art historian Niru Ratnam, 'when several of the maps made over a period of years are considered together, they become a telling representation of the mutability

of political powers in the world.'[305] In other words, the utterance of the maps concerns global issues. Another example of a thematically global work of art, which is also described by Ratnam, is Cildo Meireles' *Insertions into Ideological Circuits: Coca-Cola Project*, which was carried out in 1970, in Brazil. In this activist-conceptual work, the artist purchased bottles of Coca-Cola beverages, printed the text 'Yankees go Home' on the bottles and put them back into market circulation as 'a critique of global capitalism.'[306] Accordingly, both Boetti's and Meireles' works articulate globalization: the former by depicting the visual symbols of sovereign states, their flags and outlines, and the latter though critical intervention in multinational commodity colonization.

Whereas it might seem obvious that the works just mentioned somehow articulate issues of globalization, it is in fact almost impossible to determine in any absolute sense whether or not a work of art is thematically global. Significantly, we have now moved from the descriptive area of the institutional theory and the question of whether something *is* art or not, or *how* it is art, into the interpretative area of what the works are *about*. Here, everybody can have their say – especially after Roland Barthes proclaimed the "Death of the Author" and handed over the power of and responsibility for the creation of signification to the reader/viewer.[307] And today artists themselves often encourage the audience to search for their own interpretations of the works. Naturally, not everyone agrees on one interpretation of a specific work, which means that the question of whether the works by Meireles and Boetti really 'articulate issues of globalisation', as I claimed above, and Ratnam suggests, is not that simple. Apart from the varying opinions of the art audience themselves, it is common for an audience to ask about the artists' own intention with the works, and thereby play the ball back into the artists' court, regardless of Barthes' ideas. In any case, there is no given correct answer as to what the work 'really' means.

In addition to the question of interpreting whether or not a given work of art engages with global issues, the question of aesthetic judgement and aesthetic relation is at work at the thematic level of the work. Therefore, the following will investigate some of the fundamental ideas in aesthetic theory that are relevant in the analysis of the issues of globalization in contemporary art. In order for an aesthetic relation to occur, two things are required: evaluation and indeterminacy.[308]

Evaluation – judgement of taste

The evaluative aspect is a significant part of the aesthetic judgement of taste, and is what separates aesthetic judgement from mere description. In the example above, Ratnam gives a description, and not an aesthetic judgement, when he speaks of '[T]he Indigenous Australian art shown at "Magiciens de la terre"' and claims that 'Such work engages with the conditions of Indigenous Australian life and traditions', meaning that it does not address global issues. In accordance with the decorum of academic writing, Ratnam does not evaluate whether or not he considers the Indigenous Australian art in question to be, for instance, 'good', 'bad', 'brilliant expressions of local culture' or 'lacking global relevance'.

For the sake of argument, it will be relevant to consult briefly how Kant distinguished between different types of judgement, since Kant's distinctions are helpful in order to understand the advantages and implications of distinguishing between global art in a formal and a thematic sense respectively. Kant distinguished between three kinds of judgements that are relevant here: Pure aesthetic judgement, aesthetic-normative judgement, and cognitive judgement.[309]

Pure aesthetic judgement is an evaluative judgement, and can only be passed on objects that possess finality without representation of a specific purpose. Therefore, it *cannot* be passed on works of art, since they represent their own purpose as art – whether they were intended as art or were appropriated as art later. Pure aesthetic judgement can be disregarded for now, since it does not apply at all to works of art, but can be evoked only in relation to nature. Conversely, *aesthetic-normative judgement*, which is evaluative too, can be passed on works of art, if the works follow cognitive rules that are accepted as norms. These norms could involve, for instance, institutional art theory. And finally there is *cognitive judgement*, which is not evaluative at all, but instead analyses art as objects of knowledge. Therefore, cognitive judgement can function as a norm that frames the aesthetic-normative judgement. Jean-Marie Schaeffer offers a useful example of cognitive judgement:

> A cognitive judgment on the tectonics of the geological plates responsible for the formations of the Alps is communicable independently of any direct experience of its object. I can [...] form my own cognitive judgment on the genesis of the Alps without my having to repeat all the geological experiments on the object in

question; when a sufficiently elaborated theory is concerned, I can even correct my judgment [...] *on the basis of purely formal considerations, on the basis of a simple "calculation" (...) without any "sensuous contact" with the Alps.*[310]

Likewise, according to the logic of the institutional theory of art, it is possible to determine whether an artefact is art or not without any sensuous contact with the artefact, and therefore cognitive judgement is relevant here, since it functions like institutional art theory. If I can find out who made the artefact, if it has ever been reviewed by an art critic, exhibited by an art gallery/museum etc., then I can determine if it is art or not on the basis of a simple 'calculation'. Hence, institutional art theory is based on a cognitive rather than an aesthetic judgement. But since it is based on a cognitive judgement, institutional art theory is not evaluative and cannot pass normative judgements that state whether a work or an exhibition is 'uninspired', 'moving', 'dull', 'successfully global', etc. In order to do so, I must pass an aesthetic-normative judgement, which, therefore, can be described as placed between the opposite positions of pure aesthetic judgement and cognitive judgement. The aesthetic-normative judgement is evaluative, *and*, since it can be passed on art, it is not pure.

It is because of the two different kinds of judgements involved in the domain of art, the cognitive and the aesthetic-normative, that it is possible and necessary to distinguish between the formal dimension of the realization of the new international interest, on the one hand, and the thematic dimension, on the other. At the thematic level there are, again, two different ways of speaking of global art: descriptive, which is neutral – for instance, 'such work engages with the conditions of Indigenous Australian life and traditions' – and evaluative, which requires some kind of value-laden context, for instance that it does so 'successfully' or 'badly'. Therefore, we now have three different dimensions for considering art to be global: In a *formal* way, which in reality applies to all contemporary art, since it is linked to a global institutional apparatus; by means of *thematic interpretation*, which is neutral but requires sensuous contact; and through *thematic evaluation*, which involves aesthetic-normative judgements of taste that claim how works of art or exhibitions deal with 'the global' (successfully or not). As stated above, however, aesthetic relation requires not only an evaluative aesthetic judgement, but also indeterminacy, to which we will now turn.

Indeterminacy

Taking Kant as his starting point, philosopher Martin Seel argues that an aesthetic experience arises when the encounter between a subject and an object is characterized by *indeterminacy*. More accurately, what is required is an indeterminate relationship or even inconsistency between the expectations of an object/phenomenon and the experience of the object/phenomenon.[311] Therefore, if my *experience* in the encounter with an object is fully in accordance with my *expectations* of that object, it cannot be an aesthetic experience. Put roughly, the more my expectations are challenged, the greater the potential for aesthetic experience. This is why Kant trusted encounters with nature to be of greater, or more 'pure' aesthetic potential than encounters with art, which were tainted by the fact that the audience already prior to the actual encounter expect art to possess sensuous qualities. As philosopher and art historian Thierry de Duve puts it, 'Any given object that has found its way into a museum or an art gallery carries an invisible sign saying "this is art".'[312]

According to Seel, the aesthetic-normative judgement which applies to art feeds off a fundamental uncertainty in art that stems from an interlacing of the different art forms. An aesthetic experience is likely to occur in the domain of art because when we perceive that a specific work of art belongs to a specific *art form,* that work simultaneously relates to and communicates in a special way with other art forms, thus surpassing our expectations of the individual art form and forcing us to reflect on it. Seel describes this fundamental communication between the arts as a rupture in the continuum of what can be expected, and

> It is this rupture that essentially constitutes the productive uncertainty that distinguishes artistic presentations from illegible answer sheets, confusing talks, and instruction manuals that are only too clear.[313]

What is of particular interest is that if we follow this logic of communication between the arts – where rupture in continuum and indeterminacy leads to aesthetic experience – even greater potential for aesthetic experience should emerge from the communication between art as such, and art-external domains as such, the reality of other domains. The relationship between different spheres, and hence the challenging of different expectations, would be even greater in such a case than in the fundamental encounters between one artistic domain and another. As Seel states: "The experience of art lives off experience

outside art", which means that the particularity of art is only recognized if it is possible to compare it to something that is not art.[314]

Philosopher Jacques Rancière also comments on this space of indeterminacy between art and non-art, which may potentially result in aesthetic experience. With reference to Schiller, and in accordance with Seel, Rancière argues that the object of aesthetic experience 'is "aesthetic", insofar as it is not – or at least not only – art.'[315] If a work of art is experienced strictly and solely as a work of art and nothing else, there is no play of indeterminacy, no sensuous challenge, no evaluative judgement, and, therefore, it is not an aesthetic experience – though it is still art, according to the logic of institutional theory. Hence, to consider art aesthetically involves indeterminacy. This differentiation between art and aesthetic relation obviously applies to fine art in general and not just visual arts.

Rancière's account of the three different artistic regimes are of relevance here: Briefly summarized, art in the *ethical regime* is assigned to higher ethical standards, to which art is a means. As a consequence, art cannot be autonomous within the ethical regime. Conversely, autonomy is possible within the *representative regime*, where the individual's place in society determines the extent to which his/her utterances are received as art. However, when the workers laid claim to and made use of poetic language, the representative regime was, in that very moment, challenged by the *aesthetic regime*, which is based on artistic equality, and hence is relevant when investigating New Internationalism's specific concern for the visual arts.[316] According to Rancière, the aesthetic regime of art secures a fundamental equality in the distribution of the sensible, which he describes with regard to literature:

> The equality of all subject matter is the negation of any relationship of necessity between a determined form and a determined content [...] the very equality of everything that comes to pass on a written page, available as it is to everyone's eyes [...] This equality destroys all of the hierarchies of representation and also establishes a community of readers as a community without legitimacy, a community formed only by the random circulation of the written word.[317]

As this quote testifies, it is significant to stress the fundamental equality of the aesthetic regime, which is founded on a freedom from given relations between artist, work, expression, media, audience etc. This fundamental freedom renders the aesthetic regime political and emancipating precisely because it does

not focus on and promote a specific political (ethical or representative) message. According to Rancière, indeterminacy is related to politics, because the aesthetic regime of art is a meta-political regime with powerful emancipative potential, due to its fundamental principle of equality.[318] This fundamental principle of equality, however, must not be confused with specific political statements. Rancière elaborates on this in relation to contemporary visual art, when he states:

> [E]mancipation can't be expected from forms of art that presuppose the imbecility of the viewer while anticipating their precise effect on that viewer: for example, exhibitions that capitalize on the denunciation of the 'society of the spectacle' or of 'consumer society' [...] An art is emancipated and emancipating when it renounces the authority of the imposed message, the target audience, and the univocal mode of explicating the world, when, in other words, it stops *wanting* to emancipate us.[319]

Thus, within the aesthetic regime, art is not subject to any *pre*determined task or normative theory – it is neutral or foreign to itself. The fact that art in the aesthetic regime does not 'want' anything specific reconciles it with a fundamental indeterminacy.

Even though art is considered aesthetically in the aesthetic regime of art, and therefore follows the speculative theory of art, the aesthetic regime's characteristics of equality and freedom of hierarchies or specific purpose are actually in accordance with the neutral descriptiveness of institutional theory of art. Therefore, to a large extent the contemporary visual art scene belongs to an aesthetic regime of art, insofar as it is inscribed in the art institution along the formal principles of institutional art theory. However, this structural agreement between the aesthetic regime and institutional art theory does not require that contemporary art as such belongs *solely* to the aesthetic regime. Though some regimes may dominate certain periods in Western culture, it is important to stress that the different regimes of art – ethical, representative, and aesthetic – may well co-exist, as will be demonstrated shortly.

We have now established that art's global dimensions may unfold at different levels: formally (at the level of the institutional apparatus, and through the global character of the notion 'contemporary') and thematically (interpretative through the works' subject matter, and evaluative through individual aesthetic judgements of the works). We may consider the formal global dimensions to be of descriptive character, whereas the thematic global dimension belongs to

the domain of normativity. This is significant, because New Internationalism initially expressed strong reservations regarding the normatively based discrimination carried out by the traditional Western art institutional management. Whereas initiatives such as the Black Arts Movement thought to challenge these institutional norms by promoting a different set of normative values, New Internationalism expressed intentions to move 'beyond the definitions of "Black Art"', in a direction freed from normative institutional discrimination. The nodal point that drives the process of articulation of the discourse is the notion of 'plain' visual art – not 'Western art', 'black art', 'diaspora art' or other kinds of normatively determined art. Accordingly, the discourse subscribes to an understanding of art within the principles of the aesthetic regime only insofar as this is freed from representative or ethical purposes. More precisely, what applies to the interest of New Internationalism is the descriptively cognitive judgement of the *concept* of art – not to be confused with aesthetic-normative judgements of *specific* works of art.

The reason that different types of theoretical investigations of judgement, regimes of art, and indeterminacy are relevant when analysing New Internationalism is that these concepts are inevitably at work in the concrete mechanisms of the art institutional apparatus. Each exhibition involves judgements: by the curator when selecting the works to be included, by the critics reviewing it, and by the audience who sees it. The following will therefore investigate the function of the formal and thematic global dimensions in concrete exhibitions.

The ambiguity of Magiciens de la terre

Magiciens de la terre, in 1989, was curatorially focused on global inclusion, and based its concept on selecting works by 50 Western and 50 non-Western artists. But it did not really reflect on the problematic aspects surrounding the notion of art in itself in relation to this new, global inclusion. Instead, *Magiciens de la terre* adhered to an understanding of art as transcendental, magical, and visually sensuous, in accordance with the kind of (outdated) formalist art theory presented a century ago by art historian Roger Fry, who believed that the sensuous qualities of a work of art (line, mass, space, light/shade and colours) were capable of arousing emotions of universal significance in the viewer.[320]

In spite of a normative curatorial concept that adopted a formalist point of view as its starting point, the exhibition itself, paradoxically, demonstrated institutional theory at work, when the curators decided to include Kane Kwei's

Mercedes, for instance, in the exhibition. The curators of *Magiciens de la terre* made *de facto* use of institutional theory, when appropriating the art-external everyday object of a coffin into the exhibition, thus transforming it from a work of craft into a work of art. When appropriated by the art world, the coffin became a work of art without any visible modifications, and thus became compatible with all other works of art, some of which were initially intended as craftwork, or as ritual objects, while others were intended as works of art from the outset. This levelling of the different objects at *Magiciens de la terre* was criticized by anthropologist Cesare Poppi, who rhetorically posed the following questions:

> [Why] has an African coffin not been displayed alongside a European coffin? Why did the organizers of the exhibition overlook function – or, conversely, why did they underplay the 'artistic' content of a European equivalent?[321]

Poppi touches here upon an important issue concerning the relation between art and the global: that in spite of the theoretical openness of institutional theory, its actual designations of art may occur for different normative reasons, including reasons that consider the everyday objects of some geographical or cultural origins more attractive than those of other origins. As Poppi polemically put it, 'Is there, today, anything African not worth exhibiting?'[322]

What Poppi alludes to in his rhetorical question is the tendency of curators to transfer items of popular/visual culture, *especially* from non-Western cultures, to the sphere of art. This is why an African but not a European coffin was included in the exhibition. The fact that this does not occur to the same extent with artefacts from Western cultures may be due to orientalizing or primitivist fantasies about the fascinating strangeness of 'exotic' cultures, and this is where the art institutional appropriation of the everyday object into the art world is in accordance with a *representative* rather than an aesthetic regime. Thus, the case is an example of the intermingling between aesthetic and representative regimes, in the following way: The fact *that* a coffin can be included in the art world follows the aesthetic regime's logic of equality, which is in accordance with the descriptive institutional theory of art, whereas the fact that the coffin must be *African* in order to be included follows the logic of a representative regime.

The issue of aesthetic versus representative logics could also be detected in the conversation on Black Art between Rasheed Araeen and Eddie Chambers,

referenced in Chapter 3. When he insisted that an artist had to have black skin in order to create Black Art, Chambers implicitly argued for a representative regime, in which the skin colour of the individual subject and his/her utterances need to be firmly linked. Conversely, Araeen's opinion – that the artist's skin colour and the subject matter of his/her art were not mutually related – accorded with an aesthetic regime of art, governed by ideas of freedom and equality.

Whereas the disagreement between Chambers and Araeen is understandable in the sense that they are two different individuals, the asymmetry between Western and non-Western objects exhibited in *Magiciens de la terre* seemingly emerged from the fact that the curatorial focal point was double, and tried to unite incompatible principles in one exhibition concept. *Magiciens de la terre* attempted to do two things simultaneously: On the one hand, it aimed to demonstrate a specific, formalist, Western theory of art – that is, a normative conception of art – and its ability to 'communicate sufficiently well in a visual-sensuous manner to a Western spectator'.[323] Hence, the curators' selection of works was based on their aesthetic-normative judgement. On the other hand, the curators of *Magiciens de la terre* wanted the exhibition to be globally inclusive in a non-discriminating manner, treating each piece of art equally, according to the cognitive judgemental criterion of selecting 50 Western and 50 non-Western artists – that is, a descriptive conception that can be said to be in accordance with an aesthetic regime and institutional theory.

Considered from this perspective, *'Primitivism' in 20th Century Art* at MoMA in 1984 in fact achieved what it set out to do. In this case, the curatorial aim was to elevate one specific theory of art – the formalist modernist narrative of early to mid-twentieth century art – to a universal level, by suppressing its cultural context. In order to support this agenda, the curators interpreted works from foreign cultures through the optics of their own specific view on art, which was the same formalist modernist theory of art that was later at work in *Magiciens de la terre*. However, the curators of *'Primitivism' in 20th Century Art* carried out this strategy in an unequivocal way, so that the obvious discriminatory asymmetry between Western and non-Western works of art exposed the intention of the whole show to promote one specific *normative* concept of art. Put differently, the MoMA curators of 1984 used whatever means were necessary to promote a formalist concept of art, which in this case involved making a more or less global claim for this concept.

Whereas the objective in *'Primitivism' in 20th Century Art* was to promote

a specific formalist concept of art, and the global alibi was the *means* to that end, the twofold strategy of *Magiciens de la terre* played both games in an impossible attempt to reconcile a normative-aesthetic, culturally contextual idea of art with a descriptive and cognitively based concept of global equality. Although *Magiciens de la terre* sought to reshape traditional Western spatial hegemony and the traditional conception of internationalism at the time, it did not consequently reshape the formalist art theory of Western modernism, which, hence, remained a traditional regional concept. Figuratively speaking, the result was that *Magiciens de la terre* unsuccessfully attempted to fit a square brick into a round hole.

Formal and thematic Chris Ofili

In 2004 Rasheed Araeen looked back at "The Success and Failure of Black Art", and criticized that 'the very presence of black artists in Britain and their work – whatever its nature – was and is seen as being outside the modernist mainstream.'[324] Though Araeen is right, the question still remains as to whether the reason that there are no black artists in modernist mainstream is simply that they are not *recognized* as black artists by the protagonists of New Internationalism – including Araeen himself. For instance, the architect Zaha Hadid, who was born in Iraq and has lived in Britain since 1972, is widely recognized as an 'innovative' or 'postmodernist' rather than a 'black' architect. Likewise, Anish Kapoor, born in India, is recognized as a talented sculptor, who has been awarded a place in the modernist mainstream – for instance, by winning Britain's prestigious *Turner Prize* in 1991, and with his huge installation in the turbine hall at the Tate Modern in 2002-2003. Kapoor is represented in the Tate collection by 50 works, the earliest acquired in 1983, so by then he already had a place in the mainstream, although, due to his Indian origins, he qualifies as a Black or 'AfroAsian' artist by Araeen's own definition.[325]

The point is that just as the protagonist of New Internationalism blames the art institutional mainstream for not seeing black artists, the discourse itself renders an artist like Kapoor invisible *due* to his recognition by the mainstream. Kapoor is simply absent from the writings of New Internationalism, and he is not included in InIVA's archive of artists.[326] Chris Ofili, on the other hand, who was born in Manchester and has lived his whole life in England, is included in the archive, and his name *does* come up in writings on Black Art in Britain. The following sections will discuss why and how Ofili qualifies as a black artist,

when Kapoor does not, in order to expose how New Internationalism itself sometimes merges the formal and thematic categories described above. In order to identify specifically how and why these confusions occur, it is necessary to account for Ofili and his work in detail.

Chris Ofili was born in Manchester in 1968 to Nigerian parents, and he graduated from the Royal College of Art in London in 1993. During his education, Ofili received financial support from British Council for a study trip to Zimbabwe in 1992, where he was inspired to adopt an artistic language resembling pointillism, consisting of thousands of small, coloured map-pins, placed side by side to form patterns and motifs. Additionally, he was inspired to use sealed elephant dung in his paintings – a feature which was later recognized as his artistic characteristic.

Looking back at his career, it is safe to claim that Ofili has achieved a position as one of Britain's most esteemed artists: In 1998 he won the *Turner Prize*, with the picture *No Woman No Cry*, which was a comment on the murder of a black child in London.[327] The picture was a mix of painting and collage, and the characteristic elephant dung is placed so it resembles a piece of jewellery in the woman's necklace. In the same period, Ofili was represented at the much-debated exhibition *Sensation – Young British artists from the Saatchi Collection*. When *Sensation* arrived at the Brooklyn Museum in New York, in the autumn of 1999, Ofili's art became widely known to the general public because his work at the exhibition, *The Holy Virgin Mary* was considered highly blasphemous by New York mayor Rudolph Giuliani, who – owing to the display of Ofili's work – came very close to withdrawing all financial support for the museum, and evicting it from its communal building. This occurred after a retired schoolteacher attempted to attack the work with paint.[328] According to Giuliani and representatives of the Catholic Church, the problem was that the picture of the holy virgin rather explicitly depicted several genitals – cut by Ofili from pornographic magazines – and furthermore that the Madonna's exposed nipple seems to be composed almost entirely of elephant dung. This scandal in New York constitutes a significant part of the art institutional reception of Chris Ofili, and at the time it inscribed him in the group of young British scandal artists at the *Sensation* exhibition, along with Marcus Harvey, Damian Hirst, Tracey Emin, and Marc Quinn.

Within Reach

Ofili's position as one of the most esteemed contemporary artists was further cemented when he was chosen to represent Britain at the Venice Biennial in 2003. Since its establishment in 1985 the Venice Biennial has been joined by several more countries for which there is physically no room in its core area, the *Giardini*, and the pavilions of these countries are therefore placed in locations scattered across the city of Venice and in the old navy area, the *Arsenale*. Chris Ofili was representing Britain in its national pavilion in the *Giardini* area, with an exhibition called *Within Reach*.

On that occasion, Ofili staged the British pavilion as one big installation, which included a number of new paintings. The recurring impression of the pavilion was the colour scheme of red, green, and black, which was present in the pictures, the colours of the walls, and the lighting in the pavilion. Already at the entrance outside the pavilion the audience was met with new flags on the three flagpoles of the pavilion: redesigns of the British *Union Jack*, with blue, red, and white replaced by red, green and black in three different constellations. Ofili had had the architect David Adjaye construct a large dome consisting of red, green, and black glass specifically to fit in the ceiling of the pavilion's central room, so even the natural source of light was filtered through these colours. Since the exhibition's paintings in themselves also followed this colour scheme, it was difficult to distinguish between which colour impressions came from the lighting and which were present *in* the pictures. The only way to determine what the pictures 'really' looked like was to view them outside the exhibition in a more neutral lighting. The exhibition thus seemed to comment on the fact that works of art are in reality constituted by their institutional framing, and do not exist beyond the discourse of the art world.

Thematically the pictures depicted images of what we may call 'African-ness' in different ways: First of all, the figures in the pictures were stylized or even caricatured Africans in their appearance, which included full lips and big hairstyles, and they were placed in a vigorously ornamented environment where a mound of elephant dung seemed to shine upon them like a sun from the upper left corner. Second, the pictures rested on the well-known supports of elephant dung, thereby turning a couple of ready-mades, of almost indexically African (or Indian) origin, into the very foundation of the pictures. By letting the pictures rest on the elephant dung supports, Ofili stressed the object nature of the pictures, and hence challenged the figurative African-ness of the motifs.

Third, the word 'Afro' was very often included in the titles of the individual pictures, like in the works 'Afro Apparition' and 'Afro Jezebel', where the titles were written on the two supports of elephant dung with the same type of map pins that was used to form the motifs in large parts of the picture plane. The extensive use of map-pins was reminiscent of a geographer or explorer who had lost his way, his scholarly overview and the scientific distance between himself and his map or model, and instead found himself embedded in a frenzy of African-ness.

Finally, the exhibition's colour scheme (red, green, and black) is a familiar symbol of the struggle of the Black Movement in different contexts. The colours originate from a flag designed by Marcus Garvey in 1920, when he established the *Universal Negro Improvement Association* in the USA, and they were meant to symbolize blood, country, and skin colour respectively, as the three things that unite the African people in a broad understanding. In an interview with curator Thelma Golden, published in the catalogue for *Within Reach*, Ofili himself stated that he was inspired by Marcus Garvey's struggle. Hence, Ofili's colour scheme was far from being a random play of colours, but an intentional attempt to transform the *Union Jack* into a *Union Black*, as Ofili himself stated.[329] Ofili's flags may further be considered in relation to David Hammon's work 'African-American Flag', from 1990. Hammon, too, has used elephant dung in his works.[330]

Taken together, it is safe to state that in 2003, Ofili's exhibition in the British Pavilion had an afro-look that was so distinct that one might be tempted to wonder whether it was, in fact, caricatured kitsch. Ofili himself claimed that the purpose of these works was for the African expression to act ambivalently:

> They are meant to be very sincere paintings. I intend, when I make them, that when they're finished I'll be able to look at them and go, 'Oh, that's really nice, that seems like a cozy and comfortable environment to be in.' I think the cynical view of things that exist in the paintings, I try to submerge a little bit.[331]

The cynical contents of the works – which he seeks to embed in a deeper layer under the visible surface – is related to an Africa that is linked to a *real*, and often painful history, while simultaneously it can be represented as a tropical or exotic *sign* or emblem, whether this representation happens through afro-hair or certain colour schemes. According to Ofili, this duality rests in the facts that

For those that have been to Africa, it's not paradise it's just another country with great beauty and great tragedy. But at the same time it can be seen as the mother-land, historically and biblically, as the beginning of everything.[332]

Even though Ofili is formally a British artist – and particularly in this case, since he was chosen to represent Britain in its national pavilion – his artistic work is thus based to a great extent on a personal sympathy with the idea of an African culture, as a place of origin, and as a utopia, and he describes the exhibition title, *Within Reach*, as an optimistic feeling of freedom, of 'something you feel is good for you [...] Then some days it is within reach, it is right there.'[333]

Bearing in mind Ofili's own statements, one can hardly reject his Afro-aesthetic as purely postmodern simulacrum. One could describe his works as being engaged in African themes, and even reasonably – but of course on an individual basis – pass the aesthetic-normative judgement that he does so successfully. Against this backdrop, it might be tempting to describe Ofili's art as international or global *due* to its authenticity as something that is not only associated with Africa through formal expression, but is actually *felt* as African by the artist, something that is therefore able to widen the perspective of a traditionally narrow-minded and Euro-centric art world. That, however, would be a great mistake, because it would confuse the artist's formal position in the institutional system with the artistic, thematic position expressed in his works. Hence, the main purpose of the above description of Chris Ofili's career as an artist is to firmly state three things: That Ofili is *formally* a British artist (and quite well established in that position), that he is engaged in 'the African' as a significant *thematic* part of the iconography in his works, and that it is important not to confuse these two levels.

The African pavilion

In 2007 Ofili was once again represented at the Venice Biennial, but much more discreetly. This time, his work was exhibited not in the British pavilion (instead, his *Sensation* colleague Tracey Emin represented Britain), but in the African pavilion, which was a new initiative that differed structurally from the other pavilions. First of all, this pavilion did not represent the art of one nation but that of a whole continent. During the last decade, however, there has been a tendency at the Venice Biennial to establish more joint pavilions in which a number of nations with small cultural budgets from one region establish common pavil-

ions. In recent years, a different and interesting phenomenon has emerged in the shape of pavilions for groups without nation states: In 2003 a Palestinian 'pavilion' was present through the project "Stateless Nation" – scattered throughout the biennial to mirror the Palestinians' own homeless situation; and in 2007 a Roma pavilion was present in a palazzo that displayed contemporary art of the European Roma, who are also a people without a nation state of their own.[334]

Second, the pavilion was placed as an integrated part of the *Arsenale*, surrounded by the internationally curated exhibition. And third, the initiative for the African pavilion was taken not by an African arts council but by the biennial's chief curator this year, Robert Storr, who made an open call for suggestions for an African pavilion, and then had a jury with insight into contemporary art from Africa select one curatorial proposal out of the 37 suggested. The selected curators' suggestion for the pavilion was to show a number of different artists' work from the private Sindika Dokolo Collection, which is located in Angola. According to the owner, Sindika Dokolo, an important characteristic of this collection is that it is an African *collection* of contemporary art rather than a collection of *African* contemporary art, and this characteristic was reflected at the African pavilion, which presented works by artists that were not necessarily African citizens.[335]

This time Ofili was represented by a much smaller, less spectacular work that does not include elephant dung: an undated, untitled ink drawing of a man with a lot of hair and a turban. The drawing itself measures just 4 x 3 cm., so even with its frame the work was easily overlooked at the pavilion. We can assume that Ofili's work was included in the private collection and at the African pavilion because the motif thematically associates with an African man, just as other non-African artists were represented by works that thematically refer to something ethnically or culturally African. For instance, a couple of silk prints by Andy Warhol, representing Muhammad Ali, were included.

In addition to works by non-African artists such as Ofili and Warhol, the pavilion represented what we may term formally African artists who are citizens of an African country, but whose works did not thematically refer to something particularly African. Kendell Geers, born in South Africa, and Mounir Fatmi, born in Morocco, could serve as examples of artists at the African pavilion who were born in different parts of Africa, but whose work is thematically more international than African. Hence, the curatorial coherence of the African pavilion at the Venice Biennial 2007 consisted of an African-ness expressed through the works thematically, *or* formally, *or* both.

The African genius

The difference between the formal and the thematic aspects of a work – be it in relation to calling it 'global', 'African' or anything else – was explained above with reference to Kant's distinction between cognitive and aesthetic judgement. But as mentioned, Kant's philosophy operated with two kinds of aesthetic judgement: the *aesthetic-normative* judgement, which applies to art, and which was used to explain the mechanism of the thematic level, and the *pure aesthetic* judgement, which was not relevant, since it does not apply to art. However, Kant united nature and art in the concept of the artist-genius – a concept implicitly contested by New Internationalism, because it seemed to frame non-Western contemporary artists as 'magicians', and because this often led to situations, recalling Adrian Piper's words: 'in which the main subject of investigation is the person, not the artefact.'[336] Despite the fact that the Western definition of the art concept changed significantly in the second half of the 20th century, from a normative theory of art to a descriptive one with the institutional theory, and the fact that New Internationalism intentionally articulated itself in opposition to the artist-genius, the institutional framing of Chris Ofili suggests that the artist-genius seems to haunt the practical realization of the discourse's intentions, as the following will discuss.

Beneath Ofili's small drawing at the African Pavilion in Venice in 2007 was placed a sign saying: 'Chris Ofili, Nigeria, Untitled'. Thus, the sign testified to the fact that, reception-wise, the thematic level of Ofili's work had permeated the frame of reference to an extent where the thematic African-ness had spilled into the formal level, and transformed the citizenship of Ofili himself from British to Nigerian.

Generally, there is nothing strange in interchanging analytical inspirations between an work's thematic and formal levels. The formal level – the discursive context surrounding the art object – often affects the analytical reception of the thematic level of the work to a point where motifs and themes are interpreted in certain ways. For instance, the specific exhibition context, or the fact that the viewer may have just read the artist's autobiography, is likely to influence the viewer's interpretation of a work. Likewise, the reverse may occur where the work's theme or motif may influence how the work is curated, exhibition-wise, or how the artist's background is interpreted. However, the case of Chris Ofili's institutional transformation at the Venice Biennial, from British in 2003, to Nigerian in 2007, constituted a striking example because Ofili's entire career

has unfolded formally within a British institutional framework. But institutionally, the formal status of Ofili's work now seems to be affected by the thematic engagement of his work. The same interpretative tendency was expressed in the small catalogue for the African Pavilion, where Sindika Dokolo stated that

> Artists such as Kendell Geers, Ghada Amer, Yinka Shonibare, Billi Bidjocka, Marlène Dumas, William Kentridge, Olu Oguibe, Chris Ofili and Pascale Marthine Tayou have made their way to London and New York and become consecrated while imposing their Africanness.[337]

It is true that Ofili has made his way to London and New York, but he travelled from Manchester, where he was born, and not from Africa. Thus, despite the fact that Ofili's entire career as an artist has taken place in a British institutional context – which is not strange, since he was born, raised, and lives in Britain – the thematic expression of his art has caused the reception of his own personal national and cultural background to be displaced in a direction in which his identity as Nigerian is emphasized.

The tendency was already at work in 2003, in a text published in the catalogue for Ofili's exhibition in the British Pavilion, where Stuart Hall, when commenting on the red-green-black colour scheme, stated that, 'The fact is, no European artist would or could conceivably dream in these forms and colours today.'[338] Apart from testifying to a lack of confidence in the creative ability of European artists, Hall's statement demonstrates that even a highly respected cultural theorist with thorough insight into post-colonial theory finds it difficult to accept that Ofili is a European artist, and thus confuses the work and the artist. It is fair to assume that people like the curators of the African pavilion, the collector Sindika Dokolo, and professor of Cultural Studies Stuart Hall would genuinely welcome a new international global equality within the art world. Therefore, in theory, they should be supportive of the institutional art theory as a non-discriminatory, open-source foundation. However, from the way they describe Chris Ofili's art, they signal otherwise.

The problem with such displacements between the reception of a work's thematic and formal levels is that it involves confusion of some art theoretical concepts, and that, eventually and against the intention of the discourse of New Institutionalism, this obstructs a globally orientated art institution. This happens because the curatorial and critical practices described above undermine the descriptive definition of art – which constitutes an important

foundation for globally equal evaluations – when these practices allow the African themes in Ofili's works to influence the reception of the formal level. Recollecting Preziosi's distinction between interpreting the-man-and-his-work and the-man-as-his-work, the latter seems to be the case when Ofili's general use of elephant dung and 'afro' colours transforms him into a Nigerian who has laboriously 'made his way to London.'

Perhaps the institutional confusion is caused by the fact that Ofili – by employing elephant dung – makes use of a material characterized by strong exotic indexicality (at least to critics living in areas where elephants are not common), since the dung stems from a real elephant and is not just artificially created to resemble or symbolize elephant dung. Indeed, faeces have been used previously, to comment ironically on Romanticism's belief in the ability of the elevated artist-genius to produce works of exceptional quality. In 1961, for instance, the artist Piero Manzoni produced the work *Merde d'Artiste* consisting of 90 cans (all carefully sealed, numbered, and signed), each containing 30 g of the artist's own faeces.

However, Ofili's use of elephant dung differs significantly from Manzoni's piece in that Ofili does *not* refer to the artist subject himself as an individual. Ofili utilizes elephant dung as a ready-made material which contributed to the creation of an African universe in the British pavilion, but at no time in his career has Ofili sought to transgress the borderline between artist and work, between art's formal and thematic dimensions. Ofili does not challenge or transgress what Michel Foucault terms the 'author-function' – which differs from the author's identity as a private individual – but remains steady in his role of an artist who produces art.[339] Nevertheless, the presence of indexical elephant dung ready-mades in the works' thematic dimension turns out institutionally to hold a symbolic authority over the artist in the formal dimension.

This may seem like nothing. After all, it is just a small sign, and a few lines of text. And if a minor false statement of something African is made at a place where it does not belong, New Internationalism should only be happy, since that would be a small step in the right direction, helping the art world to become more inclusive of non-Western art, right? But according to its original interests, New Internationalism wanted contemporary *art* to be judged seriously, without it being influenced by racial or cultural prejudices against the *artists*. That is, the art of non-Western artists should be judged along the same normative-aesthetic parameters that apply to art by other artists within the descriptive domain of the art world. To do so means to be aware of the grounds

on which judgements are passed, and – accordingly – to refrain from separating aesthetic and cognitive levels in some cases, and confusing them in others.

The fact that this confusion occurs at the Venice Biennial may not be entirely accidental, since the 19th century structure of the national pavilions promotes it. An African pavilion may be a non-Western addition to this structure, but at the same time it is a justification for considering contemporary art through formally national – or, as here, regional – filters that do not really make much sense any longer, since contemporary art *is* formally international or global, as described above. Thus, the realized curatorial practice of establishing new exhibitions or new pavilions of African, Chinese, or Indian art may be counterproductive in relation to the intentions of New Internationalism.

As the confusion between the formal and thematic dimensions of Chris Ofili's work demonstrates, the realization of the discourse's interest may happen at the cost of confusion of these two levels *within* New Internationalism itself. Institutionally, it is the discourse that has made contemporary African art possible, or 'in the true', at the Venice Biennial, but it is also some of the protagonists in the discourse that create the confusion between Ofili's work and his person. This matter will be pursued in the last chapter, in which the *Documenta 11*'s emphasis on the role of postcolonial theory and radical democracy is critically investigated with regard to how this implicates the interests of New Internationalism.

From art to ethnic politics

In the first issue of *Third Text*, in 1987, Rasheed Araeen published an article called "From primitivism to ethnic art", where he claimed that the notion of 'ethnic art', in relation to the contemporary art scene at that time, was no more than a new label for institutional primitivism in Britain.[340] Since then, the struggle of New Internationalism has led to a situation where contemporary art is naturally considered in a global perspective – as the development of *Documenta* over five decades demonstrates – although confusions between the artist subject and the work of art still occur.

This final chapter will argue that the success of New Internationalism within art institutions that understand themselves as working according to the intentions of New Internationalism has led to a situation that not only goes further than originally intended, but also in some respects marks a return to the ethnic focus that the discourse originally sought to move beyond. This situation has developed out of a double move: first, a move from 'contemporary (new international) art' to 'political art', and second, from 'political art' to 'ethnic politics'. In many respects *Documenta 11* manifested this development, as we shall see in the following.

Documenta 11

Documenta 11, in 2002, is particularly interesting when investigating New Internationalism, due to its curatorial concept, its reception by art criticism, and its chief curator. The chief curator of each *Documenta* exhibition is appointed about four years prior to the exhibition, by the *Documenta* supervisory board, and the board's appointment of the critic and curator Okwui Enwezor as the leading curator of *Documenta 11* aroused a great deal of attention among critics, due to the fact that Enwezor was the first 'non-European' *Documenta*

curator, being born in Nigeria. A German headline even called him 'Der grosse Mann aus Afrika' ('The great man from Africa')[341]. Enwezor has a thorough knowledge of contemporary African art, which he has demonstrated in numerous writings and in his curatorial work (for instance, he co-edited and contributed to the InIVA publication *Reading the Contemporary: African Art, From Theory to the Marketplace*, 1999, and he curated the 2nd Johannesburg Biennale in 1997). For *Documenta 11* he selected a team of co-curators, who all have extensive curatorial experience, several of them with significant new international affiliations. For instance, Carlos Basualdo and Octavio Zaya both have a thorough knowledge of Latin American modern art, Sarat Maharaj contributed to *Global Visions*, and Mark Nash has worked with Isaac Julien on films and writings on Franz Fanon.[342] Taken together, the curatorial team behind *Documenta 11* represented an insight into contemporary art on a global scale like no other team before them, so the precondition for a new international show was in place.

In his concept for *Documenta 11* Enwezor made it clear that he sought to challenge traditional ways of thinking about art in terms of its Western autonomous origin. He presented the challenge as a massive double move: First, on a broader cultural level in his catalogue text, Enwezor repeatedly stressed the importance of postcoloniality as a useful guiding tool for comprehending the world today. For instance:

> Postcoloniality, in its demand for full inclusion within the global system and by contesting existing epistemological structures, shatters the narrow focus of Western global optics and fixes its gaze on the wider sphere of the new political, social, and cultural relations that emerged after World War II. [...] The postcolonial space is the site where experimental cultures emerge to articulate modalities that define the new meaning- and memory-making systems of the late modernity.[343]

Recollecting the ethical and political agenda of postcolonial theory – as being not identical to New Internationalism's agenda of attention to visual art – Enwezor seemed eager to move beyond the confines of art. A fact he demonstrated by attacking the very autonomy of art in his statement that:

> Documenta11's spectacular difference is that its critical spaces are not places for the normalization or uniformization of all artistic visions on their way to institutional beatification. Rather, through the continuity and circularity of the nodes of

discursivity and debate, location and translation, cultural situations and their localities [...] Documenta11's spaces are to be seen as forums of committed ethical and intellectual reflection on the possibilities of rethinking the historical procedures that are part of its contradictory heritage of grand conclusions.[344]

One 'heritage of grand conclusions' that Enwezor particularly sought to rethink was the concept of the avant-garde, which he – in opposition to avant-garde theories of the Frankfurter School, and art critic Hal Foster – believed to be hindered by art's autonomy. Thus:

> To understand what constitutes the avant-garde today, one must begin not in the field of contemporary art but in the field of culture and politics, as well as in the economic field governing all relations that have come under the overwhelming hegemony of capital [...] all notions of autonomy which radical art had formerly claimed for itself are abrogated.[345]

Regarding 'overwhelming hegemony of capital' Enwezor was directly influenced by Hardt and Negri, and in accordance with their thoughts, Enwezor ascribed to the idea of fundamental plurality, 'the multitude', as a form of necessary resistance to the 'Empire' of a hegemonizing totality of market forces that governs all social life.[346] From Enwezor's point of view, the avant-garde potentials are logically situated in art works that actually mirror public spheres, and he highlights a work that reaches into the world of finance: Maria Eichhorn's *Aktiengesellschaft*, which consists of a stock company established by the artist and functioning in accordance with the rules of the financial domain, so that anyone who buys stocks in the company automatically becomes a co-owner of the work. The artefacts physically exhibited are the documents and papers related to the stock company, and the table at which the company was founded. By turning economic mechanisms into the work itself, and vice versa, Eichhorn thus seemingly transgresses the border between art's autonomy and free trade in order to reflect critically on both.

By making his attacks on both Western culture and art's autonomy the conceptual foundation for *Documenta 11*, Enwezor seemed to make a safe bet in his challenge of the body of traditional Western art institutions to which *Documenta* itself belongs. The radical character of *Documenta 11* is demonstrated by the fact that the curatorial team did not conceive of it as an 'exhibition' but instead as a 'project' and

[R]ather than subsume the concerns of art and artists into the narrow terrain of Western institutional aesthetic discourses that are part of the current crisis, we have conceived of this project as part of the production of a common public sphere.[347]

The curatorial concept of *Documenta 11* was practically carried out in two major ways: through a concept of 'platforms', and by appropriating political and social reality into the exhibition's framework.

The platform concept consisted of staging *Documenta 11* as five different platforms, or events, instead of just one, and was carried out by staging four different platforms, dispersed temporally as well as spatially, prior to the exhibition itself in Kassel, which was linguistically deprived of some of its central and primary status by being termed 'Platform 5'. Hence, through the platforms, *Documenta 11* attempted to escape the traditional Western confines of the *Documenta* institution at a structural level, by literally moving *Documenta 11* to new areas of the globe. Each of the platforms had its own title, and they took place accordingly:

Platform 1: *Democracy Unrealized* (Vienna 15 March-20 April 2001 and Berlin 9-30 October 2001)

Platform 2: *Experiments with Truth: Transitional Justice and the Processes of Truth and Reconciliation* (New Delhi 7-21 May 2001)

Platform 3: *Créolité and Creolization* (St. Lucia in the Caribbean 12-16 January 2002)

Platform 4: *Under Siege: Four African Cities, Freetown, Johannesburg, Kinshasa, Lagos* (Lagos 15-21 March 2002)

Platform 5: *Exhibition* (Kassel 8 June-15 September 2002)

Apart from their geographical dispersion, what immediately stands out about these platforms is their titles. Except for Platform 5, none of them signal any relationship to art, and neither did works of art or artists play significant roles – if any at all – at the platforms. Thus, apart from a film programme that accompanied the conference at Platform 2, there were no works of art present at the first four platforms. Instead, they were constituted as academic conferences

with different keynote speakers, talks, and panel discussions by professors and research directors in cultural studies, urban planning, political theory etc. The lectures from the seminars were subsequently published in comprehensive volumes from each platform.[348]

Only a small minority of artists, architects, and filmmakers participated in the first four platforms – among them the artist Alfredo Jaar in Platform 2, where, significantly, he stated on the fourth day of the conference that the platform's 'space of reflection is doubly necessary because it is put forth in the context of an art conference, and I emphasize the word "art", because we haven't heard that word in the last four days.'[349] Hence, from a traditional art institutional point of view, the platforms were very radical attempts to reach out to the non-artistic fields of culture, politics, and economy.

As demonstrated, New Internationalism in the visual arts has developed into and merged with the fields of localism, visual culture, and urbanism since the mid-nineties. To a great extent it seems that *Documenta 11* continued these developments and condensed them into one fulfilling project. As Enwezor put it, *Documenta 11* was concerned with localism in terms of 'cultural situations and their localities that are transmitted and perceived through the five Platforms', and the curatorial downplay of art took place with sceptical reference to art's *autonomy*, which is exactly what separates art from the field of visual culture.[350] As for the urban, in *Documenta 11* this was related very closely to the tendency to localism, for instance, in Platform 4, and *Documenta 11* further extended its activity beyond 2002 by publishing in 2003 a research project anthology entitled 'Urban Imaginaries from Latin America'.[351] Rather than appropriating non-Western-ness or 'the global' thematically into the Western art institutional apparatus, *Documenta 11* actually altered the very structure of this apparatus by displacing it both geographically and in terms of content, where art's autonomy – its Western characteristic – was replaced by global realities. Whereas the first four platforms dealt more with political and social issues than with art, the fifth and last platform was an actual art exhibition.

The curatorial strategy to reach out to areas outside the domain of art was described by Enwezor in his introductory essay in the exhibition catalogue:

> As an exhibition project, *Documenta 11* begins from the sheer side of extraterritoriality: firstly [sic], by displacing its historical context in Kassel; secondly, by moving outside the domain of the gallery space to that of the discursive; and thirdly,

by expanding the locus of the disciplinary models that constitute and define the project's intellectual and cultural interest.[352]

As described in chapter 2, the curatorial engagement with art-external domains was also present in *Document 5* and *10* – the latter was also concerned with globalization and postcolonialism. So the fact that *Documenta 11* manifested itself as a worldwide, inclusive project might prompt one to conclude that the latest *Documenta*, number 12, in 2007 was even more radical in this respect. However, the reason *Documenta 11* is generally considered to be the most globally orientated *Documenta* so far is that the curators of *Documenta 12*, Roger Buergel and Ruth Noack, chose to move in a different direction.

Documenta 12

The concept for *Documenta 12* involved three leitmotifs: 'Is modernity our antiquity?', 'What is bare life?', and 'What is to be done?'. Since the exhibition itself, however, was not organized in a detectable way around these motifs, they did not have much impact. The curators did not elaborate much on the concept, perhaps because they generally attempted to create an exhibition with more emphasis on the aesthetic as opposed to the political emphasis of *Documenta 11*. Thus, their preface to the catalogue reads:

> [E]xhibitions are only worth looking at if we manage to dispense with preordained categories and arrive at a plateau where art communicates itself and on its own terms. This is aesthetic experience in its true sense: The exhibition becomes a medium in its own right and can thus hope to involve its audience in its compositional moves.[353]

Whereas the curators themselves did not offer any elaborated explanation of their ideas, they conceived of a journal project to do so. Instead of different platforms, *Documenta 12* included a Magazine Project, in which 90 different art magazines from different parts of the world were invited to reflect on the three leitmotifs. However, as the Magazine Project was delegated to the magazines themselves, this project did not attract as much attention as the Kassel exhibition itself, which was reinstalled as the single, big event it has traditionally been. As David Cunningham and Stewart Martin from *Radical Philosophy*, which was among the magazines invited to the project, describe *Documenta 12*:

Perhaps the most obvious concern was that the Magazines Project was little more than an extravagant veil, deployed to conceal Buergel's neo-formalism from objections to its conservatism [...] From this perspective, the Project functioned to flatter the political-conceptual ambitions coming out of documentas X and 11, while effectively stunting their realization and dislocating them from the exhibition.[354]

As this comment illustrates, *Documenta 12* was generally not very well received by the critics. For instance, the headline for Richard Dorment's review of the exhibition in the *Telegraph* read: 'The worst art show ever'.[355] Viewed from the perspective of New Internationalism, however, the exhibition was successful, insofar as it included more non-Western artists than even *Documenta 11*, despite the fact that neither globalization nor post-colonial theory played any role in the curatorial concept. As art historian Claire Bishop wrote, in an analysis generally critical of the exhibition, its most distinctive characteristic '[W]as an emphasis on non-canonical, non-Western art, with particularly strong presentations from South America, Eastern Europe and India.'[356]

Interestingly, the exhibition included several works of art that temporally as well as culturally were not confined to the boundaries of 'Modern Western art'. Displayed next to contemporary works were, among other things, a Chinese lacquer work panel from the 17th century, a Persian miniature from the 14th century, and a 19th century bridal face veil from Tajikistan. This inclusion of older works in *Documenta 12* created some controversy; as Bishop explains:

> What prompted debate in documenta 12 was the way in which these artefacts were presented alongside contemporary objects without contextual information, apparently flirting with the crimes of *'Primitivism' in Twentieth-Century Art: Affinities of the Tribal and the Modern* (1985) and *Magiciens de la Terre* (1989), two exhibitions that received extensive criticism for their neo-colonial imposition of Western art historical norms upon non-Western artefacts.[357]

One could argue, however, according to the logic of Danto and Belting, that the bringing together of such different works and artefacts rendered the show truly contemporary, since it created a simultaneity of otherwise heterogeneous temporalities. And that gave rise to a certain degree of indeterminacy and, thus, potentially aesthetic experience. Compared to this aesthetic approach of *Documenta 12*, it seems that *Documenta 11*'s strong commitment to challenging traditional structures of Western modernism made it a more successful

articulation of the interest of New Internationalism. The aesthetic dimensions of *Documenta 11*, however, are worth closer consideration.

Aesthetic dimensions of *Documenta 11*

As a consequence of its curatorial strategy, *Documenta 11* was partly met with the same kind of critique that Rosalind Krauss and others levelled at the notorious *Whitney Biennial 1993* and, as curator and writer Norman Kleeblatt stated, *Documenta 11* 'was caricatured as being not adequately aesthetic, short on pleasure, highly political, and too didactic, as well as using objects with multiple taxonomies.'[358] However, the fact that *Documenta 11* used objects with 'multiple taxonomies' actually contrasts the claim that it was 'not adequately aesthetic', according to the logic of Martin Seel. As described above, indeterminacy plays a significant role in the establishment of aesthetic relation, and the taxonomic plurality of the objects/phenomena included in *Documenta 11* – the same thing can be considered a happening, a stock joint company, an installation, a work of art etc. – may reconcile the audience's experience with indeterminacy, and is therefore likely to result in aesthetic experience.

This 'un-disciplinarity', to use Rogoff's description of Visual Culture, which was at work in *Documenta 11*, is stressed in the exhibition catalogue in the texts by Jean Fisher and Sarat Maharaj, who both contributed to *Global Visions* in 1994, too.[359] Fischer refers to the trickster as an ideal character for creating artistic modes of communication. The trickster is not limited by the morality governing particular discourses, but takes advantage of discursive anomalies. In addition, the trickster 'functions as a mediator and translator between the spheres of the divine and the human, or between different languages and discursive systems.'[360] And in his text for the *Documenta 11* catalogue, Maharaj uses the notion of 'xeno-epistemics' to describe how 'the visual interacts with sonic-tactile-somatic registers' in contemporary art, to launch '"other ways" of knowing and ways of knowing "otherness".'[361] Hence, the 'objects of multiple taxonomies' translate between different discursive systems, and enabled xeno-epistemics to transgress our expectations regarding specific art forms, and, perhaps, art as such, and to create indeterminacy.

Through its vast concentration on art-external domains in the platform themes, and the deliberate privileging of art works that interact with other discourses, *Documenta 11* thus activated not only *artistic* experience but also, and perhaps especially, *aesthetic* experience. Therefore, the use of 'multiple

taxonomies', which is considered negatively and as standing in opposition to 'adequately aesthetic' in the quote above, actually might facilitate *greater* aesthetic experiences than visual excitement alone is able to provide. Accordingly, it may be accurate to consider *Documenta 11*'s attempt to challenge the sphere of art as an aesthetic turn in the Kantian sense. This aesthetic turn, however, should not be mistaken for the focus on the visual, sensuous experience of things, as promoted in *Magiciens de la terre*, but rather arises from the communication between different taxonomies of art and reality. This raises the question, however, of how a global perspective may fit into this aesthetic turn.

Postcolonial versus global dimensions of *Documenta 11*

The global seemed to be present as a consequence of the curatorial concept of *Documenta 11*, in two ways: by the direct references to postcoloniality in the curatorial statements, and by favouring works that engaged strongly with art-external domains of everyday life and mechanisms of globalization. Regarding the former, the curatorial references to postcoloniality, however, it would be more precise to distinguish between 'postcoloniality' and 'the global', as does Enwezor himself, than to consider the two notions similar.

Postcoloniality, which is what Enwezor subscribes to in his *Documenta 11* catalogue text, is a set of theories and practices engaged in disclosing and replacing the structures of former colonial suppression with strategies 'to lay claim to the modernized, metropolitan world of empire by making empire's former "other" visible and present at all times."[362] Postcoloniality, therefore, as we have seen, offers first and foremost *ethical* counter-models to the grand narrative of European modernity. For instance, Enwezor describes postcoloniality partly as a 'regime of subjectivity' and characterizes its difference from postmodernism like this[363]:

> While postmodernism was preoccupied with relativizing historical transformations and contesting the lapses and prejudices of epistemological grand narratives, postcoloniality does the obverse, seeking instead to sublate and replace all grand narratives through new ethical demands on modes of historical interpretation.[364]

Whereas the difference between postcoloniality and postmodernity thus lies in the ethics of the former as opposed to the relativity of the latter, what separates

postcoloniality from globalization, for Enwezor, seems to be the *good* ethics of postcoloniality as opposed to the *bad* (Western) ethics of globalization. From the way Enwezor describes 'the global' it seems that he interprets it as similar to the way 'internationalism' was understood before New Internationalism came along. For instance, he uses phrases like: 'The postcolonial aftermath of globalization', 'Postcoloniality, in its demand for full inclusion within the global system'; and 'the narrow focus of Western global optics'[365], and the only difference between the 'old-internationalism' and the global seems to be that the latter is much more totalizing. Thus, with reference to Hardt and Negri, Enwezor speaks of Empire as a 'new type of global sovereignty [... which is...] materializing, hegemonizing, and attempting to regulate all forms of social relations and cultural exchanges'.[366]

The fact that Enwezor subscribes to postcoloniality, rather than what he terms 'globalism', is also evident from the placements of the platforms of *Documenta 11*, which, it may be appropriate to recall, took place in Vienna/Berlin, New Delhi, St. Lucia, Lagos, and Kassel.[367] Apart from the first and the last – the German-Austrian framing – the geographies involved specifically have a history of colonization by England and France, and it would be safe to claim that the locations of the platforms were not selected randomly across the globe. Enwezor's embracing of postcoloniality suggests that the locations of the platforms could not just have been replaced by, for instance, St. Petersburg, Seoul, and Chicago.

At a general level, the view that postcoloniality, according to Enwezor, seeks 'to sublate and replace all grand narratives through new ethical demands on modes of historical interpretation' is supported by the postcolonial theorist Gayatri Chakravorty Spivak. However, Spivak takes a much more critical stance towards the character of the ethics demonstrated by postcoloniality.[368] First of all, she does not understand postcoloniality and the global as being in opposition to each other in the same way that Enwezor does. Instead, she distinguishes between

> *[N]eo-colonialism* – dominant economic, political, and culturalist manoeuvres emerging in our century after the uneven dissolution of the territorial empires – and *postcoloniality* – the contemporary global condition.[369]

Thus, Spivak uses the notion of 'postcoloniality' in a more neutral manner – as a description of the 'contemporary global condition' – than Enwezor. Second,

Spivak seems to distinguish between postcoloniality and postcolonialism, and interestingly she has a different view on the ethics of the latter than Enwezor, insofar as she is very critical of what she terms a tendency to 'academico-cultural "postcolonialism"'.[370] She identifies the basis for this tendency in the texts of Kant, Hegel, and Marx, and estimates that 'these source texts of European ethico-political selfrepresentation are also complicitous with what is today a self-styled postcolonial discourse.'[371]

According to Spivak, the problem of this 'Elite "postcolonialism"', to which – she admits – she perhaps belongs herself, is that it 'seems to be as much a strategy of differentiating oneself from the racial underclass as it is to speak in its name.'[372] Considered from this point of view, one could argue that Enwezor's concept for *Documenta 11* belongs to 'Elite "postcolonialism"'. After all, is an art exhibition capable of seriously empowering the poor and suppressed of this world, by placing a few elite seminars and conferences in Third World locations? Or by favouring art works that engage with global issues or involve local communities, by using them as artistic material for a limited period of time? What is important to stress at this point is that however different their positions may appear as they are represented here, Enwezor and Spivak agree that the postcolonial is indeed a matter of ethics.

This brings us back to the artistic regimes of Rancière, because even though the indeterminacy created by many works' engagement with art-external domains rendered *Documenta 11* aesthetic, the strong emphasis on postcoloniality in the curatorial concept on the other hand seemed to draw the exhibition towards an ethical regime of art. By stressing the postcolonial in the overall conceptual framework of *Documenta 11*, the works seemed assigned to the specific ethical agenda of postcolonialism, and in this respect the principles of freedom and equality that govern the aesthetic regime did not apply to this dimension of the exhibition. Roughly, the ethics of *Documenta 11* dictated that 'the displaced – those placed on the margins of the enjoyment of full global participation' are favoured.[373] Thus, *Documenta 11* was governed by aesthetic as well as ethical principles.

In this sense, it is important to recognize that the global dimensions of the exhibition did *not* stem from the postcolonial, ethical concept, which – following the logic of Spivak – may be considered a symptom of Western 'elite "postcolonialism"'. Instead, the global dimensions and the aspirations to equality were embedded in *Documenta 11*'s aesthetic character – more precisely, in the works' singular thematic engagement with various global

realities outside the domain of art itself. Thus, the global engagement was not in itself part of the curatorial concept, which was governed by postcoloniality, but followed from contemporary art's interest in non-artistic domains as such, since the many faces of globalization are important parts of societal reality today. Therefore, the global was directly demonstrated as specific lived experiences that were considered in works of art. Consequently, the global aspect of *Documenta 11* was an 'accidental' by-product, resulting from the curatorial selection of works of art that articulated concrete and contextual realities rather than standing out as transcendental, magical objects like the works in *Magiciens de la terre*.

Conclusively, *Documenta 11* actually did realize an important initial interest of New Internationalism by recognizing artistic modernity, what Enwezor referred to as avant-garde today, wherever it was to be found in forms like a bicycle service by Meshac Gaba, mobile ice-vendors by Cildo Meireles, photographs by Ravi Argarwal, a joint-stock company by Maria Eichhorn etc. The fact that the artists mentioned here are from Benin, Brazil, India, and Germany respectively was merely an 'accidental' circumstance. What mattered to *Documenta 11*'s curatorial team was the fact that the works by these artists and many others thematically fitted the concept of searching for the avant-garde of today in art-external domains.

Fundamentally, a significant difference between *Magiciens de la terre* and *Documenta 11* consisted in *how* the exhibitions appropriated the art-external. If, for a moment, we imagine that *Documenta 11* had included Kwei's *Mercedes* in its Platform 5 exhibition, along with Eichhorn's joint-stock company, it would almost certainly have been in order to stress its art-external aspect – to adhere to Ghanesean funeral culture in an odd manner, just as Eichhorn's work adheres to stock trade and the institutional physicality of *Documenta* in an odd manner. It would not have been included in order to promote visual sensuous art as a normatively global phenomenon.

Political art: art as authenticity

As demonstrated by the works at *Documenta 11*, contemporary art very often intervenes in or considers the practices of real life. It is helpful to look into some of the strategies that artists and curators adopt when incorporating life into the domain of art, since these strategies affect how the globalization of contemporary art is managed today. The problems occur when the concepts

of 'art', 'autonomy', and 'authenticity' are confused, and a brief glance at these terms may therefore be useful.

When art is understood in accordance with institutional theory – meaning that art is not defined by sensuous qualities, subject matter or origin, but instead by the very inclusion of an artefact or phenomenon in an institution – the term 'art' is used entirely descriptively.[374] This institutional conception of art relates closely to the idea of art's autonomy, and its freedom from ethical or representative ties, as explained by Rancière. While originally developed in a normative way, as a term to cover privileged aesthetic experiences, or as a channel for liberating the spirit, the autonomy of art as understood today is closely linked to the framework of the bourgeois art institution as a space or sphere where works of art are *considered* separately from other discourses in society.[375] By participating in an institutional discourse on art, as opposed to existing in an everyday discourse, the status of art is ascribed to the object, and it is regarded as holding an autonomous quality which enables it to both comment on and observe everyday life 'from the outside', so to speak. Hence, art's autonomy is just as descriptive as the bourgeois understanding of art itself, since it is an essential aspect of art.

Conversely, the term 'authenticity' is highly dependent on context, and functions at a different level than art and its autonomy.[376] It does not make sense to speak of 'authentic art', since art in its descriptive definition either is or is not art; but one can speak of authenticity in relation to artists, as well as to the subject matter or material of a work of art. For instance, it may make sense to ask if a work is made of authentic wood, or of plastic made to look like wood; if a skinned rabbit 'really' looks like it does in a painting, etc.

Furthermore, the presence of an authentic artist is of the utmost importance in art institutions, which is why art museums, in general, deliberately do not include works by anonymous artists in their collections. Anonymous works mainly exist in collections of older art: for instance, a work might originally have been included in a private collection because of its sensuous qualities, the collector not minding the anonymity of the artist; conversely, a work may no longer be attributed to a particular artist, as happened in the case of a number of Rembrandts that were examined by the Rembrandt Research Project in the 1980s and 1990s and found not to be by the great master himself. Nevertheless, the definition of art applied by institutions to works of art has proved to be more important than the identification of an artist, since the works deprived of their Rembrandt status have not been removed from museums' collections,

but merely repositioned to less prominent walls, and provided with a 'follower of', 'circle of' or 'style of' prefix.

Apart from questions of descriptive authenticity regarding the genuineness of the artist, the material, and so forth – questions that can be answered by a simple 'yes' or 'no' – many contemporary works of art deal with authenticity as a *value-laden* part of the work's subject matter on the thematic level. When artists intervene in the political or social domains of everyday life in a globalized world, it is often an important part of the work that the motif or strategy stems from a socio-politically authentic reality. Maria Eichhorn's *Aktiengesellschaft* and Cildo Meireles' *Insertion into circuit: Coca-Cola* have already been mentioned as examples of works whose motif or strategy stems from the trade mechanisms in a domain of economic reality, but other works go even further in their engagement with economic reality. For instance, another prime example of a work collaborating with the art-external domain of global capitalism and trade is the *Guaraná Power* project (2003-) by the Danish art group Superflex, which aims at changing the trading conditions for Guaraná farmers in the Brazilian Amazon. To allow the farmers to be independent of the traditionally unfavourable prices offered by the multinational soft drink companies, Superflex cooperated with the farmers to set up their own company to produce the "Guaraná Power" soft drink brand, which allows the farmers to benefit directly from the sales, rather than retailers and producers from outside.[377]

Superflex's *Guaraná Power* is clearly authentic insofar as the project actually exists in real life, outside the domain of art: the "Guaraná Power" soft drink is sold in stores and bars to customers who may not be aware of the product's involvement in the sphere of art. Simultaneously, however, the project upholds its autonomy as a work of art in the framework of the art institution, in that it is displayed in exhibitions, listed in catalogues, reviewed by critics and so on.[378] If we tentatively update Kant's distinction between natural and artificially made objects to one that replaces artificially made products with art, and nature with non-art, we may more accurately understand how Superflex's work can be subject to *both* pure *and* normative aesthetic judgements, regarding the context in which it is experienced. When enjoyed (or not) as a beverage from a store, "Guaraná Power" is 'pure' reality; and when considered as a work of art, it *cannot* be pure reality. No matter how much the work thematizes reality, how much it engages with and appropriates reality, it does not cross the line and become reality, when considered as art.

Hal Foster has described this relationship between the formal autonomy of art and the authenticity of reality incorporated *in* art in his book *The Return of the Real* (1996). According to Foster, it is not a question of relating to *either* art *or* life, as traditional avant-garde theories would have it.[379] Instead of attempting to conquer the art institution with real life, various avant-garde movements (especially the second neo-avant-garde of the late 1960s) have worked to describe, analyze, and test the institution, and

> As a result contemporary artists concerned to develop the institutional analysis of the second avant-garde have moved away from grand *oppositions* to subtle *displacements* (...) and/or strategic *collaborations* with different groups (...).[380]

Thus, autonomy and *thematic* authenticity co-exist to a great extent in contemporary art, but do not depend on each other, since they belong to different orders. Evidently, it is possible for a work of art to be formally autonomous – since art is defined as such – without relating directly to authentic everyday life in its content, in the same way as a project or an artefact that engages with the domain of daily life is not necessarily accepted as a work of art.

A more positive view on the ability of works to stage themselves as life is presented by professor of philosophy and art theory Boris Groys in the catalogue for *Documenta 11*. Groys sees 'art documentation' as a new strategy of contemporary art that differs from the traditional work by relating more accurately to real life:

> It is no coincidence that museums are traditionally compared to cemeteries: by presenting art as the end result of a life, they obliterate this life once and for all. Art documentation, by contrast, marks the attempt to use artistic media within art spaces to *refer* to life itself, that is, to a *pure* activity, to *pure* practice, to an artistic life, as it were, without wishing to present it directly.[381]

The reason for contemporary art to engage in art documentation is, according to Groys, that we live in a biopolitical era that results in "shaping of the lifespan itself – in the shaping of life as a pure activity that occurs in time."[382] And, as he phrases it:

> The dominant medium of modern biopolitics is thus bureaucratic and technological documentation, which includes planning, decrees, fact-finding reports,

statistical inquiries, and project plans. It is no coincidence that art also uses the same medium of documentation when it wants to refer to itself as life.[383]

Thus, when a work of art includes economic strategies, cost-benefit analyses, or participation inquiries it is because the work wishes to stage itself as the 'pure' activity of life that it refers to and comments on. By camouflaging the work as reality, the artist, according to Groys, provides it with an ability to participate in the *political* shaping of life. And the avant-garde debates about art's ability or inability to become real life are fundamentally governed by the question of art's ability to act politically.

Relational aesthetics

A much debated contribution to the discussions of the relationship between contemporary art and life is curator and art critic Nicolas Bourriaud's idea of *Relational Aesthetics*. Bourriaud describes contemporary art, especially of the 90s, as a 'social interstice' that should neither be contemplated nor walked through, but be 'lived through, like an opening to unlimited discussion.'[384] Thus, whereas Foster describes contemporary art's engagement with political and social issues as existing *within* the art institutional framework, and Groys suggests that art documentation refers to and stages itself *as if* it is life, Bourriaud is more enthusiastic about contemporary art's ability to *be* life.

According to Bourriaud, contemporary art is able to constitute micro-communities that actively include the audience – which, hence, are considered 'participants' – and initiate and embrace *real* human relations. The notion of relational *aesthetics* tells us that because Bourriaud considers works of art as aesthetic practices rather than art, his ideas are not limited by art's institutional framework. As he states: 'Relational aesthetics does not represent a theory of art [...] but a theory of form.'[385] Theoretically, then, relational aesthetics is a different discursive formation than that of art, and Bourriaud explicitly states that 'the "institutional criterion" dear to Danto seems to me to be a bit limiting'.[386] Yet, Bourriaud's discursive formation of relational aesthetics happens to consist exclusively of contemporary works of *art* that, according to Bourriaud, constitute relations.

Examples of some of the artists whom Bourriaud points to, as working in accordance with relational aesthetics, are Félix Gonzales-Torres, Liam Gillick, and Rirkrit Tiravanija, which may demonstrate that the idea of relational aes-

thetics does not discriminate between the artists' geographical origin. In fact, Bourriaud identifies the historical origin of relational aesthetics as a 'world-wide urban culture' emerging after World War II, and he sees it as a 'radical upheaval of the aesthetic, cultural, and political goals introduced by modern art' – which, as discussed earlier, were synonymous with Western art.[387] Significantly, Bourriaud claims that 'Contemporary art is definitely developing a *political* project when it endeavours to move into the relational realm by turning it into an issue.'[388]

Now, it is clear that Bourriaud does *not* consider the works in question from the perspective where their status as art is important, but does he really consider them aesthetically? Insofar as he identifies their specific function – or even purpose – as that of creating relations, the experience of the works is no longer governed by indeterminacy, and, as Claire Bishop has argued, Bourriaud does not seem to pass any judgement on the works, either.[389] Bishop tests Bourriaud's idea that contemporary art is political, due to its 'move into the relational realm' against the political theory of Laclau and Mouffe, and she concludes that the works promoted by Bourriaud fail to be political because they suggest – according to Bourriaud's interpretation – that any kind of relation is always a *good* relation. Hence, the fact that antagonistic conflicts constitute any political field, according to Laclau and Mouffe, is ignored by Bourriaud. Furthermore, if all relations are automatically considered to be good relations, no aesthetic judgements are involved in relational aesthetics. Bishop promotes the works by Santiago Sierra and Thomas Hirschhorn as examples of works of art that *successfully* articulate the political, because they reveal tensions; whereas the works by Bourriaud's own favourites, Tiravanija and Gillick, *fail* to do so. And interestingly, the tensions that are revealed by the work of Sierra and Hirschhorn exist in the gap between art and reality, as Bishop states:

> The work of Hirschhorn and Sierra is better art not simply for being better politics (...). Their work acknowledges the limitations of what is possible as art ("I am not an animator, teacher or social-worker," says Hirschhorn) and subjects to scrutiny all easy claims for a transitive relationship between art and society.[390]

Thus, Bishop's view is in accordance with that of Rancière, insofar as the authentically political in contemporary art resides in '*how* contemporary art addresses the viewer', not what contemporary art *wants* – for instance to create relations.[391]

163

What Rancière, Foster, and Bishop argue against is a general institutional tendency to unjustly promote art as 'political' due to its thematic engagement with an authentic political reality – and not correctly, due to the works' status as art within an aesthetic regime. According to Rasheed Araeen, this 'political' turn of contemporary art stems primarily from postcolonial theory, which to a large extent 'is what has prevented us from achieving our full objectives.'[392] What has happened to New Internationalism is that along the way 'The struggle has been highjacked', as Araeen puts it, meaning that artists of colour today are heralded not as artists, but as exiled victims, and 'the victim is important for the liberal gaze, it is the way the powerful prove their humanism, and thus deflect the critical gaze of the deprived from its source of power.'[393] Since it has become institutionally fashionable to represent authentically political victims in art, artists that somehow themselves can be staged as authentic victims are regarded as creating even more authentically political art. As Araeen describes the situation:

> In the name of a political or critical engagement, a Palestinian artist can now articulate his or her experiences of exile; an Iranian artist living in New York can now represent the condition of Iranian women in Iran today in a highly exotic fashion; Chinese artists can make fun of what is going on in China; South African artists can show us what happened during apartheid, and so on.[394]

Foster has critically analysed this postcolonial-political tendency of contemporary art, and argues that three problematic assumptions govern this tendency:

> First is the assumption that the site of political transformation is the site of artistic transformation as well [...] Second is the assumption that this site is always elsewhere, in the field of the other [...] Third is the assumption that if the invoked artist is not perceived as socially and/or culturally other, he or she has but limited access to this transformative alterity, and that if he or she is perceived as other, he or she has automatic access to it.[395]

Whereas Foster's critique mainly addresses artistic practice – artists' focus on ethnographic themes – it is also a suitable description of the current institutional/curatorial tendencies. What is disturbing, from the perspective of New Internationalism, is not the relationship between art and life. Since authentic life as a theme in a work of art is already part of the art institution at a formal

level – insofar as it exists in art, and art formally belongs to the art institution – the work's status as art is safeguarded. But when political authenticity is applied to the status of the artist subject, for instance, a 'genuine' cultural exile, things get confused. Thus, the question of authenticity is yet another issue that separates postcolonial theory from New Internationalism. Not only may the formal and thematic dimensions of the work be mistaken, as in the case of Chris Ofili's work described above, but art itself – the nodal point of New Internationalism – is at risk, which will be elaborated in the following.

Authenticity beyond art

Whereas the above investigated the move from framing (non-Western) art as 'contemporary' or 'global' to framing it as 'political' art, this section analyses the turn from political art to what we may call 'ethnic politics'. Until now it has been argued that the tendency towards art's thematic engagement in political authenticity is unproblematic – though this is not what 'really' renders art political, according to discourse theory. However, a different strategy of incorporating authenticity seems more disturbing to New Internationalism: Namely, the curatorial tendency to bring thematic statements on authentic life directly into the art institution, by bypassing the works of art altogether. The following will analyse this tendency by looking into how it is identified, why it emerges, and what implications it brings about.

In the present curating of international contemporary art, there is a tendency to curate not only the works of art on display, but also fragments of political and social reality that may serve as contextual backdrops or explanatory material for the works of art. These elements of real life are presented in the form of images (documentary photos), texts (written by theorists in the political or social domain, and often not concerned with art at all), or talks and discussions (on issues of a political or social nature).

This tendency to curate political or social *reality* – not art – is easily demonstrated through a few examples of exhibitions of international contemporary art. The exhibition catalogue for *Cities on the Move* (1997-1999), for example, is full of colourful images showing neon-lit mosques in Indonesia, traditionally-dressed Hindus speaking on their cell phones, the chaos of white-collar traders at the Shanghai Stock Exchange, and so on. Likewise, the catalogue for *Populism* (2005) – an exhibition project on the concept of populism in a broad sense, which took place in four European cities – contains several essays by writers

working with international affairs, such as philosophy and gay activism, and research into social, political, economic, and educational affairs.[396] Writing about the exhibition, *Inklusion/Exklusion* (1996), Charlotte Bydler describes how a symposium in connection with the exhibition functioned as a way 'the contractor could order the globalization s/he wanted for an exhibition symposium.'[397] As Bydler observes, 'the invited key-note-speakers for the most part had not seen the art show [...] they offered general points on the globalization of economy, society and culture.'[398]

More radical is the incorporation of art-external reality in *Documenta 11*'s considerations of the contemporary avant-garde from a postcolonial perspective. Like the *Populism* catalogue, the final, comprehensive catalogue for *Documenta 11* contains essays by writers who are not normally concerned with art, in this case social scientists Simone AbdouMaliq and Sverker Sörlin. Moreover, the catalogue's first 30 pages contain neither a colophon nor a list of contents, but only a riot of documentary photos showing refugee camps, Israeli soldiers with machine guns, protesters at a G8 summit, the disaster of 9/11 etc. These introductory documentary photos of the *Documenta 11* catalogue are neither reproductions of works made by artists nor mere visual graphics created by the

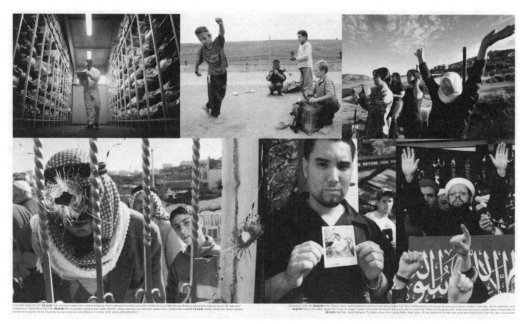

5. Spread of page 22-23 from the catalogue for *Documenta 11*, press photos

graphic designers of the catalogue, but apparently serve as thematic statements on life outside the art world.

Specifically, these photos differ from the reproductions of works further inside the catalogue by displaying rasterizing: a grid of fine, coloured dots that are not present in the reproductions of the works of art proper. The photos are thus visually coded to look as if they are seen through a medium of poorer quality than an art catalogue, for instance a newspaper or a TV monitor, which aligns them with a more authentic credibility. In addition to this visual code of authenticity, the captions differ from the captions for the works of art by dating each photo and by elaborating on the motifs of the photos, but not on their

6. Spread of page 177 from the catalogue for *Documenta 11,* still photos from video work

technical origin, which, conversely, is customary in relation to art photography (for instance: 'silver gelatin prints on paper', 'c-print', '35 mm black and white transparencies', etc.).

For example, the caption for artist Kutlug Ataman opening in the *Documenta 11* catalogue reads "KUTLUG ATAMAN *Semiha B. Unplugged*. 1997. Video: color, sound, 7 h. 45 min." This specific work by Ataman refers to the life of an authentic Turkish opera singer, but the thematic authenticity of the work is not mentioned in the caption. The opening for page 22-23, however, is much longer.[399] The caption from page 22 will serve as a sufficient example:

CLOCKWISE FROM TOP LEFT: **02-12-02** Tuzla: A forensic expert at the Institute for Missing Persons attempts to identify some of the remains of around 3500 Bosnian Muslims, most of them from the former UN 'safe zone' of Srebrenica. DAMIR SAGOLJ/REUTERS **08-30-96** With the ceasefire holding for over a week, daily life is slowly returning to the Chechnyan capital, Grozny. MINDAUGAS KULBIS/AP **12-16-01** Hebron: Palestinian Yakoub Idkadak, member of the Islamic Hamas movement, has been killed by Israeli soldiers in his home. NAYEF HASHLAMOUN/REUTERS[400]

Hence, the catalogue not only grants an insight into the works of art in the exhibitions and the artistic tendencies they follow, but also provides the viewer/reader with information on and analyses of the political and social realities outside the discursive domain of the specific works of art, thus seeming to transgress the autonomous art world in general in accordance with one of the major curatorial intentions of *Documenta 11*.

Far from encouraging art to reach out to authentic life, as seen in strategies like the documentary installations of Superflex and many others, this curatorial tendency is instead an attempt to curate authentic life *directly* into the art institution. Why, however, do curators find it necessary to provide the art institution with the real life of globalization, when contemporary artists already address such issues thematically to a large extent in their work?

Whereas contemporary artists – both historically and in the present-day – that include life in their works of art do so without anticipating a transgression of the autonomy of the art institution (as described by Foster and Groys), the curatorial tendency to connect with real life actually seeks to do so by dismantling artistic autonomy. The political and social themes considered by

curators simply seem more real when not tainted with the autonomous aura automatically attached to works of art. The aim is to present not only artistic interpretations of and comments on real life, but real life itself, and the curatorial strategy is thus comparable to the historical avant-garde's attempt – as conceived by Peter Bürger – to destroy art's autonomy in bourgeois society.[401]

The strategy resembles a psychoanalytical attempt to bypass the symbolic phantasms of reality in order to reach the Lacanian real, and thus finally to face unmediated truth. Hal Foster criticizes this tendency, which he considers an anthropological turn within contemporary art, because it treats real, non-Western cultures according to primitivist fantasies of otherness.[402] Here, however, it is the curator, not the artist, who explores; and unlike the case of *Magiciens de la terre*, what is explored is not exciting, different artistic cultures, but the field of non-art altogether, in an attempt to shed light on the *real* real. This tendency gives rise to two interrelated problems, one technical or structural, and the other more essential.

First of all, the desire to step beyond art's autonomy to see real life as it really is forms a structural problem that has been well described by Slavoj Žižek. The attempt to move beyond the art world in order to face the real world is based on the assumption that once we negate or conquer the autonomy of the work of art, we will be able to see the true identity of global reality: we may, for instance, be able to document 9/11 or the Palestinian situation directly through the eyes of the press-photographer. However, as Žižek states,

> [E]very identity is already in itself blocked [by the Lacanian, *un-representable* real], and the external enemy [in this case art's autonomy] is simply a small piece, the rest of reality upon which we 'project' or 'externalize' this intrinsic, immanent impossibility [of realising full identity].[403]

Thus, *Documenta 11*'s curators act as if the evocation of real life can only happen through the negation of its projected 'other' – the not-so-real real life that is articulated thematically in the autonomous work of art – and this negation happens by abandoning the work of art, when showing the 'real' 9/11, for example. By negating the autonomous sphere of the work of art, the curatorial strategy is to finally face the sphere of the reality of globalization, and this explains why it is not only sufficient, in the catalogues and exhibitions, to focus on real life as it is interpreted in art, but it is considered necessary also to display *real* real life next to the real life of art. By documenting real life adjacent to the works

of art, a comparative effect is created that alienates the works by stressing their "art-ness" as other than the "real-ness" in the documentary material. Hence, the articles and documentary photos function didactically as examples of what the works of art are *actually* about.

This curatorial strategy leads to the second and more essential problem, namely that in the exhibitions the works of art seem to be regarded as secondary in importance, since they are reduced to being mere illustrations of their own subject matter. This is tantamount to saying 'if Superflex's work deals with Latin American farmers, why not just focus on the Latin American farmers and forget about the work of art?' This tendency develops out of an institutional attempt to meet the quests of works involved in institutional critique.

New Institutionalism

Institutional critique emerged as a tendency on the art scene in the 60s, with artists such as Daniel Buren, Marcel Broodthaers, and Hans Haacke as some of its pioneers, and it can be described as art that critically discloses art's institutional framework. An example is Haacke's *Manet Project* from 1974, which was a work-proposal for an exhibition at the Wallrat-Richartz-Museum in Cologne. Haacke simply suggested the exhibition of Manet's *Bunch of Asparagus* (1880) from the museum's permanent collection, along with wall panels that were to 'present the social and economic position of the persons who have owned the painting over the years and the prices paid for it.'[404] This account of the painting's provenance would describe, for instance, how the family of the previous owner, the painter Max Liebermann, was persecuted by the Nazis, and how the promoter and organizer of the Museum's acquisition of the Manet painting, the chairman of the Friends of the Museum, Hermann J. Abs, held a trusted position with the minister of economics of the Reich.[405] Haacke's proposal for the work was voted down by the museum, which caused several of the other artists to withdraw their works.

As the above example demonstrates, the aim of institutional critique was to broaden the scope of the audience's attention. Whereas it was common practice to focus on art *within* the institutional framework of the museum, institutional critique directed the audience's attention to the framework itself. Today, practical usage and definitions of notions such as 'institutional critique', 'political art', 'relational aesthetics', and 'context art', often overlap, but whatever we choose to call contemporary art that engages thematically in 'real' political

issues or institutional mechanisms, this type of art has challenged traditional institutional ways of exhibiting art.[406]

In order to meet this challenge, or in an attempt to re-frame institutional critique, many institutions of art have themselves developed new methods of presenting art that correspond to this new kind of artistic engagement. Like the artists, many art institutions now wish to explore their own positions of power by participating more actively in dialogues with surrounding communities. This institutional tendency goes by the name 'New Institutionalism' (not to be confused with New Internationalism). Examples of New Institutionalism are that rather than curating a work of art that has already been made, curators may invite artists to conduct an investigation or project with the active participation of groups of local citizens from the institution's (sub)urban area. The resulting work – or to use Groy's term 'art documentation' – is thus a kind of commissioned work created on site. Another popular way for art institutions to actively engage in institutional (self-)critique is to have artists design the museum's bookstore or café, or reorganize the collections in an 'institutional critique' manner, which for instance artist Fred Wilson has turned into his artistic characteristic.[407]

Hal Foster has commented critically on this institutional development, by stating that 'In these cases the institution may shadow the work that it otherwise highlights: it becomes the spectacle, it collects the cultural capital, and the director-curator becomes the star.'[408] By some of its critics, New Institutionalism is considered to have gone too far in its endeavour to act like artists. Thus, New Institutionalism seems to be 'sometimes contesting the role of the artist as the "prime mover" of the art scene', as artist Jonas Ekeberg puts it.[409] Ironically, it seems that with New Institutionalism, many art institutions have deprived artists of their own agendas, which are instead promoted by the institutions.

The debate around who should rightfully represent art – artists or curators – was illustrated by a book edited by curator Jens Hoffmann in 2004, in which he asked 28 contemporary artists/artist groups to respond to the statement *The Next Documenta Should Be Curated by an Artist*.[410] The responses to this statement vary from agreement to elaborate puzzlement, to total disagreement. Lawrence Weiner's response may serve as a humorous example of the third category, as he claims that 'The Next Documenta Should be Curated by an Artist & The Next Omelet Should Be Made By a Carpenter'.[411] Weiner elaborates on this statement by adding

The purpose of art is to question the material relationships to their world in relation to human beings. The purpose of curating is to agglomerate those questions (in effect to present them). Why should an artist curate the next WHATEVER show WHENEVER.[412]

It is worth noticing that even though Weiner fully acknowledges the legitimacy of curators, he refers explicitly to a division of labour, under which the artists *question* different relations and the curator *collects* and *presents* the questions asked by the artists. In other words: The artists, and not the curators, are those who investigate relations.

Documenta 11 manifested global inclusion (through its broad selection of artists for the final exhibition and the fact that numerous works regarded global issues thematically) and, at the same time, it promoted the principles of New *Institutionalism* (by curating reality, through sidestepping or by-passing art). Since art and artistic practice constitute a nodal point for New Internationalism, the new institutional tendency massively present at *Documenta 11* – along with the postcolonial focus – can be viewed as preventing New Internationalism from being fully realized. When curators of contemporary international art seek to provide the audience with authentic documentation of the facts that may also be considered by the works of art, they highlight only one aspect of the works (the works' reference to the realities of globalization)

Recollecting the interest of New Internationalism, however, this is disturbing because, as opposed to authenticity thematized *by* and *in* art, authenticity curated directly into the *formal* level of art, occurs at the cost of art, as it becomes a cognitive knowledge of globalization in general, instead of cognitive knowledge of art. What is lost in this process are the potentials and characteristics of art; that is, art's special discursive ability to observe and interpret life in an odd manner – an ability it possesses precisely because it exists in the autonomous sphere of art, or put differently: because it is authentic as art, and not authentic as reality. The implications of this tendency of the institutional disregard of art are elaborated in the following.

The implications of by-passing art

Within New Institutionalism, the desire to break free of art's autonomy and be as truly critical as possible is often founded on an imagined figure of opposition between artistic autonomy and political engagement. *Documenta 11*'s attempt

to exceed the limits of art's autonomy thus makes use of descriptions that rhetorically outline such a dichotomy, as in Enwezor's formulation that 'linked together the exhibition counterpoises the supposed purity and autonomy of the art object against a rethinking of modernity based on ideas of transculturality and extraterritoriality.'[413]

Here, autonomy is described as lacking transculturality, but as demonstrated above, this impression of opposition is false, since it is perfectly normal for many contemporary art practices to be *both* art, and hence autonomous, *and* – as art – thematically engaged in specific global-political questions. Though Enwezor at one point accepts that art 'through its unique institutions and procedure [can...] construct for itself a space from which to engage critically with all domains of socio-political life without being integrated within their mechanism', he generally seems reluctant to acknowledge the idea of art's *autonomy* as having any relevance today.[414]

One implication of New Institutionalism's tendency to curate authenticity without art is that the institutions in question must define *what* they understand by authenticity. As the following will demonstrate, Enwezor's departure from autonomy is motivated by his engagement with the political theory of radical, pluralistic democracy as presented by Laclau and Mouffe's ideas on discourse theory. We recollect that radical democracy is principally characterized by complex antagonisms that are constantly changing, and fundamentally unfixable. However, the articulatory practices of hegemony institute nodal points

> [T]hat partially fix the meaning of the social in an organized system of difference. The discursive system articulated by a hegemonic project is delimited by specific political frontiers resulting from the expansion of chains of equivalence.[415]

In discourse theory, autonomy is an aspect of hegemonic projects, and Laclau and Mouffe describe it as 'a form of hegemonic construction [...] an internal moment of a wider hegemonic operation.'[416] As described, art's autonomy thus belongs to the formal description of art, insofar as we consider art to be a hegemonic project, an articulated and institutionally manifested discourse, and not an essential given. Discourse theory distinguishes between two different kinds of 'social antagonism': a simple, *popular* subject position, which divides the whole of the political space into two antagonistic camps with no leftovers, and a complex *democratic* subject position, which describes a delim-

ited antagonism that does not divide the political space in that way.[417] Put differently, a popular antagonism unifies – and hence simplifies through chains of equivalence – many democratic antagonisms into one.

In accordance with this understanding, Enwezor implicitly refers to colonialism as a popular antagonism, when he describes 'colonialism's dichotomizing oppositions' as 'the cleavage that defines the separation between Western artistic universalism and tribal object particularities'.[418] Conversely, he subscribes to and sees *Documenta 11* as a constantly undetermined, articulatory process.[419] Enwezor explicitly states that

> I am mostly interested in the kind of democratic spirit whose referent is constituted by the degree to which a plethora of institutions – formal and informal, public and private – rather than mediating all aspects of popular sovereignty, make room within their regimes for the experimental, the imperfect and unfinished.[420]

Thus, Enwezor clearly commits to New Institutionalism, and 'the domain of the discursive rather than the museological.'[421] And just how radically complex he considers *Documenta 11* to be is demonstrated by his conclusive claim that

> The collected result in the form of a series of volumes and the exhibition is placed at the dialectical intersection of contemporary art and culture. Such an intersection equally marks the liminal limits out of which the postcolonial, post-Cold War, post-ideological, transnational, deterritorialized, diasporic, global world has written [...] Their impact, as well as their material and symbolic ordering, is woven through procedures of translation, interpretation, subversion, hybridization, creolization, displacement, and reassemblage.[422]

In the quote above, the simultaneous invocation of the numerous prefixed words alone ought to be a clear sign of Enwezor's commitment to a complex, democratic antagonism.

In effect, however, Enwezor's concept for *Documenta 11* unifies different antagonisms to a degree that closely resembles simple, popular antagonism. As we have seen by now, Enwezor's concept for *Documenta 11* rests upon three different curatorial guidelines: Postcoloniality, engagement with art-external domains, and the idea of radical democracy. Taken together, these interests stand in opposition to what Enwezor terms 'Westernism', which is the cluster of Western colonial history, the discriminatory mechanisms of the Western

notion of autonomous art, and Western capitalism and democracy.[423] Interestingly, Rasheed Araeen – the grand old man of New Internationalism – is rather critical of Enwezor's text in the *Documenta 11* catalogue. As Araeen states,

> In Enwezor's text, which is fundamental for understanding his agenda, what one finds is not a profound or honest articulation of the specific purpose of this Documenta but a façade of Manichaean rhetoric – loaded with absurdly meaningless sentences full of jargon and cliché – against what he calls 'Westernism'.[424]

It is an interesting detail that Laclau and Mouffe were themselves part of the non-art authenticity that was curated into *Documenta 11*, as they participated in *Platform 1, Democracy Unrealized* and contributed to the subsequent publication with separate texts.[425] In her text from this volume, Mouffe promotes her notion of 'agonistic struggle', which is defined by disagreements that recognize the common framework within which they take place – as opposed to antagonisms that do not necessarily acknowledge such a common set of rules.[426] Agonism means that 'the presence of antagonism is not eliminated but "tamed", so to speak.'[427] What is of greater significance, however, is that in spite of her suggestion of a 'tamed' antagonism, and her affiliation with the political Left, Mouffe argues *against* the fact that politics is played out in what she calls a 'moral register'. This moral register of contemporary politics is constituted by 'the centrality of a human rights discourse, which has displaced all other discourses.'[428] According to Mouffe, this human rights discourse functions like this:

> There cannot be an 'us' without a 'them' and the very identity of any group depends on the existence of a 'constitutive outside'. So the 'us of all the good democrats' must be secured by the definition of a 'them.' However, since the 'them' cannot be defined as a political adversary, it can only be defined as a moral enemy, as the 'evil them.' In most cases, it is, of course the 'extreme right' that provides the 'evil them' required by the very existence of the good democrats.[429]

Accordingly, Mouffe separates the complex mechanisms of radical democracy from specific morals or ethics. Enwezor, however, seems to unite the two into a single chain of equivalence in his curatorial guidelines, by merging taxonomically different domains into *one* concept, 'Westernism', and presenting *Documenta 11* as its antagonist. A popular antagonism thus emerges as the curatorial

basis of *Documenta 11* – contrary to the exhibition's self-understanding, as presented by Enwezor. Two consequences of this, in reality, simple popular antagonism of *Documenta 11* are relevant here, and both stem from the ar-ticulations of equivalence between art and colonialism, on the one hand, and on the other, non-art and postcoloniality.

The first consequence is that the authenticity that is curated into *Documenta 11* by sidestepping the works of art is not just any kind of art-external reality, but specifically an ethically postcolonial authenticity. It is obvious – from his writing in the catalogue, the themes of the first four platforms, and the visual material presented at the beginning of the catalogue – that Enwezor is very direct in his allusions to postcolonial and critical theory, and their legacy as constituting 'the political' proper. Thus, on the one hand he argues for an openness in the articulatory process, while on the other, he fixes it in a specific ethical discourse. Apparently, it is not just a matter of transgressing art's autonomy and engaging with the authentic reality, but also of connecting with the 'right' kind of authentic reality: that is, the reality of postcolonially informed political conflicts and developments, rather than, for instance, the ordinary or even dull everyday reality of a suburban middle-class or the social problems of trailer-park 'white trash'. As art historian Anthony Downey puts it, in his critical review of *Documenta 11*, 'The politics that informs postcolonial criticism and theory is advanced here as a predicative model for the content and form of the art chosen to be included in the exhibition.'[430]

According to Downey, however – and this is the second consequence of *Documenta 11*'s articulation of a popular (anti-'Westernism') antagonism – 'there is also a demand to explore the extent to which art is indeed different from politics or other forms of documentary.'[431] Thus, whereas *Documenta 11*'s focus on art-external domains *as such* led to a borderland of indetermi-nacy between art as such and authentic non-art as such, which positioned the project within an aesthetic regime of art, the *specific* overdetermination of this authentic reality as a *postcolonial* reality positions the project within an ethical regime of art. The ethics of *Documenta 11*'s social antagonism, set against the hegemony of 'Westernism', then becomes the nodal point that attempts to fix the moments, among them art, into a different hegemony.

By radically incorporating New Institutionalism, *Documenta 11* has inspired numerous curators within the art world to curate authentic political realities into art projects, based on an ethical point of departure. An illustrative exam-ple is the project *Rethinking Nordic Colonialism*, which took place in 2006

under the auspices of the Nordic Institute of Contemporary Art, NIFCA. Like *Documenta 11*'s platform concept, this project was articulated as five different 'Acts', and covered Iceland, Greenland, The Faroe Islands, Sápmi, Denmark, Finland, Norway, and Sweden.[432] The project was organized by independent curators Frederikke Hansen and Tone Olaf Nielsen, who stated that the aim of *Rethinking Nordic Colonialism* was to shed a critical light on the colonial history and present of the Nordic countries.[433] Apart from exhibitions of works by Nordic as well as non-Nordic artists, the different Acts included film screenings, hearings, and conferences. For instance, "Act 1" included a talk by the Secretariat Director of the Tanzania Youth Coalition, Humphrey Polepole, who delivered a paper entitled "Third World Underdevelopment, Economic Crisis, Foreign Aid and AIDS Policies as a Legacy of Colonialism: Challenges and Opportunities".

No matter how sympathetic and highly needed the idea of critically addressing Nordic colonialism is, it seems that linking AIDS policy and the development in the Third World on the one hand, and, for instance, the difficulties experienced by the Sámi people and the history of Iceland on the other, is the result of an articulation of equivalence where anything non-Western or anti-Western, regardless of its taxonomic 'origin', is clustered into an entity characterized by being ethically good. Recollecting Cesare Poppi's rhetorical comment regarding *Magiciens de la terre*, one may repeat his question "Is there, today, anything African not worth exhibiting?"[434]

How, then, do these implications relate to the intentions of New Internationalism? From the original nine paragraphs in the mission statement that led to the establishment of InIVA (1991), and from the *Global Visions* seminar (1994), it is clear that the notion of art – the recognition of contemporary visual art, without prejudging cultural or racial filters – functions as a very significant nodal point for New Internationalism. Hence, even though *Documenta 11*'s antagonism against 'Westernism' is, to a large extent, based on the same motives that initially encouraged New Internationalism (unjust discrimination against non-Western cultures), *Documenta 11*'s consequent demotion of art is counterproductive to this important interest of New Internationalism. In conclusion, the most significant implication of the new institutional tendency to curate authentic political issues *directly* into the art institutions – as opposed to simply curating works of art that are thematically engaged in political issues – is that what was, around 1994, a very crucial nodal point in the articulation of New Internationalism is lost. New Internationalism is a discourse specifically

concerned with visual art, and one of its explicit intentions was to promote a call for a greater focus on *artistic* practice and theory as significant in themselves, considered separately from anthropological and cultural concerns. But since *Documenta 11* did not just curate any kind of authentic issues into the project, but was exclusively concerned with postcolonial realities, this may be considered partly an anthropological investigation. The objects of this anthropological investigation were neither 'the black soul of Africans', 'the mysterious mind of Asians' or similar old-fashioned stereotypes that haunted the discourse of the so-called 'old internationalism', but rather the conflicts resulting from 'Westernism'. Roughly stated, this situation describes a turn from 'political art' to 'ethnic politics'.

Conclusion

There is no doubt that New Internationalism has had a profound impact on the art world in general. Especially during the last decade, the scene of contemporary art has broadened its global perspective to a point where, today, it is in fact international, since institutions for contemporary art have spread to every corner of the world. Even a *Biennial of the End of the World* was established in 2007 in the city of Ushuaia, in Southern Argentina 3,000 km from Buenos Aires, but only 1,000 km from the ice cap of the Antarctic.[435] Furthermore, today the notion of 'global' is used in most dimensions of the art institutional apparatus.

For instance, since 1993, the art magazine *Flash Art* has included a small 1-2 page section called 'Global Art' in every issue.[436] The magazine describes the concept behind the brief feature as follows: 'In the Global Art section of *Flash Art*, a writer is invited to discuss one work by a contemporary artist.' The actual content of the 'Global Art' section in *Flash Art*, however, does not reveal why the works of this section are more global than others featured in the rest of the magazine, which focuses exclusively on contemporary art through features, reports and reviews on various exhibitions, biennials, and art trends from all over the world. The description of the conceptual installation work *What's the Time?* by the artist Kris Martin in 'Global Art', in the May/June 2008 issue is symptomatic.[437] Briefly, the work consists of two loudspeakers, with a repeated dialogue in which one voice asks 'What's the time?' followed quickly by the interruption of another, harsh, voice responding 'Shh!'. The text considers the work in relation to other works by Martin, and concludes that '[H]is ongoing explorations into the frailty of the artistic gesture and the ephemeral nature of time continue to present rich and enduring propositions.'[438] To the reader of *Flash Art*, the reason for discussing this work under the specific heading of 'Global Art' remains opaque.

Even *Third Text* uses the term 'global art' as a given, with no further explanation or reflection, as was the case in the January 2008 issue, with the publication

of an article entitled "The Hot Spot of Global Art", which was about the art scene of Istanbul, yet neither mentioned the term 'global' again after the title, nor presented any broader considerations of the notion.[439]

This frequent use of the term 'global art' in descriptions of contemporary art is in itself evidence that the perspective of the art world has generally expanded beyond the confinements of the West, and that contemporary art today is automatically considered to be global. As the above examples demonstrate, however, the widespread usage of the term 'global art', or the mere ascertainment that the contemporary art scene is globalized, does not always reflect the premises and implications of this situation. It has been the aim of this book to do so. Many of, if not all, the concrete phenomena analysed in the book have been investigated academically before, by others. *Magiciens de la terre, The Whitney Biennial 1993, Documenta 11*, 'institutional critique', 'global capitalism', 'relational aesthetics', etc. are all events and notions that have been studied and discussed thoroughly in academic parts of the art world. The concept of New Internationalism, too, has been directly addressed and discussed by others before.[440]

Therefore, the aim of this book has not been to account for these phenomena in isolation. Instead, it has attempted to conduct a critical investigation of the propositions, naturalisations and presumptions at work in the globalization of contemporary art driven by the discourse of New Internationalism. Thus, its has been a question of analyzing on what concrete and theoretical *conditions* the world of contemporary art, to a greater extent, now matches the geographic world. Therefore, references to and subanalyses of the above phenomena have been of relevance only insofar as they have been of significance to the overall investigation of this book.

Specifically, in its first three chapters, the book has looked at how New Internationalism has been articulated, in order to identify the discourse's aim and interest, which turned out to be: equal institutional premises for contemporary art anchored around the nodal point of art, as opposed to racial, anthropological and cultural discriminations. In chapters four to seven this interest has been critically investigated and compared to the actual realizations and manifestations of the discourse. Out of these investigations the picture of two significant current scenarios for New Internationalism has emerged, which I shall sum up:

Judging from the development from political art to ethnic politics, one scenario is that of acknowledgement of *non-Western contemporary* art within

an ethical and specific political framing, as was the case with *Documenta 11*. As discussed, however, this realization has come at the price of a partial neglect of art. Since art is the significant nodal point of New Internationalism, this scenario implies that in practice the premise for deconstruction of standard art historical structures occurs, to some extent, at the sacrifice of the nodal point of art. We may consider the fact that *Documenta 11* emphasized engagement with art-external realities by largely bypassing the works of art, as an opening-up towards art's 'other', towards heteronomy rather than autonomy, and towards aesthetics rather than art. As it turned out, however, *Documenta 11* provided little experience of indeterminacy, since a specific agenda of postcoloniality dominated the project. Accordingly, this scenario presents a dilemma when compared to the initial interest of New Internationalism, insofar as it forces the discourse to choose between, on the one side, critical deconstruction of the autonomous sphere of art – the discourse's very nodal point – and, on the other side, attentiveness to the modernities and contemporaneity of non-Western regions and cultures that have earlier been denied art institutional access in the West.

The other main scenario is the potential given to contemporary art on a global scale, by the forces of the art market. Non-Western contemporary art is given access to the framework of the market on the same terms as Western art, and though capitalism itself in its early days was a means of Western control, it has evolved into its current state of existing as an independent, global system that is culturally and geographically neutral. This second scenario of the art market was not initially of any interest to New Internationalism – probably because capitalism is traditionally considered by the political Left to be a tool of exploitation and suppression, and the theoretical ancestors of New Internationalism belong to the left. However, confronted with global capitalism as a possible ally, New Internationalism is likely to adopt a subject position that negates such a proposition, like when Rasheed Araeen regrets the fact that the work 'is simply reduced to a reified commodity for the art market.'[441] Accordingly, the new international potentials of global capitalism are rather paradoxical.

Even when they are traded like any other goods, works of art certainly keep a privileged, autonomous status as art, since their trading value in the market depends on this status. The market forces of capitalism have been considered foreign to the traditional Western art institutional apparatus ever since Western modernity's institutional differentiation, and global capitalism,

accordingly, seems a legitimate weapon against that apparatus. On the other hand, the market has mechanisms of discrimination of its own. For instance, we may regard the market's preference for object art as discriminating against other art forms – it is difficult to auction the act of having 1,001 Chinese men and women visit *Documenta 12* at Sotheby's – but these discriminations are not based on race or cultural origin. Compared to the first scenario, however, it seems that the global art market is more capable of furthering the interest of New Internationalism.

The fact that the art market seems to function more in accordance with the interest of New Internationalism than with a progressive team of curators with thorough knowledge of contemporary art world wide suggests that the situation today differs significantly from that of the early 90s. Since articulations of discursive formations are constantly in process, the articulations of New Internationalism have simply changed since the beginning of the 90s, and, simultaneously, New Internationalism has had an impact on the art institutional apparatus in general, which, then, has affected the discourse in a process of mutual influence. Accordingly, the results of the challenges presented by the discourse are unpredictable. For instance, we may well entertain the idea that not only has the discourse's antagonism resulted in an increased recognition of non-Western contemporary art – as contemporary art – in museums and exhibitions, but it has also provided the art market with a demand for new 'goods', for instance, contemporary art from China and India.

How are we to judge the fact that the realized impact of New Internationalism has taken place through institutional practices that, to a certain degree, seem to compromise the discourse's initial interest? Does this imply that the discourse has failed or succeeded? The answer could be that the discourse has succeeded in its failure insofar as the project of combining globally equal terms with the Western notion of art, which originally was a normative concept that gave rise to the dominating Western art institutional apparatus, was doomed to fail from the outset. Though institutional art theory is in itself neutral and descriptive, and therefore provides New Internationalism with an important opening for overcoming the ideology of the 'modernity = West' trope, in reality exhibitions are always curated on the basis of normative concepts – otherwise they would not be exhibitions, but merely absurd accumulations. And currently, many curators tend to emphasize broader cultural and societal questions in their exhibition concepts.

Accordingly, it appears that the mechanisms of the market on the one side,

and the question of ethics on the other, play bigger roles in the art world today than the question of global inclusion of non-Western artists and their art, and we may interpret this as an indication that the problem of institutional discrimination based on ethnicity or geographical origin is less widespread today. In other words: the art world has been globalized since the 90s, and non-Western contemporary art is now a full member of the art world: Like contemporary art of Western origin, it has gained the privileges of being framed by global capitalism, by curatorial tendencies to promote political issues of interest, and by celebration of the artist-genius.

Bibliography

Adorno, Theodor: "Culture Industry Reconsidered" in *New German Review*, Autumn 1975, pp. 12-19.

Ai Weiwei, Sigg, Uli / Frehner, Matthias, Pi Li in Fibicher, Bernhard; Frehner, Mattias (eds.): *Mahjong. Contemporary Chinese Art from the Sigg Collection*, 2005, Hatje Cantz.

Alcoff, Linda Martín: "Philosophy and Racial Identity" in Peter Osborne and Stella Sandford (eds.): *Philosophies of Race and Ethnicity*, 2002, Continuum, pp. 13-28 (originally 1996 in *Radical Philosophy*).

Appadurai, Arjun: *Modernity at Large: Cultural Dimensions of Globalization*, 1996, University of Minnesota.

Araeen, Rasheed; Chambers, Eddie: "Black Art. A Discussion" in *Third Text* no. 5, winter 1988/89, pp. 51-77.

Araeen, Rasheed: "From Primitivism to Ethnic Art" in *Third Text*, no. 1, autumn 1987, pp. 6-25.

Araeen, Rasheed: "In the heart of the black box" in *Art Monthly* no. 259, 2002, p. 17.

Araeen, Rasheed: "Preliminary Notes for a Black Manifesto" *Black Phoenix* no. 1, January 1978, pp. 3-12.

Araeen, Rasheed: "Sleeping with the Enemy and Re-visiting Postcolonial Theory" in *Third Text* no. 56, Autumn 2001, pp. 75-79.

Araeen, Rasheed: "New Internationalism – Or the Multiculturalism of Global Bantustans" in Fisher (ed.): 1994, pp. 3-11.

Araeen, Rasheed: "The Success and Failure of Black Art" in *Third Text*, March 2004, pp. 135-152.

Araeen: "A New Beginning: Beyond Postcolonial Cultural Theory and Identity Politics" (2000) in Araeen; Cubitt; Sardar (eds.): *The Third Text Reader*, 2002, Continuum, pp. 333-345.

Armleder, John et al.: "How has Art Changed? Survey" in *Frieze*, October 2005, pp. 158-169.

Bærøe, Birgit (ed): *Deterritorializations. Art and Aesthetics in the 90s*, 2000, Spartacus Forlag & Bokförlaget Nya Doxa (Part II, "New Internationalism").

Baker, George; Müller, Christian Philipp: "A Balancing Act" in *October*, Autumn, 1997, pp. 94-118.

Barthes, Roland: "The Death of the Author" (1968) in *Image, Music, Text*, 1998 (1977), Hill and Wang, pp. 142-148.

Basualdo, Carlos (ed.): Tropicália, a Revolution in Brazilian Culture, 2005, Cosac Naify.

Belting, Hans: "Contemporary Art and the Museum in the Global Age" in Weibel; Buddensieg (eds.): *Contemporary Art and the Museum*, 2007, Hatje Cantz, pp. 16-38.

Belting, Hans: *The End of the History of Art?*, 1987, University of Chicago Press.

Bennett, Gordon: "The Non-Sovereign Self (Diaspora Identities)" in Fisher (ed.): 1994, pp. 120-130.

Bennett, Tony: *The Birth of the Museum*, 1995, Routledge.

Bevan, Roger: "Damien Hirst is rewriting the rules of the market (1)" in *The Art Newspaper*, 10 July 2008.

Bhabha, Homi K: *The Location of Culture*, 1994, Routledge.

Bishop, Claire: "Antagonism and Relational Aesthetics" in *October* no. 110, 2004, pp. 51-79.

Bishop, Claire: "Vienna Inc.: The Analytic documenta" in *Journal of Visual Culture*, vol. 7, issue 2, 2008, pp. 206-214.

Blazwick, Iwona (ed.): *Century City, Art and Culture in the Modern Metropolis*, 2001, Tate Gallery Publishing Ltd.

Blitz Review, Oct. 26 1998.

Bode, Arnold et. al. (eds.): *Documenta – Kunst des XX. Jahrhunderts, internationale Ausstellung im Museum Fridericianum in Kassel*, 1955, Prestel-Verlag München.

Bois, Yve-Alain: "La Pensée Sauvage" in *Art in America*, April 1985, pp. 178-189.

Bolt, Mikkel: "Oväsen eller röster. Om de lägre klassernas intelligens hos Jacques Rancière" in *Tidskrift för litteraturvetenskab*, no. 1-2, 2007, pp. 43-54.

Bonami, Francesco et al. (eds.): *Biennale di Venezia: Dreams and conflicts: The dictatorship of the viewer. 50th international art exhibition*, 2003, Thames & Hudson.

Bourdieu, Pierre: "The Historical Genesis of a Pure Aesthetic" in *The Journal of Aesthetics and Art Criticism*, 1987, pp. 201-210.

Bourdieu: *The Rules of Art, Genesis and Structure of the Literary Field*, 1996, Polity Press (French edition 1992).

Bourriaud, Nicolas: "Magiciens de la terre" in *Flash Art* no. 148, 1989, pp. 119-121.

Bourriaud, Nicolas: *Relational Aesthetics*, 2002, Les presses du réel (French edition 1998).

Brett, Guy: "Venice, Paris, Kassel, Sao Paulo and Habana" in *Third Text* no. 20, autumn 1992.

Buchloh, Benjamin H.D., Martin, Jean-Hubert: "Interview" *Third Text*, no. 6, Spring 1989, pp. 19-27.

Buchloh, Benjamin H.D.: "The Whole Earth Show" *Art in America*, May 1989, pp. 150-159.

Buergel, Roger; Noack, Ruth: *Documenta 12 Katalog/Catalogue*, 2007, documenta Veranstalungs GmbH and Taschen GmbH.

Bürger, Peter: *Theory of the Avant-garde*, 1984, University of Minnesota (German edition 1974).

Butler, Judith: *Gender Trouble*, 1990, Routledge.

Bydler, Charlotte: *The Global ArtWorld Inc.*, 2004, Acta Universitatis Upsaliensis, Uppsala.

Carnevale, Fulvia and Kelsey, John: "Art of the Possible: An Interview with Jacques Rancière" in *Artforum*, March 2007, pp. 256-269.

Carroll, Noël: "Art and Globalization: Then and Now" in *Journal of Aesthetics and Art Criticism*, vol. 65, issue 1, 2007, pp. 131-143.

Chambers, Eddie: *Black Art, Plotting the Course*, 1988, Oldham Art Gallery.

Channing, Joseph: "City Arts Set for Asia Week" in *The New York Sun*, March 12, 2007.

Clifford, James: "Histories of the Tribal and the Modern" in *Art in America*, April 1985, pp. 164-177+215.

Coombes, Annie E.: "Inventing the 'Postcolonial': Hybridity and Constituency in Contemporary Curating" in Preziosi (ed.): *The Art of Art History: A Critical Anthology*, 1998, Oxford University Press, pp. 486-497.

Coombes, Annie E.: "The recalcitrant object: culture contact and the question of hybridity" in Barker, Francis; Hulme, Peter; Iversen, Margaret (eds.): *Colonial discourse / postcolonial theory*, 1994, Manchester University Press, pp. 89-114.

Cosentino, Donald J.: "Hip-Hop Assemblage: The Chris Ofili Affair" in *African Arts*, spring, 2000, pp. 40-51+95-96.

Crimp, Douglas: *On the Museum's Ruins*, 1993, MIT Press.

Culler, Jonathan: *Framing the Sign. Criticism and its Institutions*, 1988, University of Oklahoma Press.

Cunningham, David; Martin, Stewart: "The Death of a Project" in *Journal of Visual Culture*, vol. 7, issue 2, 2008, pp. 214-218.

Danto, Arthur C.: "The Artworld" in *Journal of Philosophy*, Oct. 1964, pp. 571-584.

Danto, Arthur C.: "The 1993 Whitney Biennial" in *The Nation*, April 19 1993, pp. 533-536.

Danto, Arthur C.: *After the End of Art*, 1997, Princeton University Press.

David, Catherine; Chevrier, Jean-Francois: *Documenta X*, 1997, Cantz Verlag, Documenta and Museum Friedericianum Veranstaltungs GmbH, Kassel.

De Andrade, Oswald: "Anthropophagous manifesto" (1928) in Basualdo: 2005, pp. 205-207.

de Duve, Thierry: "Museets etik efter Duchamp" in Torzen, Lene and Lønstrup, Ansa (eds.): *Kunsten og værket. Æstetiskstudier VI*, 1999, Aarhus Universitetsforlag, pp. 9-30.

Di Martino, Enzo: *The History of the Venice Biennale 1895-2005*, 2005, Papiro Arte.

Dickie, George: *The Art Circle*, 1984, Haven Publications.

Dickie, George: *Art and Value*, 2001, Blackwell.

Dikovitskaya, Margaret: *Visual Culture: the study of the visual after the cultural turn*, 2005, MIT Press.

Dimitrakaki, Angela: "Art and Politics Continued: Avant-garde, Resistance and the Multitude in Documenta 11" in *Historical Materialism*, vol. 11, issue 3, 2003, pp. 153-176.

Dokolo, Sindika: "African Collection of Contemporary Art" in *African Pavillon – 52nd. Venice Biennale International Contemporary Art Exhibition* (not published, download from http://universes-in-universe.de/car/venezia/eng/2007/tour/africa/index.htm (accessed Jan. 2 2010).

Dorment, Richard: "The worst art show ever" in *Telegraph,* June 19, 2007.

Downey, Anthony: "The Spectacular Difference of Documenta XI" in *Third Text*, March 2003, pp. 85-92.

Duncan, Carol: "The Art Museum as Ritual" (1995) in Preziosi (ed.): *The Art of Art History*, 1998, Oxford University Press, pp. 473-485.

Dussel, Enrique: "Beyond Eurocentrism: The World-System and the Limits of Modernity" in Jameson, Fredric; Miyoshi, Masao (eds.): *The Cultures of Globalization*, 1998, Duke University Press, pp. 3-31.

Dutton, Denis: "Authenticity in Art" in Levinson, Jerrold (Ed.): *The Oxford Handbook of Aesthetics*, 2003, Oxford University Press, pp. 258-274.

Editorial: "Why Third Text?" in *Third Text* no. 1, autumn 1987, pp. 3-5.

Ekeberg, Jonas (ed.): *New Institutionalism*, 2003, Office for contemporary art Norway.

Ekpo, Denis: "The Failure of Postmodernity – How Africa misunderstood the West" in Araeen, Rasheed; Cubitt, Sean; Sardar, Ziauddin (eds.): *The Third Text Reader on Art, Culture and Theory*, 2002, Continuum, pp. 255-266.

Elkins, James: *Our Beautiful, Dry, and Distant Texts: Art History as Writing*, 2000 (1997), Routledge.

Elkins, James: *Stories of Art*, 2002, Routledge.

Elkins, James: *Visual Studies: a skeptical introduction*, 2003, Routledge.

Elkins, James (ed.): *Is Art History Global?*, 2007, Routledge.

Enwezor et al. (eds.): *Documenta 11 Catalogue*, 2002, Hatje Cantz Publishers.

Enwezor, Okwui et al. (eds.): *Créolité and Creolization, Documenta11_Platform 3,* 2003, Hatje Cantz Publishers.

Enwezor, Okwui et al. (eds.): *Democracy Unrealized, Documenta11_Platform 1,* 2002, Hatje Cantz, p. 11.

Enwezor, Okwui et al. (eds.): *Experiments with the Truth, Documenta11_Platform 2,* 2002, Hatje Cantz Publishers.

Enwezor, Okwui et al. (eds.): *Under Siege: Four African Cities Freetown, Johannesburg, Kinshasa, Lagos, Documenta11_Platform 4,* 2002, Hatje Cantz Publishers.

Enwezor, Okwui: "The Black Box" in Enwezor et al. (eds.): *Documenta 11 Catalogue,* 2002, Hatje Cantz Publishers, pp. 42-55.

Errington, Shelly: "Globalizing Art History" in Elkins, James (ed.): *Is Art History Global?,* 2007, Routledge, pp. 405-440.

Exhibition catalogue: *XXIV Bienal de São Paulo. Núcleo Histórico: Antropofagia e Histórias de Canibalismos,* 1998, Fundaçao Bienal de São Paulo.

Exhibition paper *Global Cities, 20 June – 27 August 2007* printed by the Tate Modern, unpublished.

Fisher, Jean: "Toward a Metaphysics of Shit" in Enwezor et al. (eds.): *Documenta 11 Catalogue,* pp. 63-70.

Foster, Hal et al.: "The Politics of the Signifier: A Conversation on the Whitney Biennial" in *October,* autumn 1993, pp. 3-27.

Foster, Hal: *Recodings. Art, Spectacle, Cultural Politics,* 1999 (1985), The New Press.

Foster, Hal: *The Return of the Real,* 1996, Massachusetts Institute of Technology.

Foucault, Michel: "The Order of Discourse" in Young (ed.): *Untying the Text: A Post-Structuralist Reader,* 1981, Routledge & Kegan Paul Ltd., pp. 52- 64.

Foucault, Michel: "What is an Author?" (1969) in Rabinow, Paul (ed.): *The Foucault Reader,* 1984, Pantheon Books, pp. 101-120.

Francesco Bonami in Griffin, Tim: "Global Tendencies. Globalism and the Large-Scale Exhibition" in *Artforum,* November 2003, pp. 152-163 + 206.

Fry, Roger: "An Essay in Aesthetics" (1909) in Goodwin, Craufurd D. (ed.): *Art and the Market – Roger Fry on Commerce in Art,* 1998, The University of Michigan Press, pp. 73-85.

Gao Minglu: "Toward a Transnational Modernity" in Gao Minglu (ed.): *Inside Out. New Chinese Art,* 1998, University of California Press, pp. 15-40.

Gerlis, Melanie: "China overtakes France" in *The Art Newspaper,* issue 188, 7 Feb. 2008.

Gibbs, Michael: "Documenta 11/1" in *Art Monthly* no. 258, 2002, pp. 1-5.

Giddens, Anthony: *The Consequences of Modernity,* 1990, Polity Press.

Gilroy, Paul: *The Black Atlantic, Modernity and Double Consciousness,* 1995 (1993), Verso.

Godfrey, Mark: "Traveling Hopefully" in *Frieze*, October 2005, pp. 170-175, p. 173.

Golden, Thelma; Ofili, Chris: "A Conversation" in *Chris Ofili: Within Reach, volume 1 "Words"*, 2003, Victoria Miro Gallery, London, pp. 1-19.

Goodnough, Abby: "Mayor Threatens to Evict Museum Over Exhibit He Dislikes" in *The New York Times,* September 24 1999.

Groys, Boris: "Art in the Age of Biopolitics. From Artwork to Art Documentation" Enwezor, Okwui et al. (eds.): *Documenta 11 Catalogue*, 2002, Hatje Cantz Publishers, pp. 108-114.

Guggenheim: "Press Release", January 20, 2006.

Haagemann, Jannie; Høholt, Stine: "Mod et nyt kunstnerisk verdenskort?" in Christensen, Hans Dam; Michelsen, Anders; Wamberg, Jacob (eds.): *Kunstteori – positioner i nutidig kunstdebat*, 1999, Borgen.

Hall, James: "Panopticism at the Pompidou" in *Apollo, the Magazine of the Art*s, 1989, no. 130, pp. 120-121.

Hall, Stuart: "Chris Ofili in Paradise: Dreaming in Afro" in *Chris Ofili: Within Reach, Volume 1 "Words"*, 2003, Victoria Miro Gallery, London, pp. 39-43.

Hall, Stuart: "The West and the Rest: Discourse and Power" in Gieben; Hall (eds.): *Formations of Modernity*, 1992, The Open University, pp. 275-331.

Hardt, Michael; Negri, Antonio: *Empire*, 2000, Harvard University Press.

Harris, Jonathan: *The New Art History: A Critical Introduction*, 2001, Routledge.

Heartney, Eleanor: "Boomtowns of the Avant-Garde" in *Art in America*, September 2001, pp. 65-71.

Heartney, Eleanor: "A 600-Hour Documenta" in *Art in America*, Sep. 2002, pp. 86-95.

Heartney, Eleanor: *Postmodernism*, 2001, Tate Gallery Publishing Ltd.

Hoffmann, Jens (ed.): *The Next Documenta Should Be Curated by an Artist*, 2004, Revolver Archiv für aktuelle Kunst.

Hou Hanru; Obrist, Hans Ulrich: "Cities on the Move" (1997) in Hou Hanru: *On the Mid-Ground*, 2002, Timezone 8, pp. 214-229.

Hou Hanru: "Entropy; Chinese Artists, Western Art Institutions, a New Internationalism" in Fisher (ed.): 1994, pp. 79-88.

http://universes-in-universe.de/english.htm (accessed Jan. 2 2010).

http://www.apec.org/apec/about_apec.html (accessed Jan. 2 2010).

http://www.bienalfindelmundo.org/ (accessed Jan. 2 2010).

http://www.britishmuseum.org/explore/highlights/highlight_objects/aoa/t/throne_of_weapons.aspx (accessed Jan. 2 2010).

http://www.documenta12.de/100_tage.html?&L=1 (accessed Jan. 2 2010).

http://www.documenta12.de/archiv/d11/data/english/index.html (accessed Jan. 2 2010).

http://www.documenta12.de/d1_d111.html?&L=1 (accessed Jan. 2 2010).

http://www.documenta12.de/d12.html?&L=1 (accessed Jan 2 2010). http://www.hkw.de/en/hkw/selbstdarstellung/anfang.php (accessed Jan. 2 2010).

http://www.hugoboss-prize.com (accessed Jan. 2 2010).

http://www.iniva.org/content.php?page_id=3263&type=Artist (accessed Jan. 2 2010).

http://www.metmuseum.org/works_of_art/collection_database/listview.aspx?page=2&sort=5&sortdir=asc&keyword=&fp=1&dd1=6&dd2=27 (accessed Jan. 2 2010).

http://www.rethinking-nordic-colonialism.org (accessed Jan. 2 2010).

http://www.superflex.net/tools/supercopy/guarana.shtml (accessed Jan. 2 2010).

http://www.tate.org.uk/modern/exhibitions/centurycity (accessed Jan. 2 2010).

http://www.tate.org.uk/modern/exhibitions/globalcitics/default.shtm (accessed Jan. 2 2010).

http://www.tate.org.uk/servlet/ViewWork?workid=26547&searchid=37710 (accessed Jan. 2 2010).

http://www.tropenmuseum.nl/smartsite.shtml?ch=FAB&id=5860 (accessed Jan. 2 2010).

http://www.tropenmuseum.nl/smartsite.shtml?ch=FAB&id=TM_AGENDA_ENGLISH&ActiviteitID=3604 (accessed Jan. 2 2010).

Hylland Eriksen, Thomas: *Ethnicity and Nationalism. Anthropological Perspectives*, 1993, Pluto Press.

Hylton, Richard: *The Nature of the Beast. Cultural Diversity and the Visual Arts Sector: A study of policies, initatives and attitudes 1976-2006*, 2007, ICIA, University of Bath.

Jameson, Fredric: "Culture and Finance Capital" in *The Cultural Turn. Selected Writings on the Postmodern, 1983-1998*, 1998, Verso, pp. 136-161.

Jameson, Fredric: "Notes on Globalization as a Philosophical Issue" in Jameson; Miyoshi (eds.): 1998, pp. 54-77.

Jameson, Fredric: *Postmodernism, or, the Cultural Logic of Late Capitalism*, 1991, Duke University Press.

Jameson, Fredric and Miyoshi, Masao (eds.): *The Cultures of Globalization*, 1998, Duke University Press.

Jantjes, Gavin; Wilson, Sarah: *Final Report. The Institute of New International Visual Arts*, 1991, London Arts Board; Arts Council.

Jones, Amelia: "Feminism Incorporated: Reading 'Postfeminism' in an Anti-feminist Age" in Jones, Amelia (ed.): *The Feminism and Visual Culture Reader*, 2003, Routledge, pp. 314-328.

Kant, Immanuel: *The Critique of Judgement*, (1790) eBook ISBN: 9780585051345, Raleigh, N.C. Alex Catalogue.

Kaplan, Janet A.: "*Century City*: Conversation with the Curators" in *Art Journal*, Fall 2001, pp. 48-65.

Kapur, Geeta: "A New Inter Nationalism; The Missing Hyphen" in Fisher (ed.): 1994, pp. 39-49.

Kleeblatt, Norman L.: "Identity Roller Coaster" in *Art Journal*, spring 2005, pp. 61-63.

Kyndrup, Morten: *Den æstetiske relation*, 2008, Gyldendal.

Lacan, Jacques: "Of the Gaze as *Objet Petit a*" in Jacques-Alain Miller (ed.): *The Four Fundamental Concepts of Psycho-analysis*, 1998, Vintage, (French edition 1973).

Laclau, Ernesto and Mouffe, Chantal: *Hegemony and Socialist Strategy*, 2001 (1985), Verso.

Laclau, Ernesto: "Democracy between Autonomy and Heteronomy" in Enwezor et al. (Eds.): *Democracy Unrealised*, 2002, pp. 377-386.

Laing, Ellen Johnston: *The Winking Owl: Art in the People's Republic of China*, 1989, University of California Press.

Larsen, Lars Bang, Ricupero, Christina, and Schafhausen, Nicolaus (Eds.): *Populism. The Reader*, 2005, Lukas & Sternberg.

Lash, Scott; Lury, Celia: *Global Culture Industry: the Mediation of Things*, 2007, Polity Press.

López, Yolanda; Roth, Moira: "Social Protest: Racism and Sexism" in Broude, Norma; Gerrard, Mary D. (eds.): *The Power of Feminist Art*, 1994, Harry B. Abrams, pp. 140-157.

Lord, Catherine: *The Theater of Refusal, Black Art and Mainstream Criticism*, 1993, The Fine Arts Gallery of the University of California.

Lord, Gail Dexter: "The 'Bilbao Effect': from poor port to must-see city" in *The Art Newspaper*, no. 184, Oct. 2007, p. 32.

Luhmann, Niklas: "Weltkunst" in Luhmann, Niklas; Bunsen, Frederick D.; Baecker, Dirk: *Unbeobachtbare Welt: Über Kunst und Architektur*, 1990, Bielefeld, pp. 7-45.

Luhmann, Niklas: *Art as a Social System*, 2000, Stanford University Press (German edition 1995).

Madra, Beral: "The Hot Spot of Global Art" in *Third Text*, January 2008, pp. 105-112.

Maharaj, Sarat: "Xeno-Epistemics: Makeshift Kit for Surrounding Visual Art as Knowledge Production and the Retinal Regimes" in Enwezor et al. (eds.): *Documenta 11 Catalogue*, 2002, pp. 71-84.

Maharaj, Sarat: "'Perfidious Fidelity': The Untranslatability of the Other" in Fisher (ed.): 1994, pp. 28-35.

Martin, Jean-Hubert et al. (eds.): *Magiciens de la terre*, 1989, Editions du Centre Pompidou.

Marx, Karl; Engels, Friedrich: *The Communist Manifesto*, (1848), 1998, ElecBook London.

McEvilley, Thomas: "Doctor Lawyer Indian Chief" in *Artforum*, Nov. 1984, pp. 54-61.

McLuhan, Marshall: *Understanding Media: The Extension of Man* (1964) 1994, MIT Press.

Mendieta, Ana: *Dialectics of Isolation. An Exhibition of Third World Women Artists of the United States*, 1980, A.I.R. Gallery.

Mercer, Kobena (ed.): *Cosmopolitan Modernisms*, 2005, Institute of International Visual Arts and MIT Press.

Meyer, James: "Tunnel Visions" in *Artforum*, September 2002, pp. 168-169.

Mirzoeff, Nicholas (ed.): *The Visual Culture Reader*, 1998, Routledge.

Mitchell, W.T.J.: *The Last Dinosaur Book, the Life and Times of a Cultural Icon*, 1998, The University of Chicago Press.

Molesworth, Helen: "House Work and Art Work" in *October*, spring 2000, pp. 71-97.

Mosquera, Gerardo: "Some Problems in Transcultural Curating" in Fisher (ed.): 1994, pp. 133-139.

Mouffe, Chantal: "For an Agonistic Public Sphere" in Enwezor et al. (Eds.): *Democracy Unrealised*, 2002, pp. 87-96.

Mouffe, Chantal: *The Return of the Political*, 2005 (1993), Verso.

Moxey, Keith: *The Practice of Theory: Poststructuralism, Cultural Politics, and Art History*, 1994, Cornell University.

Mudimbe, V.Y.: "Reprendre: Enunciations and Strategies in Contemporary African Arts" in Oguibe, Olu, and Enwezor, Okwui (eds.): *Reading the Contemporary. African Art from Theory to the Marketplace*, 1999, Institute of International Visual Arts, London, pp. 30-47.

Mulvey, Laura: "Visual Pleasure and Narrative Cinema" in *Screen*, vol. 16, issue 3, 1975, pp. 6-18.

Neal, Larry: "The Black Arts Movement" in Mitchell, Angelyn (ed.): *Within the Circle: An Anthology of African American Literary Criticism from the Harlem Renaissance to the Present*, 1994, Duke University Press, pp. 184-198 (1968 in The Drama Review).

Nelson, Robert S.: "The Map of Art History" in *Art Bulletin*, March 1997, pp. 28-40.

Nicholson, Sue: *Lær om verdenskunst*, 2005, Forlaget Flachs (English edition, 2004).

Nicodemus, Everlyn: "The centre of otherness" in Fisher (ed.): 1994, pp. 91-104.

Nielsen, Henrik Kaare: "Kunst og samfund" in *Konsument eller samfundsborger. Kritiske essays om kultur og samfund*, Klim, 2007.

Nochlin, Linda: "Why Have There Been No Great Women Artists?" in *ARTnews*, vol. 69, no. 9, January 1971, pp. 22-39 + 67-71.

O'Doherty, Brian: *Inside the White Cube: the Ideology of the Gallery Space*, 1999 (1986), University of California Press.

Oguibe, Olu: "A Brief Note on Internationalism" in Fisher (ed.): 1994, pp. 50-59.

Øhrgaard, Per: "Goethe og Verdenslitteraturen" in *Bogens Verden*, issue 4, 2006, pp. 4-8.

Oiticica, Hélio: "Tropicália" in Basualdo: 2005, pp. 239-241, (written March 4, 1968. First published in *Folha de Sao Paulo*, January 8, 1984).

Osborne, Peter; Sandford, Stella: (eds.): *Philosophies of Race and Ethnicity*, 2002, Continuum.

Owens, Craig: "The Discourse of Others: Feminists and Postmodernism" in Foster, Hal (ed.): *The Anti-Aesthetic*, 1998 (1983) New Press, pp. 57-82.

Papastergiadis, Nikos: "Disputes at the Boundaries of 'New Internationalism'" in *Third Text,* no. 25, 1993, pp. 95-101.

Penny, Simon: "Realities of the Virtual" in *Perspectiven der Medienkunst / Media Art Perspectives*, 1996, ZKM – Zentrum für Kunst und Medientechnologie, pp. 127-134.

Perniola, Mario; Juhl, Carsten: *Kunsten som neutral mutant*, 1996, The Royal Danish Academy of Fine Arts.

Piper, Adrian: "The Triple Negation of Colored Women Artists" (1990) in Jones (ed.): 2003, pp. 239-248.

Pollock, Griselda: *Vision and Difference: Femininity, Feminism, and Histories of Art,* 1987, Routledge.

Poppi, Cesare: "From the Suburbs of the Global Village" in *Third Text*, spring 1991, pp. 85-96.

Preziosi, Donald: *Rethinking Art History: Meditations on a Coy Science*, 1989, Yale University Press.

Rancière, Jacques: "The Aesthetic Revolution and its Outcomes. Employment of Autonomy and Heteronomy" in *New Left Review*, March/April 2002, pp. 133-151.

Rancière, Jacques: *The Politics of Aesthetics*, 2004, Continuum (French edition 2000).

Ratnam, Niru: "Art and Globalisation" in Perry; Wood (eds.): *Themes in Contemporary Art*, 2004, Yale University Press, pp. 277-313.

Reenberg, Holger and Weirup, Torben (eds.): *500 års verdenskunst*, 2004, Gyldendal.

Robertson, Roland: "Glocalization: Time-Space and Homogeneity-Heterogeneity" in Featherstone; Lash; Robertson: *Global Modernities*, 1995, SAGE, pp. 25-44.

Robertson, Roland: *Globalization: Social Theory and Global Culture*, 1992, SAGE.

Rogoff, Irit: "Om at arbejde i mørket" (interview) in *Passepartout* no. 24, 2004, pp. 102-114.

Rogoff, Irit: *Terra infirma – geography's visual culture*, 2000, Routledge.

Rubin, William: "Modernist Primitivist: An Introduction" in Rubin, William (ed.): *'Primitivism' in the 20th Century Art* (vol. 1-2), vol. 1, 1984, Museum of Modern Art, New York, pp. 1-81.

Rubin, William: "Picasso" in Rubin, William (ed.): *'Primitivism' in the 20th Century Art* (vol. 1-2), vol. 2, 1984, Museum of Modern Art, New York, pp. 241-343.

Said, Edward: *Orientalism*, 1995 (1978), Penguin Books.

Salaam, Kaluma ya: "Historical Overviews of the Black Arts Movement" in *The Oxford Companion to African American Literature*, 1997, Oxford University Press, pp. 70-74.

Santamarina, Guillermo: "Recodifying a Non-existent Field" in Fisher (ed.): 1994, pp. 20-27.

Sassen, Saskia: *The Global City: New York, London, Tokyo*, 2001 (1991) Princeton University Press.

Schulte-Sasse, Jochen: "The Prestige of the Artist under Conditions of Modernity" in *Cultural Critique* vol. 12, 1989, pp. 83-100.

Seel, Martin: "On the Scope of Aesthetic Experience" in Shusterman and Tomlin (eds.): *Aesthetic Experience*, 2008, Routledge, pp. 98-105.

Seel, Martin: *Aesthetics of Appearing*, 2005, Stanford University Press (German edition 2000).

Sevänen, Erkki: "Art as an Autopoietic Sub-System of Modern Society" in *Theory, Culture & Society*, vol. 18 (1), 2001, pp. 75-103.

Shaeffer, Jean-Marie: *Art of the Modern Age*, 2000, Princeton University Press (French edition 1992).

Shatanawi, Mirjam: "Tropical Malaise" in *Bidoun* no. 10, spring 2007, pp. 42-44.

Silva, Armando (ed.): *Urban Imaginaries from Latin America*, 2003, Hatje Cantz Publishers.

Smith, Terry: "What is Contemporary Art? Contemporaneity and Art to Come" in *Konsthistorisk Tidskrift*, 2002, vol. 71, no. 1-2, pp. 3-15.

Sotheby's: "Press release", http://www.sothebys.com/liveauctions/event/dh/BIMHF_PR_Announcement.pdf (accessed Jan. 2 2010).

Spivak, Gayatri Chakravorty: *A Critique of Postcolonial Reason*, 1999, Harvard University Press.

Stallabrass, Julian: "Free Trade/Free Art" in Dossi; Nori (eds.): *Arte Prezzo e Valore*, 2008, pp. 59-64.

Stallabrass, Julian: *Contemporary Art – a Very Short Introduction*, 2006, Oxford University Press (2004).

Storr, Robert (ed.): *Think with the senses, feel with the mind*, 2007, Fondazione La Biennale de Venezia.

Sussman, Elisabeth: "Curator's Work. The Pragmatics of Internationalism" in Fisher (ed.): 1994, pp. 161-169.

Szeemann, Harald et al. (eds.): *documenta 5. Befragung der Realität Bildwelten heute*, 1972, documenta GmbH / Verlagsgruppe Bertelsmann GmbH.

Tawadros, Gilane: "The Case of the Missing Body" in Fisher (ed.): 1994, pp. 105-112.

Tawadros, Gilane: "Acknowledgements" in Fisher (ed.): 1994, p. ix.

Thornton, Sarah: "Damien Hirst is rewriting the rules of the market (2)" in *The Art Newspaper*, 17 July 2008.

Thornton, Sarah: *Seven Days in the Art World*, 2008, W.W. Norton & Company Ltd.

Tomlinson, John: *Globalization and Cult*ure, 1999, Polity Press.

Torfing, Jacob: *New Theories of Discourse*, 1999, Blackwell Publishers.

Wallerstein, Immanuel: *The Modern World System: Capitalist Agriculture and the Origins of the European World Economy in the Sixteenth Century*, 1974, Academic Press.

Wallis, Brian (ed.): *Hans Haacke: Unfinished Business*, 1986, The Museum of Contemporary Art and Massachusetts Institute of Technology.

Weibel, Peter (ed.): *Kontext Kunst*, 1994, Dumont.

Weibel, Peter: "An End to the 'End of Art'? On the Iconoclasm of Modern Art" in Latour, Bruno; Weibel, Peter (eds.): *Iconoclash. Beyond the Image Wars in Science, Religion, and Art*, 2002, ZKM, Center for Art and Media, pp. 587-670.

Weibel, Peter: "Jenseits des weissen Würfels. Kunst zwischen Kolonialismus und Kosmopolismus" in Weibel (ed.): *Inklusion/Exklusion*, 1997, DuMont Buchverlag.

Weibel, Peter: "The World as Interface" in Timothy Druckrey (ed.): *Electronic Culture: Technology and Visual Representation*, 1996, Aperture, pp. 338-351.

Welchman, John C. (ed.): *Institutional Critique and After*, 2006, JRP, Ringier Kunstverlag AG.

Williams, Eliza: "Kris Martin: What's the Time?" in *Flash Art*, May/June 2008, p. 149.

Wilson, Fred: "The Silent Message of the Museum" in Fisher (ed.): 1994, pp. 152-160.

Ysla, Nelson Herrera: "Art, Society and the Habana Biennial" in *Atlantica* no. 8, autumn 1994, pp. 156-159.

Žižek, Slavoj: "Beyond Discourse-Analysis" in Laclau, Ernesto (ed.): *New Reflections on The Revolution of Our Time*, 1990, Verso, pp. 249-260.

Žižek, Slavoj: "Multiculturalism, Or, the Cultural Logic of Multinational Capitalism" in *New Left Review*, Sep.-Oct. 1997, pp. 28-51.

Notes

1 Buergel, Roger; Noack, Ruth: *Documenta 12 Katalog/Catalogue*, 2007, documenta Veranstalungs GmbH and Taschen GmbH, p. 208.

2 Baker, George; Müller, Christian Philipp: "A Balancing Act" in *October*, Autumn, 1997, pp. 94-118.

3 Jantjes, Gavin; Wilson, Sarah: *Final Report. The Institute of New International Visual Arts*, 1991, London Arts Board; Arts Council, p. 7 (emphasis added).

4 Tawadros, Gilane: "Acknowledgements" in Fisher, Jean (ed.): *Global Visions: Towards a New Internationalism in the Visual Arts*, 1994, Kala Press and InIVA, p. ix.

5 The speakers were (alphabetically ordered): Rasheed Araeen, Gordon Bennett, Jimmie Durham, Hal Foster, Hou Hanru, Geta Kapur, Raiji Kuroda, Sarat Maharaj, Gerardo Mosquera, Everlyn Nicodemus, Olu Oguibe, Guillermo Santamarina, Elisabeth Sussman, Gilane Tawadros, Fred Wilson, and Judith Wilson.

6 Araeen, Rasheed: "New Internationalism – Or the Multiculturalism of Global Bantustans" in Fisher (ed.): *op. cit.*, 1994, pp. 3-11, p. 3.

7 Araeen: "A New Beginning: Beyond Postcolonial Cultural Theory and Identity Politics" (2000) in Araeen; Cubitt; Sardar (eds.): *The Third Text Reader*, 2002, Continuum, pp. 333-345, p. 4.

8 Santamarina, Guillermo: "Recodifying a Non-existent Field" in Fisher (ed.): *op. cit.*, 1994, pp. 20-27, p. 25.

9 Hou Hanru: "Entropy; Chinese Artists, Western Art Institutions, a New Internationalism" in Fisher (ed.): *op. cit.*, 1994, pp. 79-88, p. 79.

10 Hou: *op. cit.*, 1994, p. 80.

11 http://www.hkw.de/en/hkw/selbstdarstellung/anfang.php (accessed Jan. 2 2010, emphasis added).

12 http://universes-in-universe.de/english.htm (accessed Jan. 2 2010).

13 Laclau, Ernesto and Mouffe, Chantal: *Hegemony and Socialist Strategy*, 2001 (1985), Verso.

14 Torfing, Jacob: *New Theories of Discourse*, 1999, Blackwell Publishers, p. 102.

15 In *Orientalism*, Edward Said acknowledges Michel Foucault's influence on his ability to analyze the discourse of Orientalism. Said, Edward: *Orientalism*, 1995 (1978), Penguin Books.

16 Appadurai, Arjun: *Modernity at Large: Cultural Dimensions of Globalization*, 1996, University of Minnesota; Tomlinson, John: *Globalization and Culture*, 1999, Polity Press; Robertson, Roland: *Globalization: Social Theory and Global Culture*, 1992, SAGE.

17 Robertson, Roland: "Glocalization: Time-Space and Homogeneity-Heterogeneity" in Featherstone; Lash; Robetson: *Global Modernities*, 1995, SAGE, pp. 25-44, p. 27.

18 Robertson, Roland: *op. cit.*, 1995, p. 27 (original emphasis).

19 See Bennett, Gordon: "The Non-Sovereign Self (Diaspora Identities)" in Fisher (ed.): *op. cit.*, 1994, pp. 120-130.

20 Carroll, Noël: "Art and Globalization: Then and Now" in *Journal of Aesthetics and Art Criticism*, vol. 65, issue 1, 2007, pp. 131-143, pp. 136+141.

21 Bydler, Charlotte: *The Global ArtWorld Inc.*, 2004, Acta Universitatis Upsaliensis, Uppsala.

22 See Bydler: *op. cit.,* appendix: "Log of international periodical exhibitions".

23 Bydler: *op. cit.,* p. 131.

24 Stallabrass, Julian: *Contemporary Art – a Very Short Introduction*, 2006, Oxford University Press, p. 95f.

25 See for instance Lord, Gail Dexter: "The 'Bilbao Effect': from poor port to must-see city" in *The Art Newspaper*, no. 184, Oct. 2007, p. 32.

26 See for instance Thornton, Sarah: *Seven Days in the Art World*, 2008, W.W. Norton & Company Ltd.

27 Mudimbe, V.Y.: "Reprendre: Enunciations and Strategies in Contemporary African Arts" in Oguibe, Olu, and Enwezor, Okwui (eds.): *Reading the Contemporary. African Art from Theory to the Marketplace*, 1999, Institute of International Visual Arts, London, pp. 30-47; Ai Weiwei, Sigg, Uli / Frehner, Matthias, Pi Li in Fibicher, Bernhard; Frehner, Mattias (eds.): *Mahjong. Contemporary Chinese Art from the Sigg Collection*, 2005, Hatje Cantz.

28 Nelson, Robert S.: "The Map of Art History" in *Art Bulletin*, March 1997, pp. 28-40.

29 Nelson: *op. cit.*, p. 35. Quotation from Janson, H.W.: *History of Art*, 1962, Harry Abrams, p. 546.

30 See survey chart of national participation throughout the history of the biennial in Di Martino, Enzo: *The History of the Venice Biennale 1895-2005*, 2005, Papiro Arte, pp. 126-129.

31 Here Nelson refers to the fourth edition of *History of Art*, from 1991.

32 Dussel, Enrique: "Beyond Eurocentrism: The World-System and the Limits of Modernity" in Jameson, Fredric; Miyoshi, Masao (eds.): *The Cultures of Globalization*, 1998, Duke University Press, pp. 3-31.

33 Dussel: *op. cit.*, quotes p. 3-4.

34 Dussel: *op. cit.*

35 Hall, Stuart: "The West and the Rest: Discourse and Power" in Gieben; Hall (eds.): *Formations of Modernity*, 1992, The Open University, pp. 275-331, p. 312.

36 Hall: *op. cit.*, 1992, p. 277.

37 See also Wallerstein, Immanuel: *The Modern World System: Capitalist Agriculture and the Origins of the European World Economy in the Sixteenth Century*, 1974, Academic Press.

38 See, for instance, Elkins, James: *Our Beautiful, Dry, and Distant Texts: Art History as Writing*, 2000 (1997), Routledge; Preziosi, Donald: *Rethinking Art History: Meditations on a Coy Science*, 1989, Yale University Press; Moxey, Keith: *The Practice of Theory: Poststructuralism, Cultural Politics, and Art History*, 1994, Cornell University; Pollock,

Griselda: *Vision and Difference: Femininity, Feminism, and Histories of Art*, 1987, Routledge.

39 Elkins, James: *Stories of Art*, 2002, Routledge, p. 18.

40 Elkins: *op. cit.*, 2002, Routledge, p. 113f.

41 Harris, Jonathan: *The New Art History: A Critical Introduction*, 2001, Routledge.

42 Errington, Shelly: "Globalizing Art History" in Elkins, James (ed.): *Is Art History Global?*, 2007, Routledge, pp. 405-440, p. 412-13.

43 Nicodemus, Everlyn: "The centre of otherness" in Fisher (ed.): *op. cit.*, 1994, pp. 91-104, p. 96.

44 Jantjes; Wilson: *op. cit.*, p. 9 (emphasis added).

45 See Bürger, Peter: *Theory of the Avant-garde*, 1984, University of Minnesota (German edition 1974); Dussel: *op. cit.*

46 Articulated in *Global Visions* differently by Jean Fisher, Rasheed Araeen, Hal Foster, Judith Wilson, Everlyn Nicodemus, and Raiji Kuroda.

47 Nicodemus: *op. cit.*, p. 100.

48 Oguibe, Olu: "A Brief Note on Internationalism" in Fisher (ed.): *op. cit.*, 1994, pp. 50-59, p. 57.

49 Hou: *op. cit.*, 1994, p. 84.

50 Santamarina: *op. cit.*, p. 26.

51 Fisher: *op. cit.*, 1994, p. xi.

52 Araeen: "A New ..." *op. cit.*, 2002, p. 10.

53 Mosquera, Gerardo: "Some Problems in Transcultural Curating" in Fisher (ed.): *op. cit.*, 1994, pp. 133-139, p. 137.

54 Tawadros, Gilane: "The Case of the Missing Body" in Fisher (ed.): *op. cit.*, 1994, pp. 105-112, p. 111

55 Articulated in *Global Visions* differently by Jean Fisher, Guillermo Santamarina, Sarat Maharaj, Geeta Kapur, and Gordon Bennett.

56 Maharaj, Sarat: "'Perfidious Fidelity': The Untranslatability of the Other" in Fisher (ed.): *op. cit.*, 1994, pp. 28-35, p. 34.

57 Kapur, Geeta: "A New Inter Nationalism; The Missing Hyphen" in Fisher (ed.): *op. cit.*, 1994, pp. 39-49.

58 Kapur: *op. cit.*, p. 48.

59 Papastergiadis, Nikos: "Disputes at the Boundaries of 'New Internationalism'" in *Third Text,* no. 25, 1993, pp. 95-101, p. 98.

60 Papastergiadis: *op. cit.*, p. 98.

61 Papastergiadis: *op. cit.*, p. 96.

62 Papastergiadis: *op. cit.*, p. 99.

63 Papastergiadis: *op. cit.*, p. 96-97.

64 Hylton, Richard: *The Nature of the Beast. Cultural Diversity and the Visual Arts Sector: A study of policies, initiatives and attitudes 1976-2006*, 2007, ICIA, University of Bath, p. 107

65 Giddens, Anthony: *The Consequences of Modernity*, 1990, Polity Press.

66 http://www.metmuseum.org/works_of_art/collection_database/listview.aspx?page=2 &sort=5&sortdir=asc&keyword=&fp=1&dd1=6&dd2=27 (accessed Jan. 2 2010).

67 See Dimitrakaki, Angela: "Art and Politics Continued: Avant-garde, Resistance and the Multitude in Documenta 11" in *Historical Materialism*, vol. 11, issue 3, 2003, pp. 153-176, p. 153; Meyer, James: "Tunnel Visions" in *Artforum*, September 2002, pp. 168-169, p. 168.

68 Belting: *Art History after Modernism,* 2005, University of Chicago Press, p. 37.

69 Since 1972, *Documenta* has taken place regularly, every five years.

70 Bode, Arnold et. al. (eds.): *Documenta – Kunst des XX. Jahrhunderts, internationale Ausstellung im Museum Fridericianum in Kassel*, 1955, Prestel-Verlag München, pp. 26-27 'Beteiligte Länder'.

71 Based on the lists of names and national belonging of the participating artists from each exhibition's subsection at the official *Documenta* webpage: http://www.documenta12. de/d1_d111.html?&L=1 (accessed Jan. 2 2010).

72 Bode et al.: *op. cit.*, p. 27.
 (my translation: 'Durch die politische Emigration aus Russland und Deutschland ist die nationale Zugehörigkeit bei einer Reihe von Künstlern unsicher geworden; sie wurden je nach dem Grad ihrer Wirkung ihren Heimat- bzw. Gastländern zugeordnet.')

73 Werner Haftmann quoted at http://www.documenta12.de/d12.html?&L=1 (accessed Jan. 2 2010).

74 Foucault, Michel: "The Order of Discourse" in Young (ed.): *Untying the Text: A Post-Structuralist Reader*, 1981, Routledge & Kegan Paul Ltd., pp. 52- 64, p. 61.

75 Foucault: *op. cit.*, p. 61.

76 According to each artist's stated place of birth, on the list of participating artists at *Documenta's* history webpage: http://www.documenta12.de/archiv/d11/data/english/ index.html (accessed Jan. 2 2010). The artists born outside the West came from: Poland, Algeria, Romania, Czechoslovakia, Argentina, Russia, Tunisia, Armenia, Hungary, Indonesia, Japan, Cuba, Egypt, Chile, Turkey, Yugoslavia, Brazil, and Mexico.

77 Rubin, William: "Picasso" in Rubin, William (ed.): *'Primitivism' in the 20th Century Art* (vol. 1-2), vol. 2, 1984, Museum of Modern Art, New York, pp. 241-343.

78 Rubin, William: "Modernist Primitivist: An Introduction" in Rubin, William (ed.): *'Primitivism' in the 20th Century Art* (vol. 1-2), vol. 1, 1984, Museum of Modern Art, New York, pp. 1-81.

79 Rubin: *op. cit.* (vol. 1), p. 41.

80 Account of Peter Hume's notion of 'stereotypical dualism' in Hall: *op.cit.* 1992.

81 Clifford, James: "Histories of the Tribal and the Modern" in *Art in America*, April 1985, pp. 164-177+215, p. 166.

82 McEvilley, Thomas: "Doctor Lawyer Indian Chief" in *Artforum*, Nov. 1984, pp. 54-61, quotes from p. 56.

83 Clifford: *op. cit.*, p. 167.

84 Bois, Yve-Alain: "La Pensée Sauvage" in *Art in America*, April 1985, pp. 178-189; Foster, Hal: *Recodings. Art, Spectacle, Cultural Politics*, 1999 (1985), The New Press, pp. 181-208 ("The "Primitive" Unconscious of Modern Art, or White Skin Black Masks". Originally: *October*, Autumn 1985).

85 Nicodemus: *op. cit.*, p. 101.

86 Kapur: *op. cit.*, p. 44.

87 Rubin: *op. cit.* (vol. 1), p. 41 (original emphasis).

88 See Szeemann, Harald et al. (eds.): *documenta 5. Befragung der Realität Bildwelten heute*, 1972, documenta GmbH / Verlagsgruppe Bertelsmann GmbH, pp. 10-11 (my translation: 'hoffentlich der Beginn einer Nachkunstmarktzeit.').

89 Szeemann et al. (eds.): *op. cit.*, p. 10 (my translation: 'die hier angebotenen Werke als stellvertretend für alle Bilder der Welt versteht.') Of the 214 artists in *Documenta 5*, 13 were born outside the West.

90 Szeemann et al. (eds.): *op. cit.* ('Trivialrealismus & Trivialemblematik', 'Politische Propaganda', 'Film')

91 Szeemann et al. (eds.): *op. cit.* ("Verzeichnis der augestellten Werke").

92 'Verzeichnis der ausgestellten Werke' in Szeemann et al. (eds.): *op. cit.* In the guide, the list of exhibited works covered 64 pages, and the advertisements 80 pages.

93 David, Catherine; Chevrier, Jean-Francois: *Documenta X*, 1997, Cantz Verlag, Documenta and Museum Friedericianum Veranstaltungs GmbH, Kassel.

94 Of the 136 artists in *Documenta 10*, 27 were born outside the West and 19 worked outside the West.

95 See for instance Mercer, Kobena (ed.): *Cosmopolitan Modernisms*, 2005, Institute of International Visual Arts and MIT Press, pp. 7-8; and Ratnam, Niru: "Art and Globalisation" in Perry; Wood (eds.): *Themes in Contemporary Art*, 2004, Yale University Press, pp. 277-313.

96 Besides Jean-Hubert Martin, the team consisted of Jan Debbaut, Mark Francis, Jean-Louis Maubant, Aline Luque, André Magnin, and Jacques Soulillou. See Martin, Jean-Hubert et al. (eds.): *Magiciens de la terre*, 1989, Éditions du Centre Pompidou.

97 Buchloh, Benjamin H.D.: "The Whole Earth Show" *Art in America*, May 1989, pp. 150-159.

98 Buchloh, Benjamin H.D., Martin, Jean-Hubert: "Interview" *Third Text*, no. 6, Spring 1989, pp. 19-27, p. 20.

99 Buchloh; Martin: *op. cit.*, p. 20.

100 Hall, James: "Panopticism at the Pompidou" in *Apollo, the Magazine of the Arts*, 1989, no. 130, pp. 120-121, p. 121.

101 Bourriaud, Nicolas: "Magiciens de la terre" in *Flash Art* no. 148, 1989, pp. 119-121, p. 120.

102 See, for instance, Santamarina: *op. cit.*; Oguibe: *op. cit.*, 1994; Hou: *op. cit.*, 1994; Nicodemus: *op. cit.*

103 Araeen: "New Internationalism ..." *op. cit.*, 2002, p. 9.

104 Araeen: "New Internationalism ..." *op. cit.*, 2002, p. 9.

105 Ekpo, Denis: "The Failure of Postmodernity – How Africa misunderstood the West" in Araeen, Rasheed; Cubitt, Sean; Sardar, Ziauddin (eds.): *op.cit.*, pp. 255-266, p. 266.

106 Žižek, Slavoj: "Multiculturalism, Or, the Cultural Logic of Multinational Capitalism" in *New Left Review*, Sep.-Oct. 1997, pp. 28-51, p. 43.

107 Žižek: *op. cit.*, 1997, p. 44 (original emphasis).

108 Sussman, Elisabeth: "Curator's Work. The Pragmatics of Internationalism" in Fisher (ed.): *op. cit.*, 1994, pp. 161-169, p. 161.

109 Giddens: *op. cit.*, p. 53 (original emphases).

110 Nicodemus: *op. cit.*, p. 96.

111 Nicodemus: *op. cit.*, p. 96.

112 Oiticica, Hélio: "Tropicália" in Basualdo, Carlos (ed.): *Tropicália, a Revolution in Brazilian Culture*, 2005, Cosac Naify, pp. 239-241, p. 240 (Written March 4, 1968. First published in *Folha de Sao Paulo*, January 8, 1984).

113 De Andrade, Oswald: "Anthropophagous manifesto" (1928) in Basualdo (ed.): *op. cit.*, pp. 205-207.

114 Oiticica: *op. cit.*, p. 240-41.

115 Oiticica: *op. cit.*, p. 241.

116 Exhibition catalogue: *XXIV Bienal de São Paulo. Núcleo Histórico: Antropofagia e Histórias de Canibalismos*, 1998, Fundaçao Bienal de São Paulo.

117 Text inside the cover for the exhibition catalogue: *XXIV Bienal de São Paulo ...*, *op. cit.*

118 Exhibition catalogue: *XXIV Bienal de São Paulo ...*, *op. cit.*

119 Gao Minglu: "Toward a Transnational Modernity" in Gao Minglu (ed.): *Inside Out. New Chinese Art*, 1998, University of California Press, pp. 15-40.

120 Laing, Ellen Johnston: *The Winking Owl: Art in the People's Republic of China*, 1989, University of California Press.

121 Gao: *op. cit.*

122 Ysla, Nelson Herrera: "Art, Society and the Habana Biennial" in *Atlantica* no. 8, autumn 1994, pp. 156-159, p. 157.

123 Ysla: *op. cit.*, p. 158.

124 Ysla: *op. cit.*, p. 158.

125 Brett, Guy: "Venice, Paris, Kassel, Sao Paulo and Habana" in *Third Text* no. 20, autumn 1992, pp. 13-22, pp. 14-15 + 18 (reference for quotation in quotation, endnote 5 in Brett: Maria Thereza Alves, statement read to 'Turning the Tables' seminar, Camarawork, London, July 1992).

126 Brett: *op. cit.*, p. 19.

127 Lacan, Jacques: "Of the Gaze as *Objet Petit a*" in Jacques-Alain Miller (ed.): *The Four Fundamental Concepts of Psycho-analysis*, 1998, Vintage, p. 95 (French edition 1973).

128 Lacan: *op. cit.*, p. 96.

129 Oguibe: *op. cit.*, p. 56.

130 Gilroy, Paul: *The Black Atlantic, Modernity and Double Consciousness*, 1995 (1993), Verso.

131 Gilroy: *op. cit.*, p. 17.

132 Gilroy: *op. cit.*, p. 5.

133 Gilroy: *op. cit.*, p. 8.

134 Said: *op. cit.*

135 Bhabha, Homi K: *The Location of Culture*, 1994, Routledge, p. 171.

136 Osborne, Peter and Sandford, Stella: "Introduction: Philosophies of Race and Ethnicity" in Osborne and Sandford (eds.): *Philosophies of Race and Ethnicity*, 2002, Continuum, p. 7.

137 Bhabha: *op. cit.*

138 See Maharaj: *op. cit.*, 1994; Coombes, Annie E.: "The recalcitrant object: culture contact and the question of hybridity" in Barker, Francis; Hulme, Peter; Iversen, Margaret (eds.): *Colonial discourse / postcolonial theory*, 1994, Manchester University Press, pp. 89-114.

139 Chambers, Eddie: "2000's got to be Black" in Brenda L. Croft (ed.): *Beyond the Pale*, 2000, Adelaide Biennial of Australian Art, Art Gallery of South Australia, p. 17. Quoted in Hylton: *op. cit.*, p. 111-112.

140 Coombes: *op. cit.*, 1994, p. 109-110. The quote is Coombes', but with reference to Paul Gilroy.

141 Coombes: *op. cit.*, 1994, p. 107.

142 Coombes: *op. cit.*, 1994, p. 107.

143 Quote by Evaisto Nugkuag in Coombes: *op. cit.*, 1994 p. 107.

144 Araeen, Rasheed: "A New ..." *op cit.*, 2002, p. 336 ff.

145 Jantjes; Wilson: *op. cit.*, p. 7.

146 Salaam, Kaluma ya: "Historical Overviews of the Black Arts Movement" in *The Oxford Companion to African American Literature*, 1997, Oxford University Press, pp. 70-74.

147 Chambers, Eddie: *Black Art, Plotting the Course*, 1988, Oldham Art Gallery.

148 Brother Knight quoted in Neal, Larry: "The Black Arts Movement" in Mitchell, Angelyn (ed.): *Within the Circle: An Anthology of African American Literary Criticism from the Harlem Renaissance to the Present*, 1994, Duke University Press, pp. 184-198 (1968 in *The Drama Review*), p. 185.

149 Neal: *op. cit.*, p. 184.

150 Neal: *op. cit.*, p. 184.

151 Neal: *op. cit.*, p. 187.

152 Araeen, Rasheed: "From Primitivism to Ethnic Art" in *Third Text*, no. 1, autumn 1987, pp. 6-25.

153 Araeen, Rasheed: "Preliminary Notes for a Black Manifesto" *Black Phoenix* no. 1, January 1978, pp. 3-12, p. 7 (original capital letters).

154 Editorial: "Why Third Text?" in *Third Text* no. 1, autumn 1987, pp. 3-5.

155 Araeen, Rasheed: "Sleeping with the Enemy and Re-visiting Postcolonial Theory" in *Third Text* no. 56, Autumn 2001, pp. 75-79.

156 Araeen, Rasheed; Chambers, Eddie: "Black Art. A Discussion" in *Third Text* no. 5, winter 1988/89, pp. 51-77.

157 Stated by Eddie Chambers in Chambers: *op. cit.*

158 Araeen; Chambers: *op. cit.*, p. 52.

159 Araeen; Chambers: *op. cit.*, p. 54.

160 Araeen; Chambers: *op. cit.*

161 Araeen; Chambers: *op. cit.*, p. 59-60.

162 Butler, Judith: *Gender Trouble*, 1990, Routledge.

163 Alcoff, Linda Martín: "Philosophy and Racial Identity" in Peter Osborne and Stella Sandford (eds.): *op. cit.*, 2002, Continuum, pp. 13-28, p. 16 (original emphasis, originally 1996 in *Radical Philosophy*).

164 Alcoff: op. cit.

165 Hylland Eriksen, Thomas: *Ethnicity and Nationalism. Anthropological Perspectives*, 1993, Pluto Press, p. 12.

166 The artists in the exhibition were all Americans of African descent: Jean-Michel Basquiat, Renee Green, David Hammons, Ben Petterson, Adrian Piper, Sandra Rowe, Gary Simmons, Lorna Simpson, Carrie Mes Weems, Pat Ward Williams, Fred Wilson.

167 Lord, Catherine: *The Theater of Refusal, Black Art and Mainstream Criticism*, 1993, The Fine Arts Gallery of the University of California, p. 6 (emphasis added).

168 Quote reproduced in Lord, Catherine: *op. cit.*, p. 44.

169 Gary Simmons in "Roundtable" in Lord, Catherine: *op. cit.*, p. 64.

170 Nochlin, Linda: "Why Have There Been No Great Women Artists?" in *ARTnews*, vol. 69, no. 9, January 1971, pp. 22-39 + 67-71.

171 Owens, Craig: "The Discourse of Others: Feminists and Postmodernism" in Foster, Hal (ed.): *The Anti-Aesthetic*, 1998 (1983) New Press, pp. 57-82, p. 59.

172 Owens: *op. cit.*, p. 62.

173 Jones, Amelia: "Feminism Incorporated: Reading 'Postfeminism' in an Anti-feminist Age" in Jones, Amelia (ed.): *The Feminism and Visual Culture Reader*, 2003, Routledge, pp. 314-328.

174 López, Yolanda; Roth, Moira: "Social Protest: Racism and Sexism" in Broude, Norma; Gerrard, Mary D. (eds.): *The Power of Feminist Art*, 1994, Harry B. Abrams, pp. 140-157.

175 Betye Saar quoted in López; Roth: *op. cit.*, p. 152.

176 Mendieta, Ana: *Dialectics of Isolation. An Exhibition of Third World Women Artists of the United States*, 1980, A.I.R. Gallery.

177 López; Roth: *op. cit.*

178 Mulvey, Laura: "Visual Pleasure and Narrative Cinema" in *Screen*, vol. 16, issue 3, 1975, pp. 6-18.

179 Molesworth, Helen: "House Work and Art Work" in *October*, spring 2000, pp. 71-97.

180 Osborne; Sandford: *op. cit.*, p. 5.

181 Jones: *op. cit.*, p. 1.

182 See Foster, Hal et al.: "The Politics of the Signifier: A Conversation on the Whitney Biennial" in *October*, autumn 1993, pp. 3-27; Danto, Arthur C.: "The 1993 Whitney Biennial" in *The Nation*, April 19 1993, pp. 533-536.

183 Rosalind Krauss in Foster et al.: *op. cit.*, 1993, pp. 22-23.

184 Danto: *op. cit.*, 1993, p. 534.

185 Benjamin Buchloh in Foster et al.: *op. cit.*, 1993, p. 14.

186 Benjamin Buchloh in Foster et al.: *op. cit.*, 1993, p. 19.

187 Weibel, Peter: "Jenseits des weissen Würfels. Kunst zwischen Kolonialismus und Kosmopolismus" in Weibel (ed.): *Inklusion/Exklusion*, 1997, DuMont Buchverlag, pp. 8-36, p. 33 (my translation. "In der Kunst hat sich der Diskurs des Kolonialismus auf mehrfache Weise wiederholt und gespiegelt. Zum einen ist die Kunst strukturell als Diskurs selbst auf der Dialektik der Differenzierung und damit auf Strategien der Ausgrenzung bzw. Abgrenzung aufgebaut und spiegelt damit in ich selbst die koloniale Denkweise. Zum anderen ist die Kunst in ihrer inhaltlichen Ideologie blanker Ausdruck der kolonialen Mentalität Europas.").

188 See Bürger: *op. cit.* (Chapter 3 "On the Problem of the Autonomy of Art in Bourgeois Society").

189 Kant, Immanuel: *The Critique of Judgement*, (1790) eBook ISBN: 9780585051345, Raleigh, N.C. Alex Catalogue (for distinction between art with a specific purpose and art without specific purpose see § 51, pp. 122-127); Shaeffer, Jean-Marie: *Art of the Modern Age*, 2000, Princeton University Press (French edition 1992), p. 31 ff.

190 Schaeffer: *op. cit.*, p. 41.

191 See Schaeffer: *op. cit.,* Chapter 2.

192 Kyndrup, Morten: *Den æstetiske relation*, 2008, Gyldendal.

193 Danto, Arthur C.: "The Artworld" *Journal of Philosophy*, Oct. 1964, pp. 571-584, p. 580.

194 Dickie, George: *The Art Circle*, 1984, Haven Publications; *Art and Value*, 2001, Blackwell.

195 For elaboration of the role of the *works* in the development of institutional theory, see Lash, Scott; Lury, Celia: *Global Culture Industry: the Mediation of Things*, 2007, Polity Press (Chapter 4, especially pp. 67-73).

196 Crimp, Douglas: *On the Museum's Ruins*, 1993, The MIT Press, p. 220.

197 Dickie: *op. cit.*, 2001.

198 Bourdieu: *The Rules of Art, Genesis and Structure of the Literary Field*, 1996, Polity Press (French edition 1992), pp. 167-168.

199 Said: *op. cit.* ("Introduction").

200 Bourdieu, Pierre: "The Historical Genesis of a Pure Aesthetic" in *The Journal of Aesthetics and Art Criticism*, 1987, pp. 201-210.

201 Coombes: *op. cit.*, 1994.

202 Preziosi: *op. cit.*, p. 26.

203 Schulte-Sasse, Jochen: "The Prestige of the Artist under Conditions of Modernity" in *Cultural Critique* vol. 12, 1989, pp. 83-100, p. 98.

204 Piper, Adrian: "The Triple Negation of Colored Women Artists" (1990) in Jones (ed.): *op. cit.*, pp. 239-248, p. 241 (original emphasis).

205 See Martin et al. (eds.): *op. cit.*, pp. 176-177.

206 Araeen, Rasheed: "The Success and Failure of Black Art" in *Third Text*, March 2004, pp. 135-152, p. 149-50.

207 Guggenheim: "Press Release", January 20, 2006.

208 Guggenheim: *op. cit.*

209 Guggenheim: *op. cit.*

210 Quoted in Channing, Joseph: "City Arts Set for Asia Week" in *The New York Sun*, March 12, 2007 (emphasis added).

211 The *Hugo Boss Prize* has been awarded every second year since 1996. The Asian finalists were Cai Guo Qiang and Yasumasa Morimura (1996); Huang Yong Ping and Lee Bul (1998); Hachiya Kazuhiko and Koo Jeong-a (2002); Yang Fudong and Rirkrit Tiravanija (winner) (2004); Cao Fei and Apichatpong Weerasethakul (winner) (2010) http://www.hugoboss-prize.com (accessed Jan. 2 2010).

212 Culler, Jonathan: *Framing the Sign. Criticism and its Institutions*, 1988, University of Oklahoma Press.

213 Bennett, Tony: *The Birth of the Museum*, 1995, Routledge, p. 42.

214 For a discussion on the art museum's sacral aspects see: Duncan, Carol: "The Art Museum as Ritual" (1995) in Preziosi (ed.): *The Art of Art History*, 1998, Oxford University Press, pp. 473-485.

215 Philip Fisher paraphrased in Bennett, Tony: *op. cit.*

216 Weibel: *op. cit.*, 1997, p. 11 (my translation: 'Daher sind unsere "Kunstmuseen" voll mit westlichen Kunstprodukten, und für die Kunst anderer Zivilisationen haben wir sogenannte "Haüser der Kulturen" gebaut. In dieser Trennung kommt symptomatisch

der kulturelle eurozentrische Exklusionsmechanismus zum Ausdruck. Die Trennung in "Kunstmuseum" und "Völkerkundemuseum" markiert genau die Grenzlinie von Inklusion und Exklusion.')

217 http://www.tropenmuseum.nl/smartsite.shtml?ch=FAB&id=5860 (accessed Jan. 2 2010).

218 Shatanawi, Mirjam: "Tropical Malaise" in *Bidoun* no. 10, spring 2007, pp. 42-44, pp. 42-43.

219 http://www.britishmuseum.org/explore/highlights/highlight_objects/aoa/t/throne_of_weapons.aspx (accessed Jan. 2 2010)

220 Shatanawi: op. cit., p. 43. See also: http://www.tropenmuseum.nl/smartsite. shtml?ch=FAB&id=TM_AGENDA_ENGLISH&ActiviteitID=3604 (accessed Sep. 14 2010).

221 Coombes, Annie E.: "Inventing the 'Postcolonial': Hybridity and Constituency in Contemporary Curating" in Preziosi (ed.): *The Art of Art History: A Critical Anthology*, 1998, Oxford University Press, pp. 486-497, p. 489.

222 See, for instance, Dikovitskaya, Margaret: *Visual Culture: the study of the visual after the cultural turn*, 2005, MIT Press; Elkins, James: *Visual Studies: a skeptical introduction*, 2003, Routledge.

223 Mirzoeff, Nicholas (ed.): *The Visual Culture Reader*, 1998, Routledge, p. 6.

224 Mirzoeff: *op. cit.*, p. 7.

225 Shohat, Ella; Stam, Robert: "Narrativizing Visual Culture: Towards a polycentric aesthetics" in Mirzoeff: *op. cit.*, pp. 37-59, p. 45.

226 Hou: *op. cit.*, 1994 p. 79.

227 Rogoff, Irit: "Om at arbejde i mørket" (interview) in *Passepartout* no. 24, 2004, pp. 102-114, p. 104.

228 Rogoff, Irit: *Terra infirma – geography's visual culture*, 2000, Routledge, p. 43.

229 Rogoff: *op. cit.*, 2000, p. 32.

230 Araeen: "A New ..." *op. cit.*, 2002, p. 10.

231 Mitchell, W.T.J.: *The Last Dinosaur Book, the Life and Times of a Cultural Icon*, 1998, The University of Chicago Press.

232 Sassen, Saskia: *The Global City: New York, London, Tokyo*, 2001 (1991) Princeton University Press.

233 Hou Hanru; Obrist, Hans Ulrich: "Cities on the Move" in Hou Hanru: *On the Mid-Ground*, 2002, Timezone 8, pp. 214-229, p. 226 (originally printed in the catalogue for the London version of the exhibition, 1997).

234 See Blazwick, Iwona (ed.): *Century City, Art and Culture in the Modern Metropolis*, 2001, Tate Gallery Publishing Ltd.; and http://www.tate.org.uk/modern/exhibitions/centurycity (accessed Jan. 2 2010).

235 Kaplan, Janet A.: "*Century City*: Conversation with the Curators" in *Art Journal*, Fall 2001, pp. 48-65, p. 49.

236 Kaplan: *op. cit.*, p. 49.

237 For a thorough account of the exhibition's different sections, see Heartney, Eleanor: "Boomtowns of the Avant-Garde" in *Art in America*, September 2001, pp. 65-71.

238 Heartney: "Boomtowns ..." *op. cit.*, 2001, p. 65.

239 See exhibition paper *Global Cities, 20 June – 27 August 2007* printed by Tate Modern, unpublished and http://www.tate.org.uk/modern/exhibitions/globalcities/default.shtm (accessed Jan. 2 2010).

240 The cities explored were Cairo, Istanbul, Johannesburg, London, Los Angeles, Mexico City, Mumbai, São Paulo, Shanghai, and Tokyo.

241 Exhibition paper: *Global Cities, op. cit.*, p. 3.

242 Exhibition paper: *Global Cities, op. cit.*, p. 7.

243 Exhibition paper: *Global Cities, op. cit.*, p. 7.

244 O'Doherty, Brian: *Inside the White Cube: the Ideology of the Gallery Space*, 1999 (1986), University of California Press.

245 Reenberg, Holger and Weirup, Torben (eds.): *500 års verdenskunst*, 2004, Gyldendal.

246 Reenberg; Weirup (eds.): *op. cit.*, pp. 10-11.

247 Nicholson, Sue: *Lær om verdenskunst*, 2005, Forlaget Flachs (English edition, 2004).

248 The following on Goethe is referred from Weibel: *op. cit.*, 1997, (paragraph V) and Øhrgaard, Per: "Goethe og Verdenslitteraturen" in *Bogens Verden*, issue 4, 2006, pp. 4-8.

249 Weibel: *op. cit.*, 1997, p. 29 (my translation: 'Weltliteratur im Sinne Goethes war also ein Hybrid, aufgebaut auf der Dialektik der Differenz von Partikularität (Nationalität) und Universalität (Gemeingut der Menschheit).')

250 Weibel: *op. cit.*, 1997, p. 11 (my translation: ""Weltkunst" ist als "Westkunst" und "Westkunst" als "weisse Kunst" definiert worden. Die Idee der "Weltkunst" ist ein Kind der westlichen Zivilisation, geboren in der ideologischen Absicht, jede künstlerische Äusserung, die sich nicht dem westlichen Kanon anpasst, zu unterdrücken und auszuschliessen.")

251 Luhmann, Niklas: "Weltkunst" in Luhmann, Niklas; Bunsen, Frederick D.; Baecker, Dirk: *Unbeobachtbare Welt: Über Kunst und Architektur*, 1990, Bielefeld, pp. 7-45, p. 20 (my translation: 'Welt muss dann verstanden werden als die in allen Unterscheidungen vorausgesetzte Einheit, als das Nichtschematische der Schemata oder auch als der blinde Fleck aller Beobachtungen, also das, was man nicht sehen kann, wenn man das, was man beobachtet, mit Hilfe einer bestimmten Unterscheidung bezeichnet.')

252 Luhmann: *op. cit.*, p. 40 (my translation: 'Wir verstehen unter "Weltkunst" nicht eine Kunst, die die Welt auf überlegene Weise repräsentiert, sondern eine Kunst, die die Welt beim Beobachtetwerden beobachtet und dabei auf Unterscheidungen achtet, von denen abhängt, was gesehen und was nicht gesehen werden kann.')

253 Luhmann, Niklas: *Art as a Social System*, 2000, Stanford University Press (German edition 1995), p. 142 (original emphasis).

254 Sevänen, Erkki: "Art as an Autopoietic Sub-System of Modern Society" in *Theory, Culture & Society*, vol. 18 (1), 2001, pp. 75-103.

255 McLuhan, Marshall: *Understanding Media: The Extension of Man* (1964) 1994, MIT Press.

256 Carroll: *op. cit.*, p. 139 (original emphasis). See, for instance Jameson, Fredric: *Postmodernism, or, the Cultural Logic of Late Capitalism*, 1991, Duke University Press; "Notes on Globalization as a Philosophical Issue" in Jameson; Miyoshi (eds.): *op. cit.*, pp. 54-77.

257 Weibel, Peter: "An End to the 'End of Art'? On the Iconoclasm of Modern Art" in Latour, Bruno; Weibel, Peter (eds.): *Iconoclash. Beyond the Image Wars in Science, Religion, and Art*, 2002, ZKM, Center for Art and Media, pp. 587-670.

258 Weibel: *op. cit.*, 2002, pp. 663-4, see Lippard, Lucy: *Six Years: the dematerialization of the art object from 1966 to 1972*, 1973, Praeger.

259 Weibel, Peter: "The World as Interface" in Timothy Druckrey (ed.): *Electronic Culture: Technology and Visual Representation*, 1996, Aperture, pp. 338-351, p. 343.

260 Weibel: *op. cit.*, 1996, p. 343.

261 Weibel: *op. cit.*, 1996, p. 346.

262 Weibel: *op. cit.*, 1996, p. 347.

263 The term stems from Mario Perniola's text in the catalogue for the 45th Venice Biennial in 1993. Part of the text was published in the Italian edition of the catalogue and the rest was added for the English edition, which never went on sale, due to copyright issues. The text was published in full in a Danish translation in Perniola, Mario; Juhl, Carsten: *Kunsten som neutral mutant*, 1996, The Royal Danish Academy of Fine Arts. Subsequent references relate to this publication.

264 Perniola; Juhl: *op. cit.*, p. 22 (my translation: '[F]orudsætter en revurdering af mellemrummene, af *l'entre-deux*, af et *Zwischen*.')

265 Weibel: *op. cit.*, 1996, pp. 342-343.

266 Armleder, John et al.: "How has Art Changed? Survey" in *Frieze*, October 2005, pp. 158-169, p. 164.

267 Stallabrass: *op. cit.*, 2006, p. 132.

268 Penny, Simon: "Realities of the Virtual" in *Perspectiven der Medienkunst / Media Art Perspectives*, 1996, ZKM – Zentrum für Kunst und Medientechnologie, pp. 127-134, pp. 127 + 130.

269 Weibel: *op. cit.*, 1996, p. 349.

270 Jameson, Fredric: "Culture and Finance Capital" in *The Cultural Turn. Selected Writings on the Postmodern, 1983-1998*, 1998, Verso, pp. 136-161.

271 Jameson: "Culture ..." *op. cit.*, 1998, pp. 153-54.

272 See Bydler: *op. cit.*, p. 154.

273 Francesco Bonami in Griffin, Tim: "Global Tendencies. Globalism and the Large-Scale Exhibition" in *Artforum*, November 2003, pp. 152-163 + 206, p. 162.

274 Bonami in Griffin: *op. cit.*, p. 162 (original emphasis).

275 See Adorno, Theodor: "Culture Industry Reconsidered" in *New German Review*, Autumn 1975, pp. 12-19.

276 Editorial: "Why Third Text?" *op. cit.*

277 Gerlis, Melanie: "China overtakes France" in *The Art Newspaper*, issue 188, 7 Feb. 2008.

278 See http://www.apec.org/apec/about_apec.html (accessed Jan. 2 2010).

279 For elaboration on corporate branding through sponsorship of art see Stallabrass: *op. cit.*, 2006.

280 Andrea Fraser in Armleder et al.: *op. cit.*, p. 162.

281 Godfrey, Mark: "Traveling Hopefully" in *Frieze*, October 2005, pp. 170-175, p. 173.

282 Weibel: *op. cit.*, 1996, p. 349.

283 Dussel: *op. cit.*, p. 17 (original emphasis).

284 Hardt, Michael; Negri, Antonio: *Empire*, 2000, Harvard University Press.

285 Hardt; Negri: *op. cit.*, p. 326-7.

286 Hardt; Negri: *op. cit.*, p. xii (original emphasis).

287 Hardt; Negri: *op. cit.*, p. 332-3.

288 Marx, Karl; Engels, Friedrich: *The Communist Manifesto*, (1848), 1998, ElecBook London, p. 34.

289 Bevan, Roger: "Damien Hirst is rewriting the rules of the market (1)" in *The Art Newspaper*, 10 July 2008 and Sotheby's press release: http://www.sothebys.com/liveauctions/event/dh/BIMHF_PR_Announcement.pdf (accessed Jan. 2 2010).

290 Bevan: *op. cit.* (emphasis added).

291 David Mugrabi quoted in Thornton, Sarah: "Damien Hirst is rewriting the rules of the market (2)" in *The Art Newspaper*, 17 July 2008.

292 Thornton: *op. cit.,* 2008.

293 Marx; Engels: *op. cit.*

294 Stallabrass, Julian: "Free Trade/Free Art" in Dossi; Nori (eds.): *Arte Prezzo e Valore*, 2008, pp. 59-64, pp. 63-4.

295 Stallabrass: *op. cit.*, 2006.

296 Ratnam: *op. cit.*, pp. 288-289 (emphasis added).

297 Ratnam: *op. cit.*, p. 289.

298 See Danto, Arthur C.: *After the End of Art*, 1997, Princeton University Press; Smith, Terry: "What is Contemporary Art? Contemporaneity and Art to Come" in *Konsthistorisk Tidskrift*, 2002, vol. 71, no. 1-2, pp. 3-15; Osborne: *op. cit.*, 1995 (Chapter, 1 "Modernity: A Different Time").

299 Danto: *op. cit.*, 1997, p. 17.

300 Belting, Hans: *The End of the History of Art?*, 1987, University of Chicago Press; Danto: *op. cit.*, 1997.

301 Belting, Hans: "Contemporary Art and the Museum in the Global Age" in Weibel; Beddensieg (eds.): *Contemporary Art and the Museum*, 2007, Hatje Cantz, pp. 16-38, p. 22.

302 Danto: *op. cit.*, 1997, p. 12.

303 Danto: *op. cit.*, 1997, p. 12.

304 Heartney, Eleanor: *Postmodernism*, 2001, Tate Gallery Publishing Ltd.

305 Ratnam: *op. cit.*, p. 297.

306 Ratnam: *op. cit.*, p. 299.

307 Barthes, Roland: "The Death of the Author" (1968) in *Image, Music, Text*, 1998 (1977), Hill and Wang, pp. 142-148.

308 Kant: *op. cit.*; Kyndrup: *op. cit.*; Seel, Martin: *Aesthetics of Appearing*, 2005, Stanford University Press (German edition 2000).

309 Kant: *op. cit.* and Schaeffer *op. cit.*

310 Schaeffer: *op. cit.,* p. 57 (emphasis added).

311 Seel, Martin: "On the Scope of Aesthetic Experience" in Shusterman and Tomlin (eds.): *Aesthetic Experience*, 2008, Routledge, pp. 98-105.

312 de Duve, Thierry: "Museets etik efter Duchamp" in Torzen, Lene and Lønstrup, Ansa (eds.): *Kunsten og værket. Æstetiskstudier VI*, 1999, Aarhus Universitetsforlag, pp. 9-30,

p. 15 (my translation: Enhver given ting som har fundet vej ind til et museum eller et kunstgalleri bærer et usynligt skilt som siger "dette er kunst".)

313 Seel: *op. cit.,* p. 104.

314 Seel: ibid.

315 Rancière, Jacques: "The Aesthetic Revolution and its Outcomes. Employment of Autonomy and Heteronomy" in *New Left Review*, March/April 2002, pp. 133-151, p 135.

316 For elaboration on this difference between a representative and an aesthetic regime, see Bolt, Mikkel: "Oväsen eller röster. Om de lägre klassernas intelligens hos Jacques Rancière" in *Tidskrift för litteraturvetenskab*, no. 1-2, 2007, pp. 43-54.

317 Rancière, Jacques: *The Politics of Aesthetics*, 2004, Continuum, (French edition 2000), p. 14.

318 Rancière, Jacques: *op.cit.*, 2004.

319 Carnevale, Fulvia and Kelsey, John: "Art of the Possible: An Interview with Jacques Rancière" in *Artforum*, March 2007, pp. 256-269, p. 258 (original emphasis).

320 Fry, Roger: "An Essay in Aesthetics" (1909) in Goodwin, Craufurd D. (ed.): *Art and the Market – Roger Fry on Commerce in Art*, 1998, The University of Michigan Press, pp. 73-85.

321 Poppi, Cesare: "From the Suburbs of the Global Village" *Third Text*, spring 1991, pp. 85-96, p. 91.

322 Poppi: *op. cit.*, p. 94.

323 Buchloh; Martin: *op. cit.*, p. 20.

324 Araeen: *op. cit.*, 2004, p. 151.

325 Araeen's definition of AfroAsian artists is referenced by Eddie Chambers in Chambers: *op. cit.*

326 http://www.iniva.org/content.php?page_id=3263&type=Artist (accessed Jan. 2 2010).

327 For elaboration of the full story behind the painting see: http://www.tate.org.uk/servlet/ViewWork?workid=26547&searchid=37710 (accessed Jan. 2 2010).

328 Goodnough, Abby: "Mayor Threatens to Evict Museum Over Exhibit He Dislikes" in *The New York Times,* September 24 1999.

329 Golden, Thelma; Ofili, Chris: "A Conversation" in *Chris Ofili: Within Reach, volume 1 "Words"*, 2003, Victoria Miro Gallery, London, pp. 1-19.

330 For a discussion of the relation between Ofili and Hammon's works see Cosentino, Donald J.: "Hip-Hop Assemblage: The Chris Ofili Affair" in *African Arts*, spring, 2000, pp. 40-51+95-96.

331 Golden; Ofili: *op. cit.*, p. 3.

332 Golden; Ofili: *op. cit.*, p. 12.

333 Golden; Ofili: *op. cit.*, p. 2.

334 The Roma pavilion was initiated by the Roma Cultural Participation Project, Art and Culture Network Program, Open Society Institute in Budapest. See Storr, Robert (ed.): Think with the senses, feel with the mind, 2007, Fondazione La Biennale de Venezia.

335 Dokolo, Sindika: "African Collection of Contemporary Art" in *African Pavillon – 52nd. Venice Biennale International Contemporary Art Exhibition* (not published but distributed as a PDF file along with the press release. Download from http://universes-in-universe. de/car/venezia/eng/2007/tour/africa/index.htm (accessed Sep. 14 2009).

336 Piper: *op. cit.*, p. 241.

337 Dokolo: *op. cit.*, p. 12.

338 Hall, Stuart: "Chris Ofili in Paradise: Dreaming in Afro" in *Chris Ofili: Within Reach, Volume 1 "Words"*, 2003, Victoria Miro Gallery, London, pp. 39-43, p. 41.

339 Foucault, Michel: "What is an Author?" (1969) in Rabinow, Paul (ed.): *The Foucault Reader*, 1984, Pantheon Books, pp. 101-120.

340 Araeen: *op. cit.*, 1987.

341 See Gibbs, Michael: "Documenta 11/1" in *Art Monthly* no. 258, 2002, pp. 1-5, p. 1; Heartney, Eleanor: "A 600-Hour Documenta" in *Art in America*, Sep. 2002, pp. 86-95, p. 86; *Blitz Review*, Oct. 26 1998.

342 Ute Meta Bauer and Susanne Ghez were also part of the curatorial team.

343 Enwezor, Okwui: "The Black Box" in Enwezor et al. (eds.): *Documenta 11 Catalogue*, 2002, Hatje Cantz Publishers, pp. 42-55, p. 44.

344 Enwezor: *op. cit.*, 2002, p. 43.

345 Enwezor: *op. cit.*, 2002, p. 46.

346 Enwezor: *op. cit.*, 2002, p. 45.

347 Enwezor, Okwui et al. (eds.): *Democracy Unrealized. Documenta11_Platform 1*, 2002, Hatje Cantz, p. 11.

348 Enwezor, Okwui et al. (eds.): *Democracy ... op. cit.*, 2002; *Experiment with Truth. Documenta11_Platform 2*, 2002, Hatje Cantz Publishers; *Créolité and Creolization, Documenta11_Platform 3*, 2003, Hatje Cantz Publishers; *Under Siege: Four African Cities Freetown, Johannesburg, Kinshasa, Lagos*, Documenta11_Platform 4, 2002, Hatje Cantz Publishers.

349 Jaar, Alfredo: "It Is Difficult" in Enwezor et al. (eds.): *Experiments ... op. cit.*, pp. 289-310, p. 289-

350 Enwezor: *op. cit.*, 2002, p. 43.

351 Silva, Armando (ed.): *Urban Imaginaries from Latin America*, 2003, Hatje Cantz Publishers.

352 Enwezor: *op. cit.*, 2002, p. 42.

353 Buergel; Ruth: *op. cit.*, pp. 11-12.

354 Cunningham, David; Martin, Stewart: "The Death of a Project" in *Journal of Visual Culture*, vol. 7, issue 2, 2008, pp. 214-218.

355 Dorment, Richard: "The worst art show ever" in the *Telegraph*, June 19, 2007.

356 Bishop, Claire: "Vienna Inc.: The Analytic documenta" in *Journal of Visual Culture*, vol. 7, issue 2, 2008, pp. 206-214, p. 206.

357 Bishop: *op. cit.*, 2008, p. 207.

358 Kleeblatt, Norman L.: "Identity Roller Coaster" in *Art Journal*, spring 2005, pp. 61-3, p. 62 (emphasis added). For such a critique of the 1993 Whitney Biennial, see Foster et al.: *op. cit.*, 1993.

359 Fisher, Jean: "Toward a Metaphysics of Shit" and Maharaj, Sarat: "Xeno-Epistemics: Makeshift Kit for Surrounding Visual Art as Knowledge Production and the Retinal Regimes" in Enwezor et al. (eds.): *op. cit. Documenta 11 Catalogue*, 2002, pp. 63-70 + 71-84.

360 Fisher: *op. cit.*, 2002, p. 67.

361 Maharaj: *op. cit.*, 2002, p. 72.

362 Enwezor: *op. cit.*, 2002, p. 45.

363 Enwezor: *op. cit.*, 2002, p. 44. Enwezor refers to Achille Mbembe and Janet Roitman as the originators of the notion of the 'regime of subjectivity' in "Figures of the Subject in Times of Crisis", *Public Culture*, no. 16, winter 1995.

364 Enwezor: *op. cit.*, 2002, p. 45.

365 Enwezor: *op. cit.*, 2002, p. 44.

366 Enwezor: *op. cit.*, 2002, p. 45.

367 Enwezor: *op. cit.*, 2002, p. 44.

368 Spivak, Gayatri Chakravorty: *A Critique of Postcolonial Reason*, 1999, Harvard University Press.

369 Spivak: *op. cit.,* p. 172 (original emphasis).

370 Spivak: *op. cit.,* p. 358. In this context Spivak consequently spells "postcolonialism" with quotation marks.

371 Spivak: *op. cit.*, p. 9.

372 Spivak: *op. cit.*, p. 358.

373 Enwezor: *op. cit.*, 2002, p. 45.

374 See Danto: *op. cit.*, 1964; Dickie: *op. cit.*, 1984, 2001.

375 See Schaeffer: *op. cit.*; Nielsen, Henrik Kaare: "Kunst og samfund" in *Konsument eller samfundsborger. Kritiske essays om kultur og samfund*, Klim, 2007; Bürger: *op. cit.*

376 Dutton, Denis: "Authenticity in Art" in Levinson, Jerrold (ed.): *The Oxford Handbook of Aesthetics*, 2003, Oxford University Press, pp. 258-274.

377 For information on the *Guaraná Power* project, see http://www.superflex.net/tools/supercopy/guarana.shtml (accessed Jan. 2 2010).

378 See, for instance, Bonami, Francesco et al. (eds): *Biennale di Venezia: Dreams and conflicts: The dictatorship of the viewer. 50th international art exhibition*, Thames & Hudson, 2003, p. 667.

379 Foster, Hal: *The Return of the Real*, 1996, Massachusetts Institute of Technology.

380 Foster: *op. cit.*, 1996, p. 25 (original emphasis).

381 Groys, Boris: "Art in the Age of Biopolitics. From Artwork to Art Documentation" Enwezor, Okwui et al. (eds.): *Documenta 11 Catalogue*, 2002, Hatje Cantz Publishers, pp. 108-114, p. 108 (emphasis added).

382 Groys: *op. cit.*, p. 109.

383 Groys: *op. cit.*, p. 109.

384 Bourriaud, Nicolas: *Relational Aesthetics*, 2002, Les presses du réel (French edition 1998), p. 15.

385 Bourriaud: *op. cit.*, 2002, p. 19.

386 Bourriaud: *op. cit.*, 2002, p. 63.

387 Bourriaud: *op. cit.*, 2002, p. 14.

388 Bourriaud: *op. cit.*, 2002, p. 17 (emphasis added)

389 Bishop, Claire: "Antagonism and Relational Aesthetics" in *October* no. 110, 2004, pp. 51-79

390 Bishop: *op. cit.*, 2004, p. 79.

391 Bishop: *op. cit.*, p. 78 (original emphasis).

392 Araeen: "A New ..." *op. cit.*, 2002, p. 334.

393 Araeen: "A New ..." *op. cit.*, 2002, p. 343 + 344.

394 Araeen: "A New ..." *op. cit.*, 2002, p. 342.

395 Foster: *op. cit.*, 1996, p. 173.

396 Larsen, Lars Bang, Ricupero, Christina, and Schafhausen, Nicolaus (eds.): *Populism. The Reader*, 2005, Lukas & Sternberg. Contributors include, among others, Mads Ted Drud-Jensen, Ernesto Laclau, Chantal Mouffe, Ivar B. Neumann, Pierre-André Taguieff, and Niels Werber.

397 Bydler: *op. cit.*, p. 64

398 Bydler: *op. cit.*, p. 64

399 Enwezor et al. (eds.): *op. cit. Documenta 11 Catalogue*, p. 176 (original font format).

400 Enwezor et al. (eds.): *op. cit. Documenta 11 Catalogue*, p. 22 (original font format).

401 Bürger: *op. cit.*

402 Foster: *op. cit.*, 1996 (Chapter 6: "The Artist as Ethnographer").

403 Žižek, Slavoj: "Beyond Discourse-Analysis" in Laclau, Ernesto (ed.): *New Reflections on The Revolution of Our Time*, 1990, Verso, pp. 249-260, p. 252.

404 From Hans Haacke's proposal quoted from Wallis, Brian (ed.): *Hans Haacke: Unfinished Business*, 1986, The Museum of Contemporary Art and Massachusetts Institute of Technology, p. 118.

405 Wallis: *op. cit.,* pp. 118-133.

406 For elaboration of Context Art, see Weibel, Peter (ed.): *Kontext Kunst*, 1994, Dumont.

407 See Wilson, Fred: "The Silent Message of the Museum" in Fisher (ed.): *op. cit.*, 1994, pp. 152-160. See also Welchman, John C. (ed.): *Institutional Critique and After*, 2006, JRP, Ringier Kunstverlag AG

408 Foster: *op. cit.*, 1996, p. 198.

409 See Ekeberg, Jonas (ed.): *New Institutionalism*, 2003, Office for contemporary art Norway, p. 13.

410 Hoffmann, Jens (ed.): *The Next Documenta Should Be Curated by an Artist*, 2004, Revolver Archiv für aktuelle Kunst.

411 Lawrence Weiner in Hoffmann: *op. cit.*, p. 75.

412 Lawrence Weiner in Hoffmann: *op. cit.*, p. 75 (original capitalization).

413 Enwezor: *op. cit.*, 2002, p. 55.

414 Enwezor: *op. cit.*, 2002, p. 54.

415 Torfing: *op. cit.*, p. 109.

416 Laclau; Mouffe: *op. cit.*, pp. 140-141.

417 Laclau; Mouffe: *op. cit.*, pp. 131-134; Torfing: *op. cit.*, pp. 126-128.

418 Enwezor: *op. cit.*, 2002, pp. 47, 46.

419 Enwezor: *op. cit.*, 2002, pp. 49-50, 54-55.

420 Enwezor: *op. cit.*, 2002, p. 54.

421 Enwezor: *op. cit.*, 2002, p. 54.

422 Enwezor: *op. cit.*, 2002, p. 55.

423 Enwezor: *op. cit.*, 2002, pp. 46-47.

424 Araeen, Rasheed: "In the heart of the black box" in *Art Monthly* no. 259, 2002, p. 17.

425 Mouffe, Chantal: "For an Agonistic Public Sphere"; Laclau, Ernesto: "Democracy between Autonomy and Heteronomy" in Enwezor et al. (eds.): *op. cit. Democracy Unrealised*, 2002, pp. 87-96, 377-386.

426 Mouffe, Chantal: *The Return of the Political*, 2005 (1993), Verso ("Introduction: For an Agonistic Pluralism", pp. 1-8); *op. cit.*, 2002.

427 Mouffe: *op. cit.*, 2002, p. 91.

428 Mouffe: *op. cit.*, 2002, p. 92.

429 Mouffe: *op. cit.*, 2002, p. 94.

430 Downey, Anthony: "The Spectacular Difference of Documenta XI" in *Third Text*, March 2003, pp. 85-92, p. 89.

431 Downey: *op. cit.*, p. 91.

432 For thorough information and documentation, see the project's homepage http://www. rethinking-nordic-colonialism.org (accessed Jan. 2 2010).

433 Kuratorisk Aktion (Frederikke Hansen and Tone Olaf Nielsen): "Nordic Amnesia: An Introduction to *Rethinking Nordic Colonialism*" at http://www.rethinking ... *op. cit.*

434 Poppi: *op. cit.*, p. 94.

435 http://www.bienalfindelmundo.org (accessed Jan. 2 2010).

436 The first issue with the 'Global Art' section was *Flash Art* no. 173, Nov/Dec 1993.

437 Williams, Eliza: "Kris Martin: What's the Time?" in *Flash Art*, May/June 2008, p. 149.

438 Williams: *op. cit.*, p. 149.

439 Madra, Beral: "The Hot Spot of Global Art" in *Third Text*, January 2008, pp. 105-112.

440 For instance: Ratnam: *op. cit.*; Hylton: *op. cit.*; Fisher (ed.): *Global Visions ... op. cit.*; Jantjes and Wilson: *op. cit.*; Papastergiadis: *op. cit.* See also Bærøe, Birgit (ed): *Deterritorializations. Art and Aesthetics in the 90s*, 2000, Spartacus Forlag & Bokförlaget Nya Doxa (Part II, "New Internationalism"); Haagemann, Jannie; Høholt, Stine: "Mod et nyt kunstnerisk verdenskort?" in Christensen, Hans Dam; Michelsen, Anders; Wamberg, Jacob (eds.): *Kunstteori – positioner i nutidig kunstdebat*, 1999, Borgen.

441 Araeen: "A New ..." *op. cit.*, 2002, p. 342.